GGN

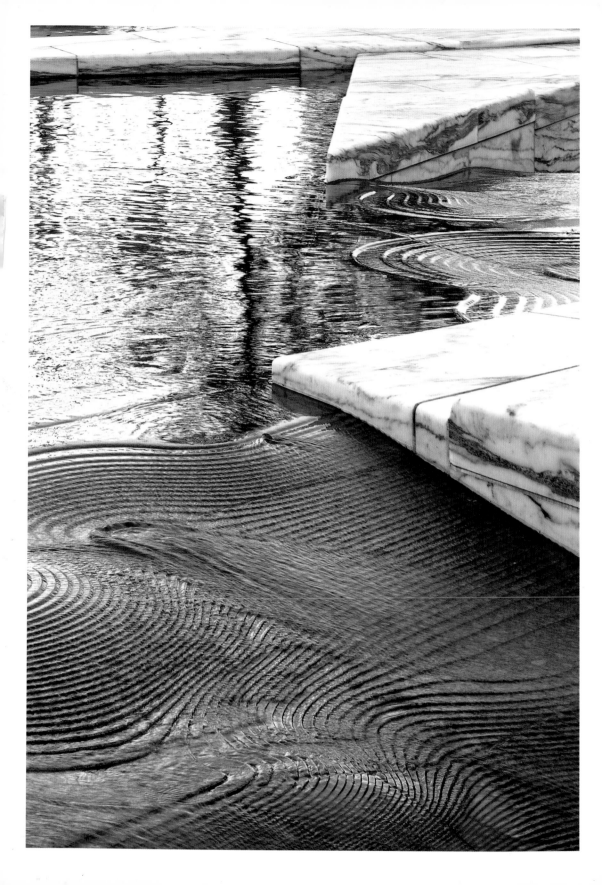

GGN
LANDSCAPES
1999–2018

WRITTEN WITH
THAÏSA WAY

TIMBER PRESS
PORTLAND, OREGON

TO OUR FAMILIES, AND TO ALL THOSE
WHO HAVE SUPPORTED US OVER THE LAST EIGHTEEN YEARS.
— GGN

TO STUDENTS OF LANDSCAPE ARCHITECTURE, WHO
ASPIRE TO SHAPE OUR PUBLIC REALM
WITH BEAUTY, INTEGRITY, AND GENEROSITY.
— THAÏSA WAY

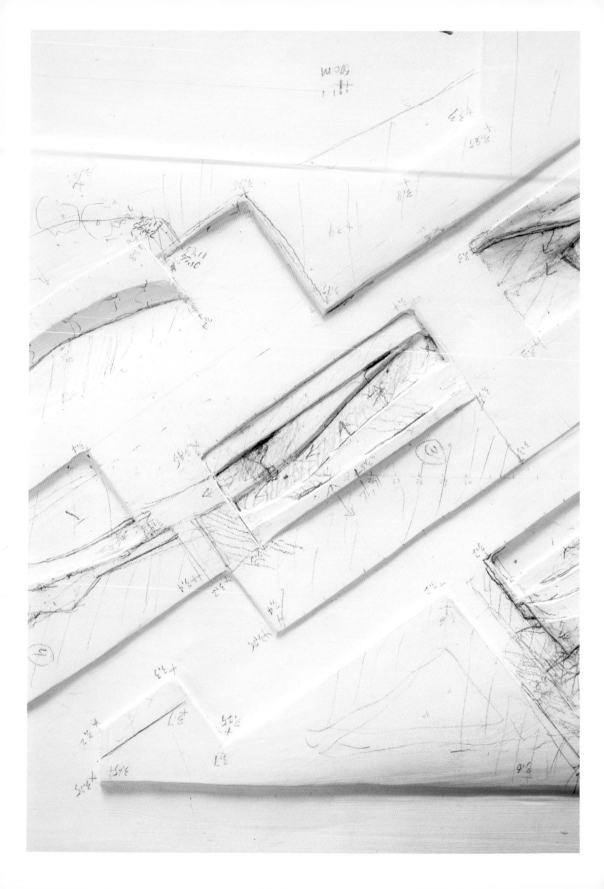

CONTENTS

9
FOREWORD
SCOTT STEWART, EXECUTIVE DIRECTOR, MILLENNIUM PARK FOUNDATION

15
INTRODUCTION
COLLABORATION, DESIGN, AND LEADERSHIP
FOUNDING THE FIRM
DRAWING TO THINK

39
DEFINING A FIRM AND DESCRIBING A PRACTICE
THE LURIE GARDEN, 2000–2004
FURNITURE, 2004–2012
SEATTLE CITY HALL PLAZA AND CIVIC CENTER CAMPUS, 2000–2005
NORTH END PARKS, 2003–2007
ROBERT AND ARLENE KOGOD COURTYARD, 2005–2007
BILL & MELINDA GATES FOUNDATION CAMPUS, 2009–2011

127
SPREADING WINGS AND EXPLORING NEW TERRITORIES
WEST CAMPUS RESIDENCES & STREETSCAPE, 2009–2012
MERCER COURT & UW FARM, 2011–2013
CITYCENTERDC MASTER PLAN AND PLAZA, 2005–2013
THE PARK AT CITYCENTER, 2006–2013
PIKE-PINE RENAISSANCE STREETSCAPE DESIGN VISION, 2012–2013
CHROMER BUILDING PARKLET & STREATERY, 2014

207
BROADENING HORIZONS AND REFINING DETAILS
UNIVERSITY OF WASHINGTON SCHOOL OF MEDICINE, 2013–2018
NU SKIN INNOVATION CENTER AND CAMPUS, 2010–2015
LOWER RAINIER VISTA & PEDESTRIAN LAND BRIDGE, 2010–2015
NATIONAL MUSEUM OF AFRICAN AMERICAN HISTORY AND CULTURE, 2009–2016
INDIA BASIN SHORELINE PARK, 2016–2018

288
ENDNOTES

289–291
STAFF LIST AND ACKNOWLEDGMENTS

292
PROJECT CREDITS

294
PHOTOGRAPHY CREDITS

FOREWORD

The desire to change our surroundings, to change our world, is at the heart of our human story. Our species, since first stepping from the tree canopies onto the plains of Africa, has sought to modify the land to fit our emotions and desires—agricultural necessity, religious function, displays of social or economic standing, or to meaningfully enhance aesthetics. For the landscape architect, being granted the task, the responsibility, of modifying the land—combining native forms and functions with a client's vision—represents a sacred modern connection to this ancient theme of the human story.

I was first exposed to the landscape architecture of Gustafson Guthrie Nichol (GGN) during a 2005 visit to the Lurie Garden in Millennium Park (Chicago, Illinois). At that time, I was a doctoral student studying environmental horticulture—the intersection of ecology and horticulture—with an interest in how natural areas management can inform public garden design and care. Having seen the considerable press coverage on the design and planting of the Lurie Garden and being familiar with the Garden's surroundings in Chicago's Loop, I felt a visit to this garden, already being labeled as "iconic," was an absolute must. As I prepared for my first visit to the Lurie Garden, I could simply not understand how this newly planted public garden, designed by, at that time, a relatively new landscape architecture firm, in what was basically a new public park, could be garnering such high praise. And this is where my lessons began on how GGN is able

to harness collaboration, design, and leadership to create beautiful, meaningful, and powerful spaces.

On that first visit to the Lurie Garden, I was immediately struck by the raw beauty of the garden. I remember thinking, "Damn, this GGN crew knows how to strike a chord in people…they really understood this space." What GGN accomplished within Lurie Garden's relatively small footprint was to reflect the big heart, and bigger history, of Chicago. Their design was a clear philosophical juxtaposition of the human condition toward love of nature versus love of monumental building— presenting a vibrant horizontal perennial landscape against the strong vertical architecture of the Chicago skyline. In partnering with Piet Oudolf on the garden's perennial plant design, GGN created a complex, symphonic experience of plants, stone, wood, water, and sky. The landscape I experienced that September day in 2005 at the Lurie Garden reflected GGN's formula for future successes: meaningful collaboration, thoughtful design, and strong leadership.

Some ten years later, I would have the opportunity to lead the Lurie Garden as its director. Assuming this leadership role presented a unique opportunity for me to learn about one of GGN's most iconic landscapes from the perspectives of both the designers themselves and those individuals who were responsible for the daily management of the garden's plantings. Finding myself thrust into leading the operations of an internationally recognized public garden was daunting; however, I quickly discovered that the

collaborative spirit first seeded into the garden's design process by GGN was very much still alive, and it provided me with a community of designers, horticulturalists, staff, and volunteers from which I could learn about the Lurie Garden in tremendous detail. The greatest lesson learned during my time at the Lurie Garden was that GGN's design process is more than just lines on paper and plants in the ground; their approach to the art and science of landscape architecture breeds long-lived, entrenched collaboration in the landscapes and people they touch.

As executive director of Millennium Park Foundation, I have the opportunity to tour parks, gardens, and public spaces throughout the world. No matter whether I am visiting Central Park and the High Line, Copenhagen Botanical Garden, or Atlanta Botanical Garden, I am always reading landscapes with the eyes of a horticulturalist. In these travels, I have found GGN's landscapes to stand above most others in the field. GGN's work strikes an uncommon balance among form, function, artistry, and the raw beauty of the land by using clean vistas and clear, but not harsh, delineation between land, plant, water, and structure. These characteristics lend to GGN landscapes a distinct modern touch without being excessive or provincial; landscapes free from unnecessary clutter. And, thinking as an ecologist for a moment, GGN's capacity to capture and re-project the human and ecological past of a site or region through design is a deeply powerful theme in all of the firm's work.

GGN, their designers, and their design process are representative of a professional attitude that lays clear claim to purposeful thought about the land as the realm of the

landscape architect—making the landscape the absolute equal to the architect and their buildings. The work of GGN creates aspirational and inspirational spaces that are responsive to the public's wishes, for today and into the future, while also engineering solutions into the landscape to integrate those spaces into local infrastructure. This elevates the landscape beyond mere municipal ornamentation into the realm of functional, meaningful municipal system. The firm is fanatical about creating landscapes that are heartfully embraced and beloved by their users, while pushing beyond accepted methodologies to create artful, unique, functional, and evolutionary spaces.

Simply said, a landscape by GGN gives truly living spaces to the public. What could be a better measure of impact and significance?

—Scott Stewart
Executive Director, Millennium Park Foundation

COLLABORATION, DESIGN, AND LEADERSHIP

For almost two decades, the firm of Gustafson Guthrie Nichol has sought to realize design's potential to create significant spaces in the landscape. These landscape spaces are three-dimensional volumes constructed through deliberate and thoughtful design, generating dynamic places that grow, change, and mature with time. GGN designers have imagined, constructed, and protected such places capable of fostering community and nurturing ecological health. Their work has engaged diverse scales—from the city parklet to the urban master plan, from private residences to whole neighborhoods—while addressing challenges from the commonplace to the remarkably complex.

From its inception, GGN has been committed to solving both the specific and the broad challenges of space and place through the process of design and the realization of beautiful and resilient landscapes. Most often, the firm tackles landscapes in complex urban contexts, notably working with communities and leaders in Seattle, Washington; Chicago, Illinois; Boston, Massachusetts; San Antonio, Texas; and Washington, DC; among others, to make a vital contribution to city life.

These multifaceted projects engage with and resolve a diversity of wicked challenges and, in turn, shape some of our country's most public realms.

As a firm, GGN approaches its work with bravery, humor, humility, and acute curiosity. Its leaders have cultivated a diverse collective of individuals who come with knowledge in landscape design, architecture, art, engineering, and ecology, as well as the humanities and social sciences. As the firm has grown from the initial three founding leaders, Shannon Nichol, Jennifer Guthrie, and Kathryn Gustafson, it has retained its emphasis on teamwork and partnership, offering each new employee space to grow and contribute. It is remarkable that, during a period when many firms were chasing commissions with starchitects, these designers were building a collaborative culture, one grounded in the belief in work as a joyful and generous pursuit.

A significant extension of this collaborative approach is also reflected in their curation of strong and deep relationships with clients and communities, valuing each as a partner in the design process. Many of their clients credit this respectful approach as an essential ingredient in GGN's timeless and beautiful landscapes. The firm reflects these shared values in their partnerships with architects and civic leaders; they work together to redefine the role of landscape architects in the twenty-first century.

GGN's designs have been recognized by countless awards, including the Smithsonian's 2011 Cooper Hewitt National Design Award for Landscape Architecture and, more recently, the American Society of Landscape Architects' 2017 National Landscape Architecture Firm Award. Such recognition, however gratefully received and welcomed, has emphasized the finished product: the elegance of the designs and the timeless beauty of the landscapes. Acknowledging the challenges of these projects and the complexity of the systems that comprise the very real landscapes as they are designed is more difficult. This book seeks to build a broader context for understanding and assessing the work of GGN, one that explores how spatial design in the landscape can be used to solve problems while simultaneously creating places where humans, culture, and environments thrive.

The book's approach explores GGN's design process from the inception of a project through to its construction and use. It considers the manner in which this process tangles with and then realizes the cultural narratives and ecological processes of the place in a manner that might optimally foster environmental and community resilience. Fewer than twenty projects were selected to highlight—emphasizing those that offer readers the opportunity to learn from a reflective review of the work, focusing on the ways in which design is used to respond to and solve, when possible, problems and challenges.

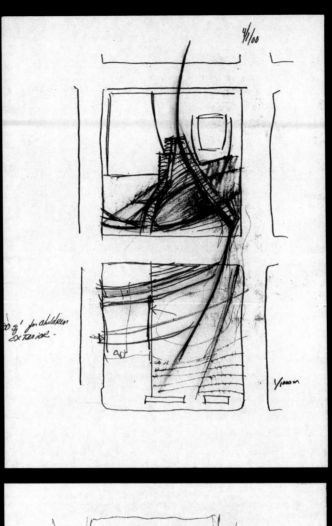

SEATTLE CIVIC CENTER OPEN SPACE

Gustafson Partners Ltd

FOUNDING THE FIRM

Jennifer Guthrie, Kathryn Gustafson, and Shannon Nichol founded GGN in 1999. They had met only a few years earlier while working on projects at Anderson & Ray, a landscape architecture office in Seattle. In working together, they discovered a shared respect for the design process as an intense exploration of landscape as a means to create spaces that would respond aesthetically, culturally, and environmentally to the multifaceted challenges that we face as individuals and as communities. In their earliest collaborations, despite differences in backgrounds, they built a trust in each other's integrity and commitment to both conceptual and technical rigor. This meeting of the minds and souls was powerful, and would eventually lead to discussions that explored a new design firm—one of their own making.

They sought to develop a firm culture where trust and conviction were sustained as core values and where each partner, and for that matter every member of the firm, gave priority to the quality of the design project before ego, ease, or convenience. The emphasis would be on what they could generate together as a design team, even as each took on a specific role or task in any given project. The design process would be grounded in deep investigations of the site, its place and people, and the development and commitment to a conceptual framework to guide the design through to completion. And in the end, design would be used to address—and whenever possible, solve—the difficulties posed by landscape and the places we reside and engage. These guiding tenets remain at the heart of the firm today.

Jennifer Guthrie grew up in Orange County, Southern California, in a family of gardeners and artists. Attending the University of Washington in Seattle, she planned to study mathematics; however, after visiting the grand houses and gardens of Great Britain on a study-abroad program focused on British art, architecture, and theater through the University of London's architecture program, she decided to instead enroll in UW's architecture program. Jennifer found she was more interested in the siting of the houses and their landscapes and gardens than she was in the architecture. She was taking a studio on structures, for which she was to design a cabin in the woods, only to find herself spending far more time siting the project than designing the structure. Two courses with landscape architect and founder of the landscape architecture department at UW, Richard Haag, confirmed her interest in landscape architecture. In 1993, Jennifer graduated with bachelor's degrees in both landscape architecture and architecture—just as a recession hit the nation.

Despite the recession and a severely limited number of available positions, Jennifer landed an opportunity soon after graduating to work with Linda Osborn, principal landscape architect and owner of the Osborn Pacific Group in Seattle. Working in a small office, Jennifer learned the intricacies of running a firm as a business and a design practice. She eventually moved to the firm of Anderson & Ray, where she would join Kathryn Gustafson and Shannon Nichol, first on a design for a football stadium and exhibit center, then on the South Coast Plaza Bridge of Gardens in Costa Mesa, California—serendipitous, as Jennifer had grown up in Costa Mesa and knew of the owners of the South Coast property, the Segerstroms. Together, Jennifer and Kathryn designed the pedestrian bridge and garden plaza, on a site near to Isamu Noguchi's 1982 *California Scenario* sculpture garden. The Bridge of Gardens scheme was an abstraction of the movements of the earth and water, and the impact of increasing population on the Southern California landscape.

As with future projects, the design concept engaged a strong spatial narrative, this one centered on the dynamics of geologic changes, the forces of faults, slips, and mounting pressure—both literal and conceptual.

Shannon Nichol was born in Arizona and grew up in Deming, Washington, at the base of Mount Baker, in the Cascade Mountain Range. Educated by two self-sufficient parents, one a systems engineer and the other an artist-naturalist, Shannon learned to make what she needed and fix what was broken. Immersed in the drawings, quilts, textile weavings, handmade clothes, and other creations of her mother, she mastered drawing and was mechanically inclined, learning to fix cars and motorcycles for herself and for friends. Building on these skills, she worked a variety of jobs, including in equipment operations, driving a pea combine harvester for the night shift, and sorting belts and washing barrels in a cannery to purchase school clothes and pay for college.

Attending the University of Washington, where she was focused on forestry and pre-engineering, Shannon enrolled in an evening course with Richard Haag, just as Jennifer had done only a few years earlier. When he described the practice of landscape architecture and showed lecture images of an altered stream bed in a Japanese garden, she knew she had found her dream career. She enrolled in the landscape architecture program and was soon awarded a

scholarship to study abroad at the University of Liverpool's architecture program. Her travels to Europe gave her a new perspective on design and helped her discover the power of urban design and landscapes. Not until her last quarter in school did she pursue the required internship, and was thrilled when the five-person firm of Anderson & Ray, which specialized in environmental restorations, was willing to take her on.

Upon graduating with a BLA in 1997, Shannon found the profession of landscape architecture emerging into an era of increased attention and applause. She chose to stay with Anderson & Ray, as it gave her the opportunity to engage in a variety of projects with an emphasis on environmental restoration, her primary interest. Her projects included landscape-restoration work in public wetlands and softened waterfront shorelines as well as composing and developing interpretive signs. While at the firm, she met Kathryn Gustafson, for whom Shannon developed the graphics for the competition to design the Arthur Ross Terrace at the American Museum of Natural History in New York City, which Gustafson partnered with Anderson & Ray to go on to win.

In 1999, both still at Anderson & Ray, Shannon and Jennifer decided to launch a firm of their own so they could more fully explore and focus on the work that most excited them. They invited Kathryn to collaborate with them on her projects in North America. She agreed on the conditions

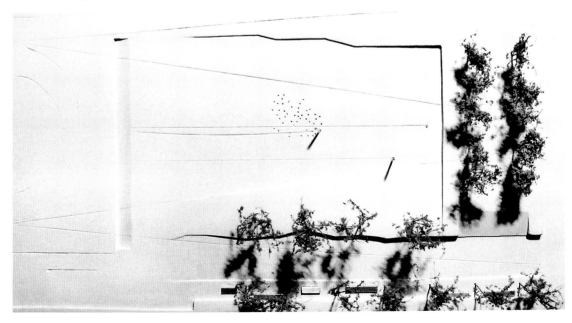

that they include her as a partner in their firm and that each would invest equally. Jennifer and Shannon remained based in Seattle, while Kathryn adopted a visiting role as she remained active in a second partnership in London, with the architect Neil Porter.

Kathryn Gustafson was born and raised on the high plateau desert of the Yakima Valley in Washington State, where the expansive sky may well be the source of her deep appreciation for its ability to shape immense spaces. Patches of farms sustained by a complex system of water canals providing irrigation to farmers throughout the valley offered lessons not lost on Kathryn—although it took a while for them to become important to her professional life. Her early interest was in fashion. She first attended the University of Washington, then transferred to the Fashion Institute of Technology in New York. On graduating, she moved to Paris to become a fashion designer.

Paris's highly stylized landscapes eventually turned Kathryn's focus from fashion to landforms and landscapes. She enrolled at L'École Nationale Supérieure du Paysage de Versailles, at that time the only school in France to offer a degree in landscape architecture. Led by Michel Corajoud, it was a rigorous education in the breadth of landscape design practice, and faculty included the critically important designer Jacques Simon. Kathryn was particularly inspired by Simon's teaching and practice. Years later, she would write about his profound engagement with the power of making space and the significant influence he had on her own practice.[1]

Kathryn launched her first firm in Paris, which she would go on to lead for seventeen years. Her work would include the Gardens of the Imagination in Terrasson-Lavilledieu, France; the city square, Place des Droits de l'Homme, in Évry, France; and later, the Garden of Forgiveness in Lebanon, with her new firm Gustafson Porter (established in 1997 with Neil Porter in London and now Gustafson Porter + Bowman). While maintaining her varied practices, Kathryn returned to her native state of Washington in 1997 to pursue local projects.

In the late 1990s, Seattle, Washington, was an exciting place in which to launch a new firm. The city had a reputation for being avant-garde and as a home to an eclectic legacy of artists. It had

been home to musician Jimi Hendrix, the band Heart in the 1970s, then later grunge bands including Soundgarden, Mudhoney, Nirvana, and Pearl Jam. There was a robust tradition of architects, including important midcentury designers such as Fred Bassetti, Paul Kirk, Paul Thiry, and Minoru Yamasaki. Contemporary contributors to the Pacific Northwest design culture included architects Ed Weinstein and Lesley Bain, both at Weinstein A+U, Bob Hull and Dave Miller of MillerHull, Jerry Ernst, Rick Zieve of SRG, and Peter Bohlin. Together these practitioners had built a culture of collaboration across firms as well as across practices and approaches. They were early local mentors and collaborators with Shannon, Jennifer, and Kathryn as GGN grew.

Along with artists, musicians, and architects, landscape architects had been working in Seattle since the early twentieth century. The Olmsted Brothers firm had developed a master plan for Seattle's parks and parkways as well as the design for the Alaska Yukon Exhibit of 1909, which became the University of Washington's campus plan. In 1962, landscape architect Richard Haag founded the new department of landscape architecture at UW while he led a firm recognized for its extensive public works. Over the following decades, he mentored many accomplished designers including Laurie Olin, Robert Hanna, Don Sakuma, and Grant Jones.

In the 1970s, Dan Kiley and Peter Ker Walker planned Discovery Park, Richard Haag designed and built Gas Works Park, and Lawrence Halprin created Freeway Park. These landscapes established Seattle's reputation for fostering innovative design solutions to complex problems. By the end of the twenty-first century's first decade, Seattle would boast a handful of new and notable design projects, including the Seattle Public Library by Rem Koolhaas, 2004, and the Olympic Sculpture Park by Weiss/Manfredi architects and Charles Anderson, 2007. As GGN emerged as a new firm, it joined a strong and growing design community.

PREVIOUS PAGES, LEFT *Shannon, Kathryn, and Jennifer in their second office space at Pier 55, 2006.* PREVIOUS PAGES, RIGHT *Plaster model of the Arthur Ross Terrace by Kathryn, with trees to explore shadows. The competition first drew Kathryn and Shannon together.* RIGHT *The Arthur Ross Terrace at the American Museum of Natural History in New York City, 2009.*

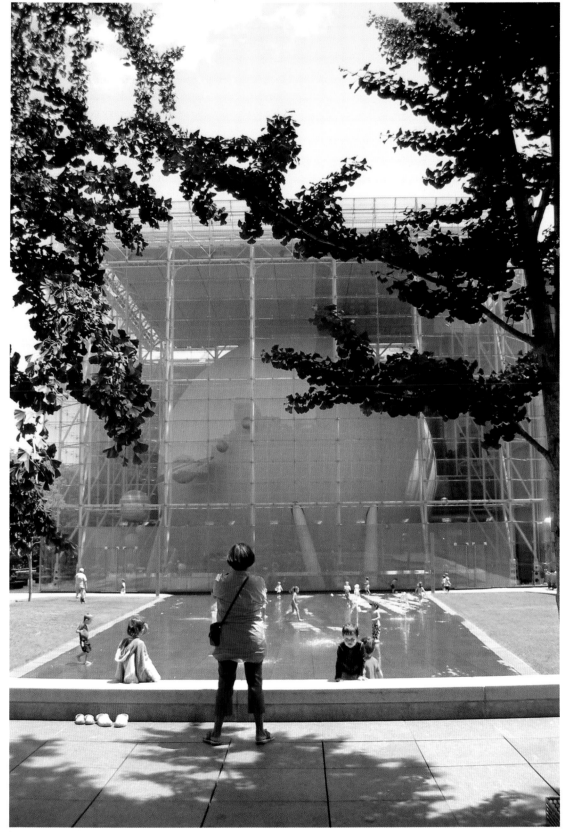

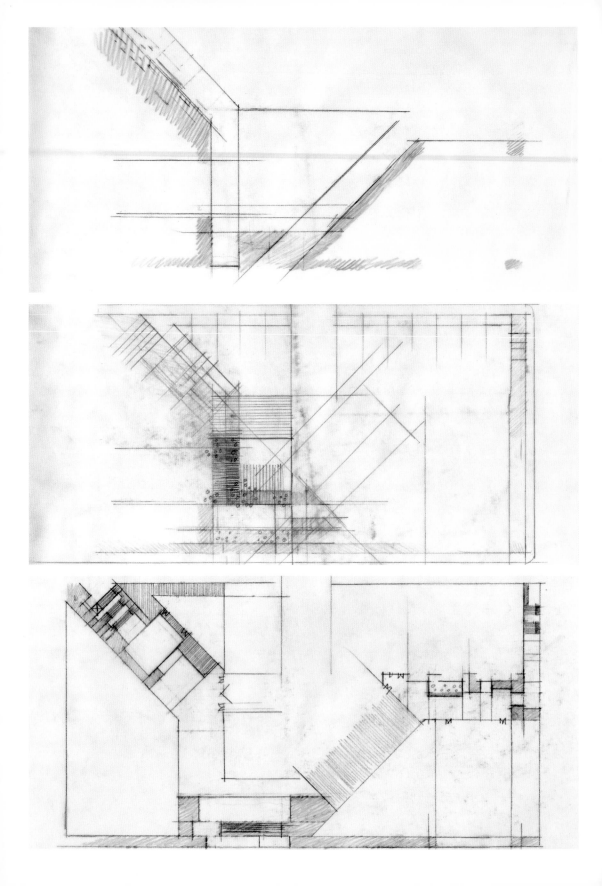

DRAWING TO THINK

As GGN designs each new landscape, they give life to Kathryn's longtime motto "the sky is mine." Their work realizes the power of "whoever draws it first owns it," requiring the designer to jump in, dig deep, and take responsibility for the design, from its conception to its final details as built. Their design process has remained grounded in explorations of scale and the power of shaping space in the landscape. These investigations can only succeed when built on the particulars of place and culture, requiring rigorous site analyses as well as close relationships with clients and future users. This means investigating geology, geography, cultural narratives, social histories, and the ecology and habitats of a site and its contexts. Only after the firm accumulates this knowledge does it turn to solving the problems at hand. It is what Shannon has called "slow design." This approach requires an expansive and iterative process, simultaneously demanding close attention to limits, restrictions, and opportunities and a focus on how design might solve problems and tackle challenges.

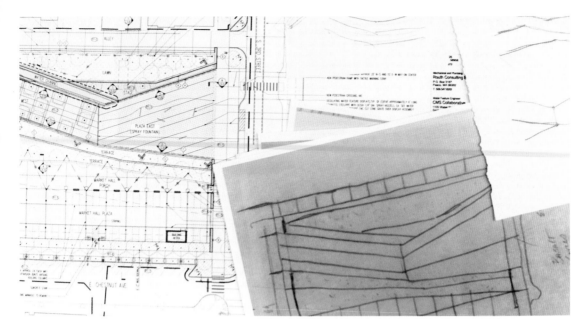

The GGN design process, evident in their earliest projects, has evolved over two decades of developing the firm and engaging a broad range of project types at multiple scales. The process begins with a deep investigation of the site and its land, what is visible and what is invisible. The designers read the landscape carefully and thoughtfully, looking for the poetry of the site, as well as the mysteries, fictions, and facts. They draw as a means to think, either doodles on scraps of available paper or intentionally on large pieces of white paper or in a sketchbook. Trace paper is not as commonly used as is solid paper, paper with texture and depth. They diagram, abstract, document, and imagine the site, the landscape, and its multiple stories and layers of change over time.

As GGN designers develop an in-depth knowledge of the land, they begin to describe a concept that will frame their design. This concept is not drawn out of pure imagination, but rather emerges from the ground, water, and sky of a particular and specific place and time, although it is rarely understood as a simple or overly didactic narrative. This concept might be loosely conceived, as was Seattle's City Hall, or it might be more tightly described, as was the Lurie Garden in Chicago. It might be more narrative, as for the National Museum of African American History and Culture, or it might be more abstract, as it was for UW's Mercer Court. The concept might have more to do with the land, as it was for Rainier Vista, or more

to do with the culture, as it was for the North End Parks or India Basin Shoreline Park. However the concept is defined, it becomes the core principle of the project. It is drawn and remains visible throughout the design process. It is against the concept that decisions are debated and decided. In talking about a project years later, the guiding concept is still used to explain, describe, and assess a GGN landscape.

In moving from concept to constructed landscape, final solutions are posited, considered, and formulated to address the problems and respond to the challenges of the site and its context. This is evident in the dozens and dozens of iterations of landform that can be found in the files for most any project or the notes that are documented and archived. To challenge each design concept, the firm has created a review process drawing on the strengths of those good at thinking on their feet, giving productive feedback, and finally sketching quickly to capture the ideas and the questions. The firm's founders—with the addition

PREVIOUS PAGES, LEFT *A series of early design drawings by Shannon for the renovated outdoor areas of the HALO at Wells Fargo Center in Bunker Hill, downtown Los Angeles.* ABOVE *Sketches, diagrams, and abstracted explorations developed by Kathryn and the Yakima Plaza team in the design process.* RIGHT, ABOVE *Drawing as a study of topopgraphy of the I-5 lid by Keith McPeters.* RIGHT *Documenting in the field while locating historic aerial features.*

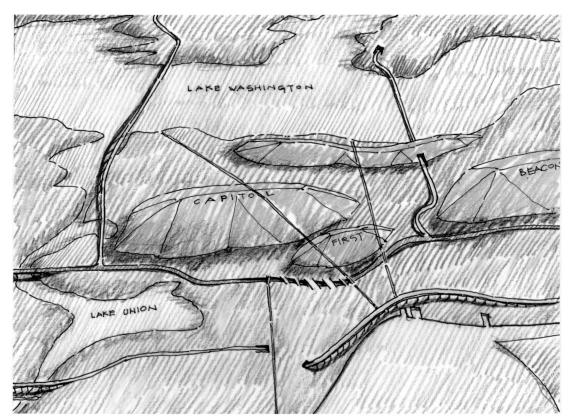

of Rodrigo Abela, Keith McPeters, and David Malda—comprise the "design critters" reviewing each project as it moves through the process of inquiry, creation, and design. It is in this process that answers are identified to the problems posed, more often than not, as design solutions rather than engineered solutions. And it is this iterative process that brings out the best in the collaborative approach as well as in each of the participating individuals. As Shannon would write about Rainier Vista, "There is nothing like having to design the very solution that you would normally avoid for spurring creativity and unscripted thinking. There is a point on nearly every project where we must wholeheartedly adopt—and make lovable—some aspect of a design that we had specifically fought against the day before. We often find the most joy in discovering that we can flip sides and make something work—while getting to a design solution that never would have otherwise entered the picture."

With the design established and ready to be constructed, others in the GGN team engage in specialty areas. Design remains core to the process from the earliest phases through construction. Even as details and systems are built, the design concept and intention is sustained. All are responsible for maintaining the vision.

The space that emerges from this process is a designed place that is intended not so much to tell stories but one where the users, whether a client or the public, can write new stories. It is a place in which history is embedded—not as a limitation or preserved narrative, but as a catalyst for understanding and reading the landscape in new ways. This is truly learning to read a landscape. GGN's approach to landscape is about shaping space for humans and for the environment in ways that promote a future—one that builds on the best of the past and the strengths of the present.

A similar commitment to solving problems through design, and more often than not transforming the problem into an asset, is evident in every GGN project. GGN designers have accomplished this at the scale of a single fire station in Seattle as well as that of Cleveland's downtown district. In the case of Fire Station 10/Emergency Operations Center (2008), a new facility by Weinstein A+U in downtown Seattle, the challenge was to simply and beautifully wrap a massive, five-bay-wide fire truck apron toward the 14-percent cross slope of the street, onto which the station's garage opened each time there was an emergency response. Using the concrete as a topographical element of the design, each bay's portion of the apron was treated as a concrete band with its own, twisting cross slope "glued" to the next band, with an embedded steel rail in the subtle "fold." Each bay received a slightly different concrete finish to offer visual relief to the expanse of the whole driveway.

In the case of Cleveland (2014), the problem was how to preserve and revive a design created by Daniel Burnham in 1903 in ways that would endure a massive expansion of a convention center under the central mall, renew the district,

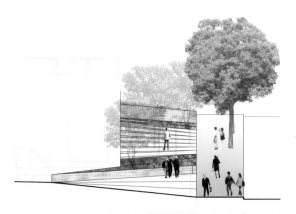

LEFT *Elevation of the warped aprons and pedestrian terraces of the engine bays at Fire Station 10 and Emergency Operations in downtown Seattle.* RIGHT, ABOVE *A series of iterations by Shannon leading to the layout concept for Lower Rainier Vista. A similar process of exploration is used for each GGN project.* RIGHT *Concept view of the Cleveland Mall by Keith showing renewed pedestrian connections to the urban grid, restoring the historic scale to the arterials that had divided Burnham Mall into isolated fields.* OVERLEAF, LEFT AND RIGHT *Drawing on the soft form of a marshmallow, the sketches investigate the potential scale, form, and layout of stone plinths for a courtyard in downtown Los Angeles. Studies by Yuichiro Tsutsumi.*

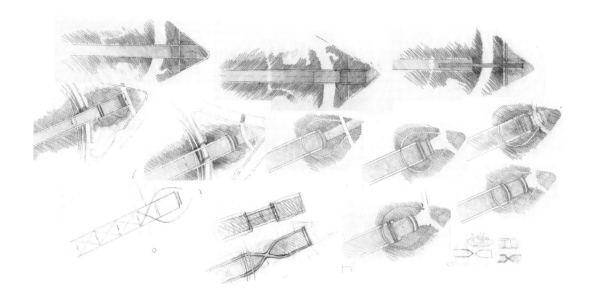

and reconnect its civic parks, streets, and prom-
enades with its lakefront. Although the request
was ambitious, the solution did not require
fancy or grand designs, but rather subtle, even
simple, guidelines for repairing pedestrian and
street fabric and clarifying the design. It needed
human scale. Allées of trees and the insertion of
simple pathways across generous lawns helped
to mediate the expansive space. The plan called
for the realignment of broken and missing streets
and pedestrian crossings that had been lost over
the years to highway-style traffic controls and

event parking facilities. Equally important was
the restoration of the street grid through the
civic center that had been interrupted in recent
decades by building additions and parking
garage ramps in the middle of pedestrian routes.
The proposed design reflected GGN's mindful
approach of restraint balanced with brave, simple
choices. Similar investigations can be found in the
sketches for their urban gardens and their civic
gathering spaces.

Design proposals are developed in the GGN
office through a process of meticulous site

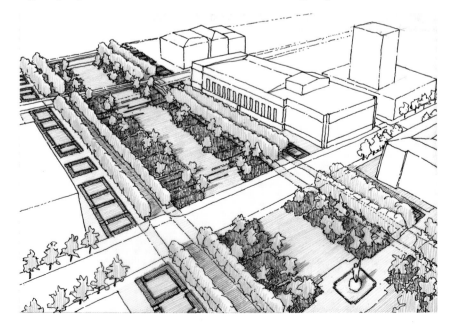

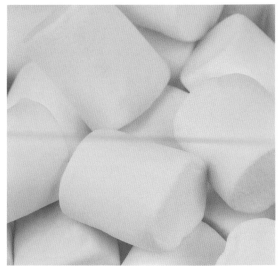

Option 8

Section Profile Options

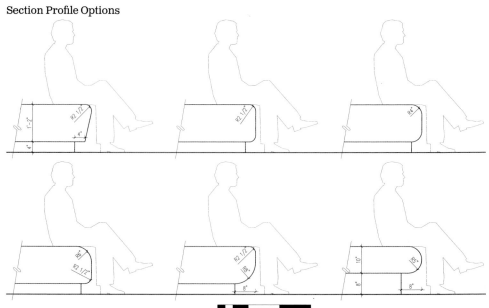

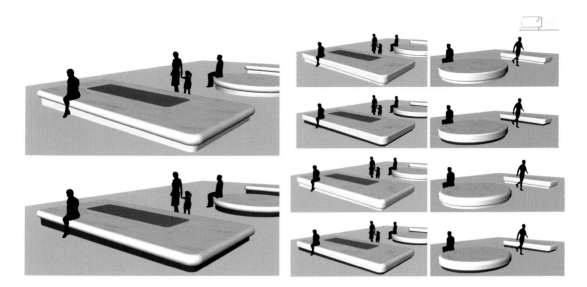

Option 1 **Option 2**

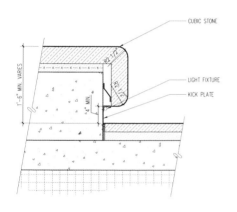

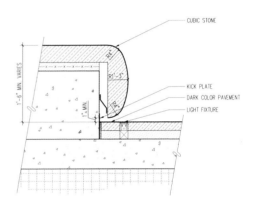

CUBIC STONE

LIGHT FIXTURE

KICK PLATE

CUBIC STONE

KICK PLATE

DARK COLOR PAVEMENT

LIGHT FIXTURE

Scale and Layout

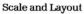

inventory, research, and analysis, as a means of reading the land. Sometimes this includes knowing more about rats than one might desire, or learning about ancient waterways, or discovering how plants reveal forgotten narratives, or making visible communities that have been neglected. While the problems facing designers are often viewed through a contemporary lens, history can often explain why and how a problem arose. History often uncovers invisible characteristics or narratives that might suggest a different approach or response to the visible landscape presented for a project. As Shannon has noted in talking about her design process, landscape architects have the opportunity to reconsider how a landscape has been transformed over time. They might choose to alter the current site to revive a former ecology or geological history, or they might strengthen the changes made by previous inhabitants and users. These choices emerge from rigorous research on the history of the landscape as an ecological, geological, and cultural site. This investigation into the history and narratives of a site are at the heart of GGN's design process,

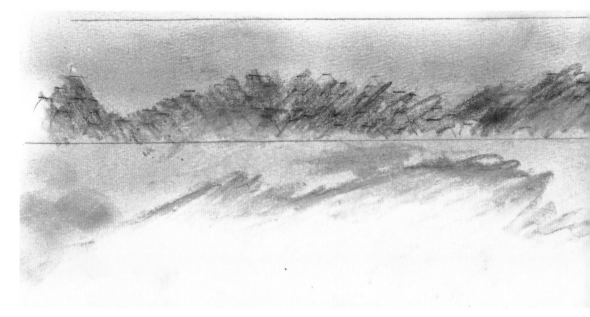

framing a response to a project's goals, challenges, and eventual manifestation.

Drawing on all of the various forms of investigations, GGN designers develop their design concepts that will shape the land and topography. It is this shaping of the ground that so often defines a GGN landscape. For Rainier Vista at the University of Washington, while the original Olmsted landscape defined the design concept, GGN's design contributes a refined elegance in the lay of the lawn as it glides downward, framed by tall, stately trees, and sky above. For the Nu Skin landscape, the land and buildings together enclose a generous place of gathering. For the National Museum of African American History and Culture, the land's topographic form echoes the contemporary nature of David Adjaye's architecture while conveying elements of the history of African Americans in the city and in the nation, connecting culture to ground.

Water, both as material and as ground, is also central to many of GGN's landscapes. In imagining the Kreielsheimer Promenade at Marion O. McCaw Hall in Seattle—GGN's second project after

KG 14 Dec 13

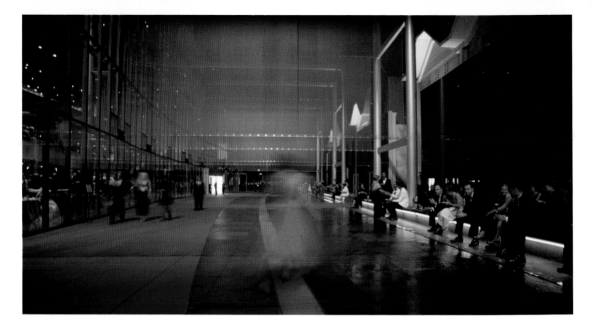

opening the office—the team collaborated closely with LMN Architects to design a dramatic meeting place for opera patrons and visitors, centered on a broad scrim of water and lights that animate the sky and space. Leni Schwendinger was commissioned to create the sequence projected onto the scrims, dubbed *Dreaming in Color*.

At just under one acre, the plaza serves as a public passage from the city into the heart of the expansive Seattle Center campus and transforms at night into a sophisticated urban spectacle. The soft green color of the quartzite stone and the

tinted concrete paving create visual depth when it rains and high contrast on a sunny afternoon. Sparkling with silvery light during the day, the stone and water become a canvas for the bold color and light projected on the scrim at night. It is a design response that addresses a series of challenges, including providing universal access, flexibility, and active use in the evening hours. The Promenade is built over mechanical rooms below, and the surface is slightly tilted toward the street. The lawn, often bathed in sun, beckons the visitor into the inner realms of the Seattle Center.

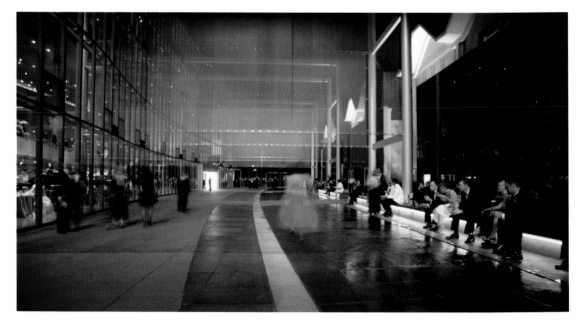

Sky is equally important to ground, aesthetically as well as in solving the problems of a site or project. For the 2008 Venice Architecture Biennale, director Aaron Betsky envisaged including a paradise, and invited Kathryn Gustafson to design the installation. GGN and Gustafson Porter partnered to create the Biennale's first landscape architecture installation. The challenge was to create a landscape for the biennale that would both draw on its site, ground and sky, while also creating an imaginary space of reflection and thought. *Towards Paradise* was conceived as an allegorical journey through earthly dilemmas that suggest what we as humans have gained and lost in the landscape and in the relationship between culture and nature. Designed on the property of the former Church of the Virgins—a thirteenth-century Benedictine nunnery destroyed in 1830 that was at the far end of the Arsenale in Venice, the site of the Biennale—the garden suggests a narrative of past, present, and future of earth, plants, and sky. For the designers, the journey began with the act of clearing a series of openings in the overgrown landscape and shaping the ground to create the suggestion of a path. For visitors, the journey started with the discovery of the garden wall; upon entering, they found themselves in the ruins of ivy-covered buildings. The path led to Lost Abundance, a warehouse whose back wall was inscribed with the Latin names of extinct fauna and flora.

Leaving the area titled Memory to explore the path through the thick overgrowth, the visitor arrived in the garden entitled Abundance, a traditional food garden honoring sustenance for both body and soul. If memory evoked those plants and animals we have lost, the food garden suggested what we could gain in abundance if we so choose. Deeper through bramble was the contrast of Enlightenment, where the sky opened and billowing white "clouds" held aloft by white helium balloons lifted one's eyes upward. Reaching for the sky, the oval landform inspired dreams of Paradise, a sculpted landform. This landform offered spaces to reflect on what has been lost and what remains abundant, suggesting the potential that they might create a future paradise. White cushions that seemed to have fallen from the white veil above provided places to sit, contemplate, dream, and connect.

Land, water, and sky are equally the domain of landscape architecture. The manifesto for *Towards Paradise* articulates this ever so well: "Our work encompasses any space or element that is open to the sky or connects to the environment. Our landscapes develop the ground plane, creating a bond with people who are of course physically connected to the earth. The essence and concept of a landscape is expressed within this plane."[2]

In their two decades of work, GGN has embraced the potential of landscape to markedly improve lives and livability at all scales. The following collection of projects focuses on the public realm and shows how creativity and problem-solving can make and shape memorable spaces. They show diverse intentions and places, and were accomplished with like-minded partners including architects, engineers, and clients. These examples by no means represent the totality of GGN's work but rather allow readers to dip into the work, explore the processes, and, we hope, reimagine the potential for urban landscapes around the world. GGN shows how we might collectively accomplish the goal of improving places for all people, in all environments.

—Thaïsa Way

PREVIOUS PAGES, TOP LEFT *Water is a recurring element in GGN designs; here a water element is studied for texture and reflection. This design element is able to be converted to a stage for outdoor performances. Study by Laurel Li.* PREVIOUS PAGES, TOP RIGHT *A study by Rodrigo for the staff garden at the United States Embassy in Athens.* PREVIOUS PAGES, BOTTOM *Conceptual study by Kathryn for the water scrim for the National Museum of African American History and Culture in Washington, DC.* ABOVE LEFT *McCaw Hall promenade with water scrim and lights that together define the elegance of the space; created in collaboration with LMN Architects and artist Leni Schwendinger.* LEFT *McCaw Hall promenade with lighting scheme shaping the experience of the space.* OVERLEAF *Venice Biennale installation, a collaboration of GGN and Gustafson Porter, 2008.*

DEFINING A FIRM
AND DESCRIBING
A PRACTICE

It was after collaborating on several projects and competitions that Jennifer, Shannon, and Kathryn decided to partner, opening their first office in December 1999. They invested equally and each oversaw an aspect of the office and practice, with Jennifer and Shannon based in Seattle full time and Kathryn traveling between London, Paris, and Seattle. While each held a distinct role, at the core it was a collaborative endeavor as they shared the design work, critiquing every design at every step, as well as advocating for one another when challenges arose, whether in a project or in running a business. They drew on their experience of landscape, sharing a deep connection to big landscapes as they recalled their youths in the Cascades, on the Palouse, near beaches, and in the High Sierras.

The first GGN office was a small studio on the top floor of a tiny, triangular brick building immediately adjacent to the decks of Seattle's Highway 99 viaduct, built on the waterfront site of Henry Yesler's mill at the foot of the original Skid Road. The storied Al Bocalino restaurant was on the ground floor and the restaurant's street-smart and charismatic owner, Carlos, ensured that the nighttime safety and appetites of the small, young office team were looked after.

The firm was initially a bit scrappy, and their efforts were not focused on office décor—that would come later. Instead they found bits and pieces of furniture and filled the airwaves with indie pop and classic '80s tunes. Reflecting their quirky interests, the firm got to meetings and sites in either Shannon's screwdriver-started 1963 Volvo p1800 or in Jennifer's Volkswagen Corrado, accompanied by Kathryn's Newfoundland, Jack.

They were inventing office management and rendering styles as they went along. For graphics, they combined laborious hand work and exploratory digital work, new tools at the time. Shannon used a favorite old sock and a butter knife to shave pastel dust onto GGN's graphics, carefully masking the edges of color fields, and blending the pigment, using circular motions, into a parchment-like fill or gradient. Digital scans of purposefully over-xeroxed "punk poster" textures were cut out and placed into photoshop

files. Hand drawing was used liberally by all partners to understand a site, express an idea, or explore detailing options, as well as to critique each other's work. The fax machine was in constant use as sketches and notes were sent back and forth to Europe, to sustain Kathryn's input and experience engaged in key projects. Jennifer spent hours working extensive and complex grading plans in both handwork and in CAD, as well as setting up the office's financial tracking systems and business systems—this in between her project leadership work on the massive Seattle Civic Center project, with Swift Company. "Everyone does everything" was the defining approach, and this collaborative and figure-it-out office culture remains today.

Soon, they began to hire collaborators, and as one of the earliest employees, Rodrigo Abela, moved to Seattle to be a part of the firm. By 2003, GGN had graduated to an established firm and numbered fifteen employees. They moved to a new office space on Pier 55, above Argosy Cruises along Seattle's waterfront. The new space had ample windows with natural light, a relief after the almost-windowless brick space of their first office. Views of Elliott Bay and the Olympic Mountains beyond kept them grounded in the Pacific Northwest. Lynda Olson and Cass Salzwedel had joined by 2003, as bookkeeper and office manager, respectively, to run the

PREVIOUS PAGES, LEFT *Lakeshore Residences, a 2002 design of an aromatic garden for clients with connections to southern France and the culinary world.* LEFT, BELOW *Early days with the three principals; the print/copy room doubled as a meeting room in their first office space in Pioneer Square.* RIGHT *Rodrigo Abela working on a plaster model, 2004.* BELOW *Shannon Nichol sculpting a plaster model.*

office—and they're still part of the team today. New projects continued to span a remarkable spectrum, from the small garden to the complex urban landscape, while early projects were winning awards.

They were also developing robust partnerships with other professionals, including the architecture firms of Foster + Partners and Bohlin Cywinski Jackson, civil and structural engineers Magnusson Klemencic Associates (MKA), and Olson Sundberg Kundig Allen Architects (now Olson Kundig) in Seattle. These relationships would continue to be productive and to generate future work. They would also increasingly benefit from new members brought into the firm from a variety of backgrounds, including architecture, engineering, and art. This expanded view of landscape architecture is at the core of GGN's ability to tackle a broad range of complex projects while remaining true to their belief in the power of simple and clear design.

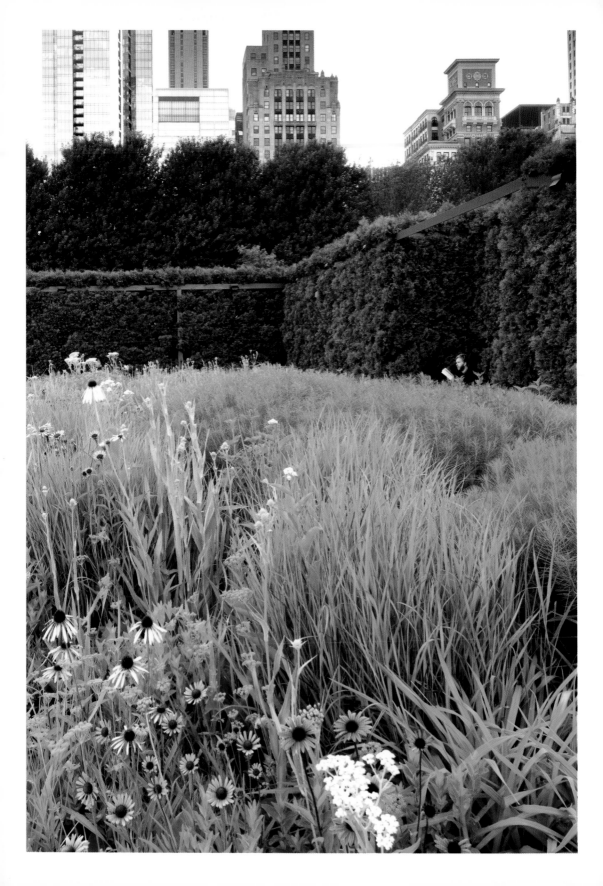

THE LURIE GARDEN
2000–2004

Chicago's Lurie Garden opened to great fanfare in 2004, and
has since become an integral part of both the famed Millennium
Park, the lakefront, and the larger city, embracing the Windy
City's motto, *Urbs in Horto* (City in a Garden). Sited between
the Jay Pritzker Music Pavilion designed by Frank Gehry &
Associates and the Art Institute of Chicago's Modern Wing by
Renzo Piano, the garden occupies prime and busy real estate
above a parking garage.

Critic Sarah Williams Goldhagen immediately recognized
the garden's strongest attributes: "Architecturally controlled,
spatially and topographically varied…a powerful experience
of quietude within the city, moments full of wildness, wild-
flowers, and an ever-changing story about the climate and
flora of the Midwestern plains."[3]

Commissioned by Millennium Park, Inc., under the direction of Edward Uhlir, the design project and construction was led by GGN in collaboration with the plantsman Piet Oudolf and lighting designer Robert Israel. Ann Lurie's gift of $10 million as a maintenance endowment, with the stewardship of remarkable gardeners and guidance from GGN and Oudolf, has helped the garden mature over fifteen years into a sophisticated, elegant, and inspiring space—a powerful model for urban parks and gardens in cities around the world.

This 3.3-acre botanical garden in Grant Park on Lake Michigan, just south of the Pritzker Pavilion, was one of the last additions to the initial Millennium Park Project. Eighteen firms were invited to submit proposals in 1999 for a "forward-looking garden with rare and unusual plantings" that would be "unique to the region and different from other Chicago venues."4 The jury found GGN's winning proposal for the Shoulder Garden, recalling Carl Sandburg's 1914 description of Chicago as a "City of Big Shoulders," as "bold, intellectual, daring, cutting edge."

The site was challenging due to its context, scale, and the engineering requirements of a significant landscape over structure. The Lurie Garden is experienced against the strong skyline of downtown Chicago as one of multiple focal points and event spaces within Millennium Park itself. Additionally, it was constructed above a vast underground parking garage, train tracks,

and bus tunnels. Chicago's stunning architecture and grand public landscapes needed to be met head-on with clear confidence, while the relatively small and intimate garden was to perform as a connective pedestrian corridor between the Pritzker Pavilion, the Chicago Music and Dance Theater, *Crown Fountain* by Jaume Plensa, Anish Kapoor's *Cloud Gate*, and to the south, Renzo Piano's Modern Wing for the Art Institute. Furthermore, to honor its role as a botanical garden, the garden needed to nurture and display a broad collection of plants in a manner that would encourage exploration and investigation. Human scale would also be critical, as the Lurie Garden had to embrace and comfort the individual while at the same time providing areas for hosting large gatherings and events. While GGN's principals had designed gardens and urban parks before, the complexities of this project were particularly challenging as well as inspiring for a young firm.

Shannon and Kathryn collaborated on the competition design and strategy, working as a team to tackle the challenges and realize the potential of the project. The complexities of the site were evident, and they soon defined the primary problem as how to create a series of raised rooftop planters that would not become isolated beds but rather be experienced as contiguous ground sliced by paths and water. The site would need to be designed as one broad landform.

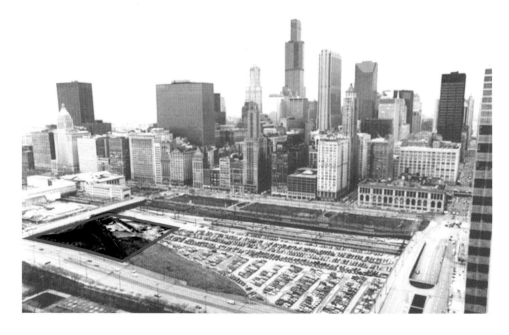

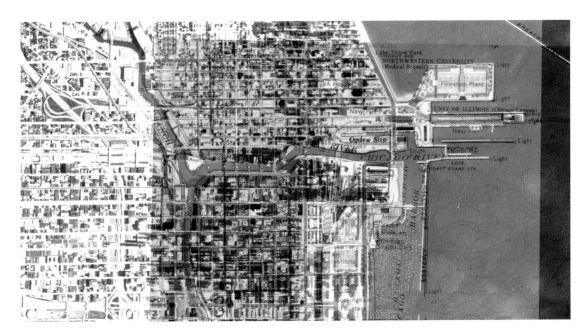

The GGN team began by trying to understand the land that lay underneath the blank parking lots and rail yards that had dominated the location for decades. They explored the natural ecologies and topographies of the region as well as the plant associations. They dug deeply into the history of how the land had been shaped and transformed as the city expanded and the waterfront site developed. They were particularly drawn to the narrative of Chicago as a city that built itself up "from marshy origins... to rise ambitiously skyward."[5] This would eventually offer a fitting allegory for a parcel of land that was once a shoreline, now deemed to become a complex and intensively planted garden.

Emerging from the broad investigations of the site's history was the concept of the land formed to recall the historic shoreline's deposits and shifting landscapes as well as the long history of railroads and transportation amenities. The historic shoreline would be reimagined by the Seam, a water channel with a boardwalk evoking earlier railway tracks that crossed the site, as well as an old retaining wall that once rose between the city

LEFT *Historic photo of Millennium Park site, with the site for the Lurie Garden outlined in red, showing the ghost of the railroad wall that marks the meeting of the marshy past and the high, dry present.* ABOVE *The site is part of Grant Park; the new Millennium Park is located on a strip of land that forms a border between the Lake Michigan shoreline and the built grid of downtown Chicago; the Lurie site is outlined in red.* RIGHT *Sketch exploring the relationship of the old shoreline and the design concept that came to juxtapose the dry and wet past landscapes of the site, expressed by the "light" and "dark" plates.* OVERLEAF *The dry Light Plate is enclosed by the shoulder hedge, with Frank O. Gehry's Pritzker Pavilion as a middleground to Chicago's skyline.*

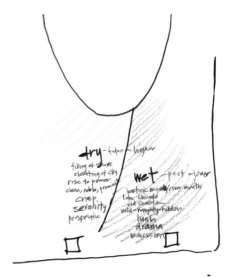

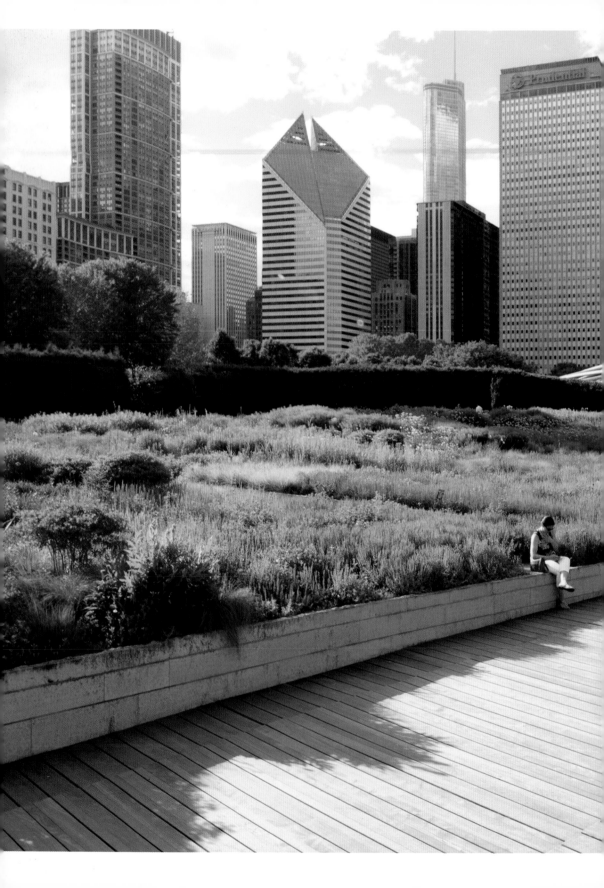

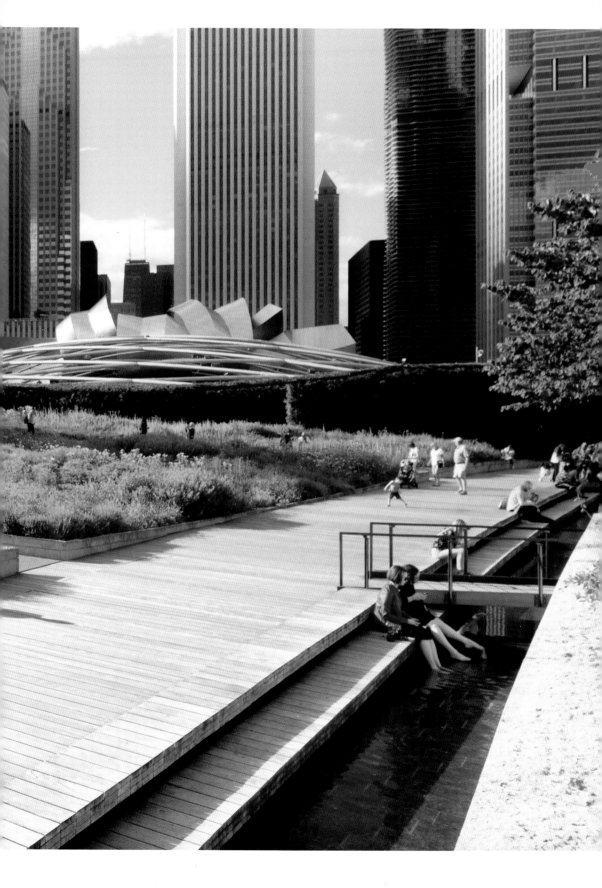

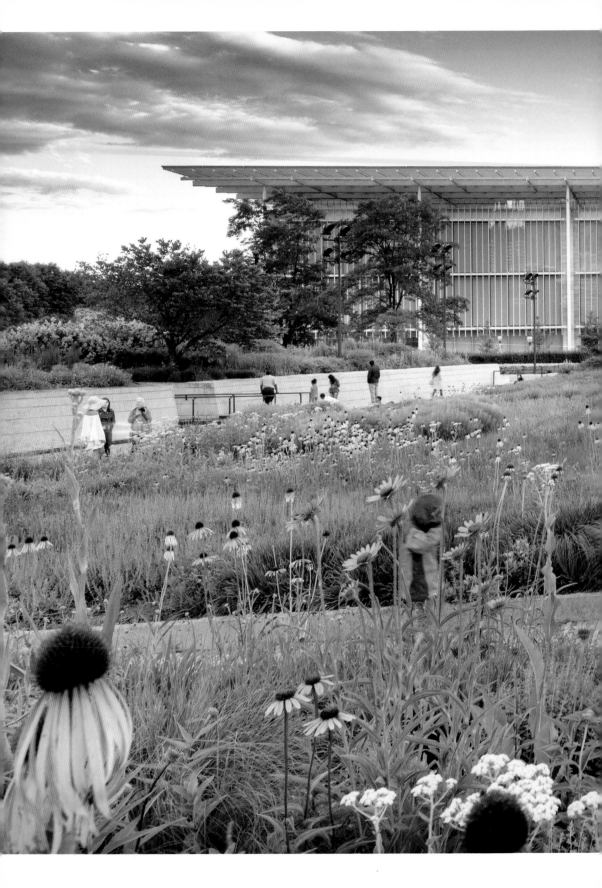

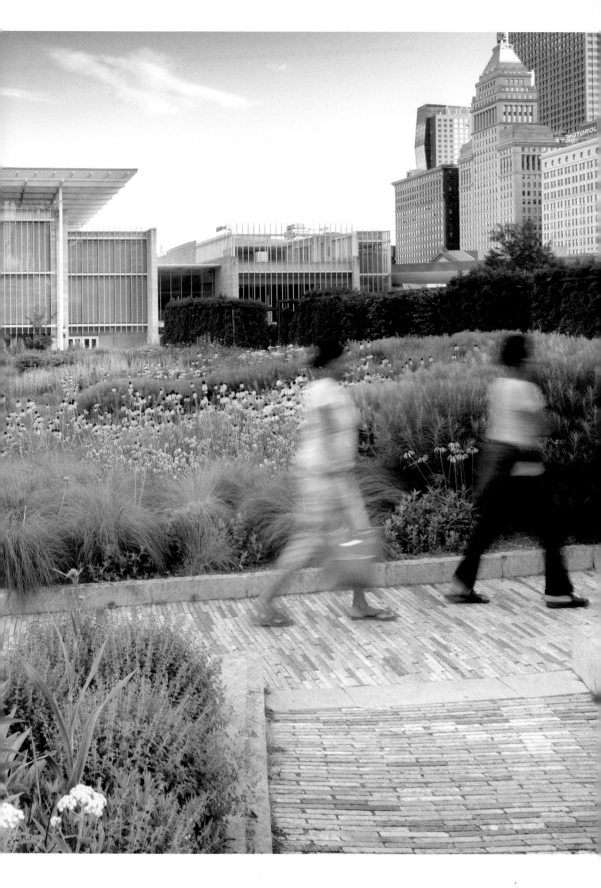

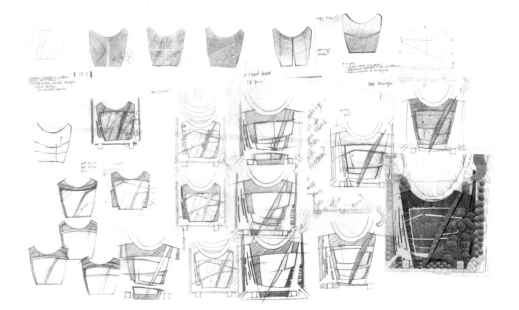

and its lake. The new landscape would rise above street level to envelop the visitor in a lush and richly textured garden and gathering space.

Working together through multiple iterations in sketches and then in clay and plaster to render the landform for the final competition interview, GGN sought to shape the garden both as a part of Chicago's broader urban landscape and as a distinct space with its own clarity and strength. The necessary connections to the street at ground level were as important as the various ways in which people would need to be able to cross the

garden on foot. The designers created paths cut from the ground to allow pedestrians to cross it, and also minimized the walls that hold the landform so they appear to visitors as subtractions from the larger ground.

Once GGN was awarded the project, Shannon and Kathryn led the design process, with Jennifer managing the team and overseeing documentation the project moved into construction. The team approach came to define the firm.

The garden is composed in two parts that draw from the history of the landscape, the Dark Plate

PREVIOUS PAGES *The Art Institute of Chicago as enjoyed from the Light Plate, with purple coneflowers and soft white, wooly, pearly everlasting bloom.* ABOVE *A series of iterations by Shannon leading to the layout concept for the Lurie Garden.* LEFT *Here an early concept of a "plant object" by Shannon is composed of a thick mass of plants with walkways sliced through for concert crowds heading from the Pritzker Pavilion lawn to the elevator pavilions and parking garage below.* RIGHT, ABOVE *On the left, an early sketch by Kathryn showing movements through the garden. On the right, a site plan sketch by Shannon merging the concept of a thick garden mass with paths, framed by a large hedge protecting the garden while opening toward views of Lake Michigan and the Art Institute.* RIGHT, BELOW *An early concept sketch by Shannon at left, exploring the natural and historic diagonal landforms hidden beneath the gridded site.* RIGHT *Plaster cast of a clay model for the Lurie's landform—note the placement of convex and concave forms.*

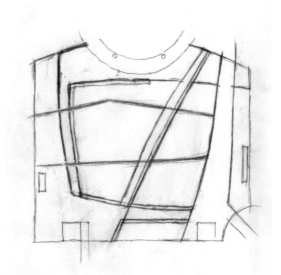

and the Light Plate, with the Seam stitching them together. To the east, the Dark Plate's land swells to a ridgeline, subtly referencing the oak swamps that once thrived at the mouth of the Chicago River. This landform is punched up from the ground, overflowing with grasses mixed with small trees. To the west, the Light Plate overflows with flowering plants and grasses, creating a garden full of nature at its lightest and brightest. It forms a bowl over which plants sweep in masses, recalling the tallgrass prairie and oak savannah, a familiar regional landscape. The botanical

collection's species were provided by Roy Diblik's Northwind Perennial Farm in Burlington, Wisconsin, and arranged to convey ancient ecologies. The Seam stitches the Dark and Light Plates together while the boardwalk offers a gracious route through the garden from the art museum to the music pavilion. This journey suggests a passage through the region's natural history with its familiar "over hill and dale" character.

To underscore the landscape as a contiguous ground, the limestone walls were carefully detailed to appear as unobtrusive slices in the

shoreline/railways pattern
—"ignores" logich pattern
— intimate paths, planting changes
landform changes
like shoreline deposits

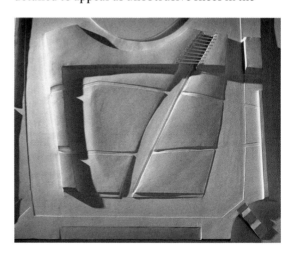

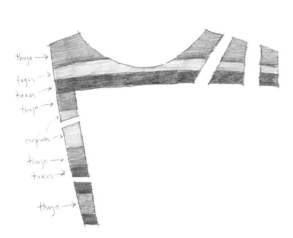

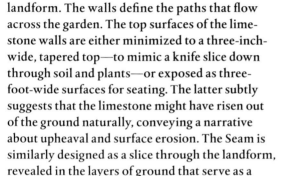

landform. The walls define the paths that flow across the garden. The top surfaces of the limestone walls are either minimized to a three-inch-wide, tapered top—to mimic a knife slice down through soil and plants—or exposed as three-foot-wide surfaces for seating. The latter subtly suggests that the limestone might have risen out of the ground naturally, conveying a narrative about upheaval and surface erosion. The Seam is similarly designed as a slice through the landform, revealed in the layers of ground that serve as a series of linear surfaces for seating and viewing.

LEFT *The Seam and its boardwalk both separate and weave the wet and dry planting beds; the features also offer a place to gather or retreat.* ABOVE, LEFT *From concept to garden: A sketch detailing the plants comprising the shoulder hedge.* ABOVE, RIGHT *The mature hedge as viewed from outside the garden; it counterbalances the lightness of the Art Institute across the street.* RIGHT *Elevation sketches of the hedge, by Shannon, showing how the Pritzker Pavilion would appear to sit on top of the garden's "shoulders." The final adopts much this same form.* OVERLEAF *Broad, stacked-wood benches are set within niches carved from the shoulder hedge, offering intimate spaces for friends.*

To enclose the garden, a high and substantial hedge was constructed on three sides, serving to separate the interior space from the surrounding city bustle. The hedge in its robust form and careful positioning also frames the steel structure of Gehry's Pavilion, suggesting Sandburg's "broad shoulders" capable of holding up Chicago's architectural splendor. Composed of wide sections of arborvitae and staccato sections of European beech trees, it is outlined by a rectangular steel scaffold of horizontal braces and vertical guides. The hedge and its armature serves to guide the

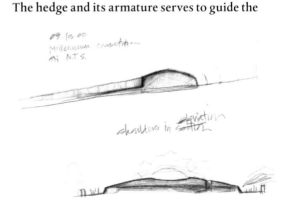

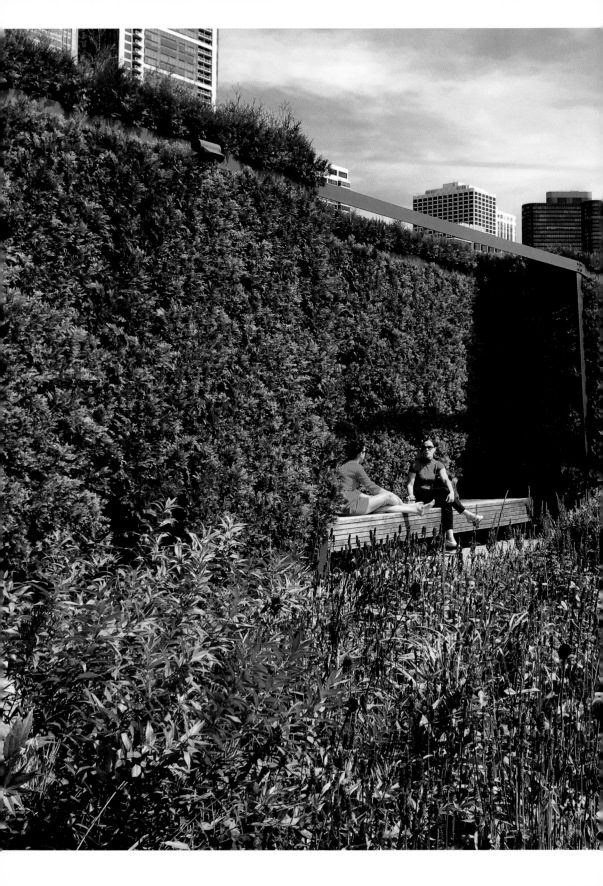

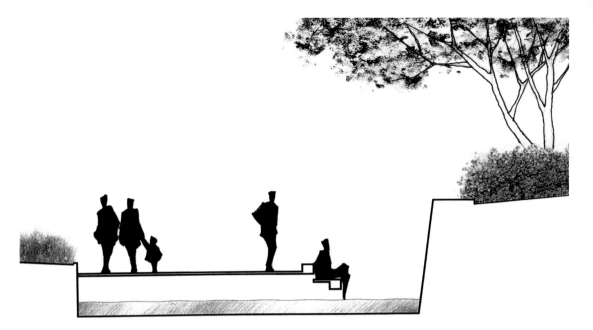

foot traffic of up to 10,000 event attendees around the garden and to park exits and parking, all while protecting the plantings. While the horizontal braces and clips have since been removed, the structure continues to underscore the architectural character of the living hedge, framing the garden's entrances, and providing a clear guideline for trimming.

Intimate nooks in the hedge, centered by wooden benches, invite people-watching or repose. Generous openings in the hedge offer access to the garden as well as two Exelon Pavilions, designed by Renzo Piano, housing the entries to the parking garage below. Holding the garden in, metaphorically and literally, this hedge resembles a breastplate in plan, suggesting its role as protectress of the garden and a haven for small animals and birds as well as visitors seeking a moment of quiet.

Selected materials both reflect the design concept and can stand up to public use through the seasons. The renewable ipe wood used for the boardwalk is practical, and also weathers to a shimmering gray that echoes the lake beyond.

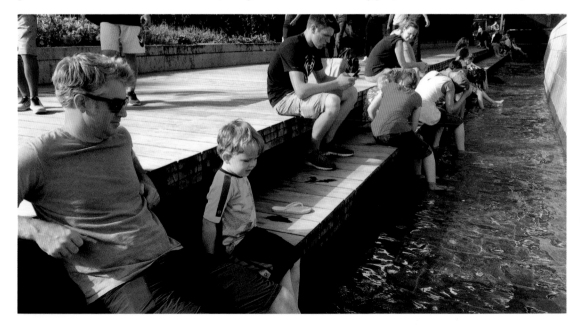

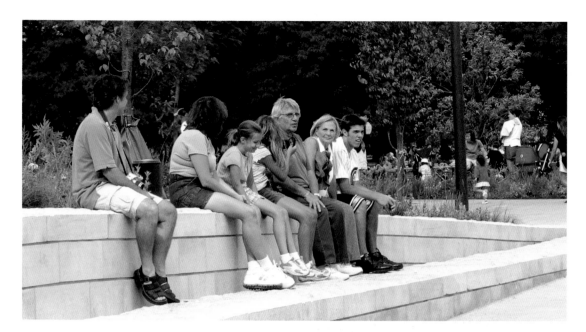

End-grain blocks are stacked to create the board-walk as well as wood seating platforms, recalling the look of rock strata exposed over time. The wood also more directly recalls the logged forests that once covered the region. The stone used in the retaining and seating walls is limestone from a local Midwestern quarry, a nod to the underly-ing geology. The limestone is finished in a "saw cut" on vertical faces and a "modified rock face" on horizontal finishes, which draw attention to the stone's texture and heft; it feels almost extruded, evoking the upward energy of Chicago's skyline.

Granite is used as paving and walls in the water channel. These stones not only suggest deep geo-logical histories, but also the history of stone as a primary building material featured in some of the magnificent nearby facades of Chicago's skyline.

At night, the garden again defies expecta-tions. Robert Israel's lighting design, done in collaboration with Shuler & Shook and GGN, is dramatic. The lights, set on tall poles, illuminate the landscape like a gallery, while the trees are carefully orchestrated to create moonlight effects suggesting a romantic garden hideaway. In 1933,

LEFT, ABOVE *Elevation rendering of the Seam revealing how the boardwalk is suspended; this suggests the historic shoreline while scaling the element to the human body.* LEFT, BELOW *The boardwalk's end-grain stacked wood provides a solid place for urban residents to sit and dip.* ABOVE AND RIGHT *The generous seating walls are built of limestone, as if extruding the site's geology with a "saw cut" on vertical faces and a "modified rock face" on horizontal finishes.* OVERLEAF AND 60–61 *At the height of the summer, the Dark Plate's perennials and flowering shrubs enclose the garden; small openings under trees frame views of the city.* PAGE 62, ABOVE *Moving plants from the nursery service yard across the broad walkway along the edge of the shoulder hedge.* PAGE 62, BELOW *Summer months in the Light Plate offered a bounty of color and textures long before the hedge was fully grown in.* PAGE 63 *The Dark Plate's shade plants create a lush garden in a variety of tones; dappled shade from trees above creates a yellow glimmer on the hedge.* PAGE 66–67 *Shannon meets periodically with Scott Stewart, Piet Oudolf, and the stewardship team.*

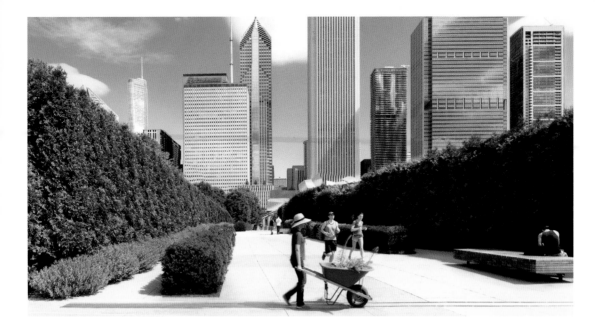

the Century of Progress Exhibition in Chicago featured a garden designed by Annette Hoyt Flanders that was one of the first to be lit by electricity; the Lurie design recalls that spectacle at a grander scale.

The Lurie Garden is a true urban public botanical garden. Its modern abstraction of the regional prairies, its interpretation of the materials evident from Chicago's past, and its direct engagement with its urban environment also update the genre and make it uniquely American. By approaching each of the challenges that came with the complex site and its many audiences, as well as the downtown context as potential design inspirations, Shannon, Kathryn, and Jennifer arrived at something unique. This urban garden succeeds because of its generosity of spirit and its engagement with its community; these will nurture its long future as Chicago's front yard.

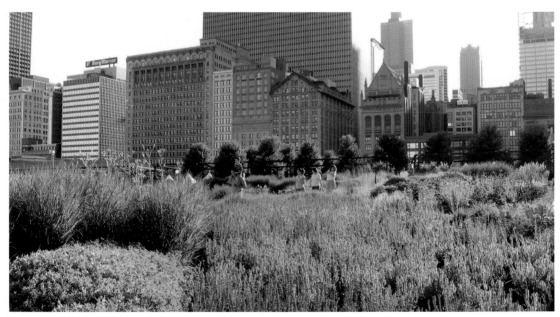

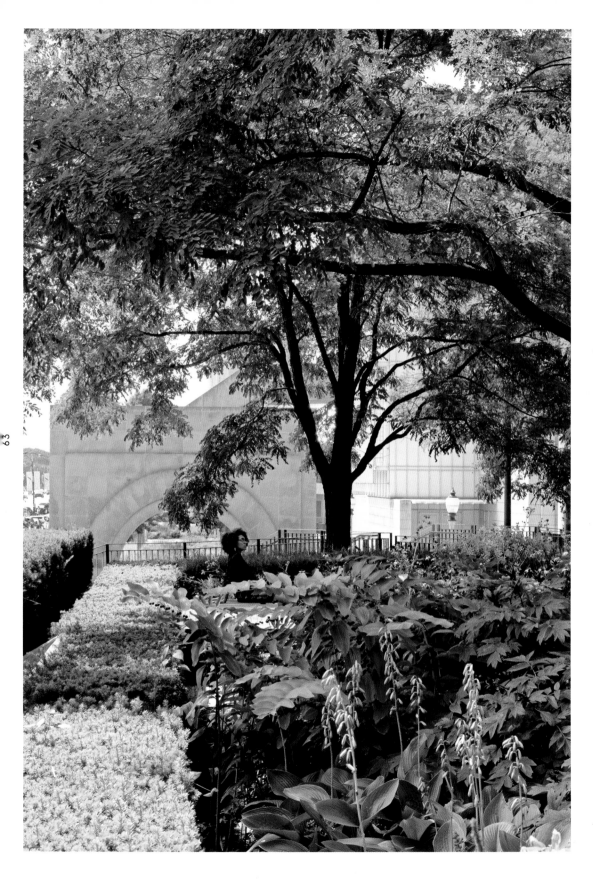

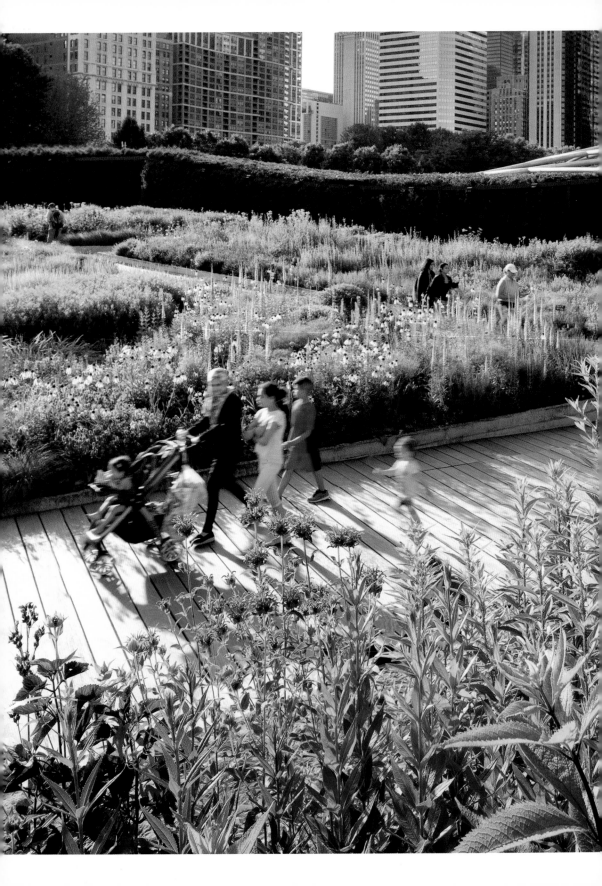

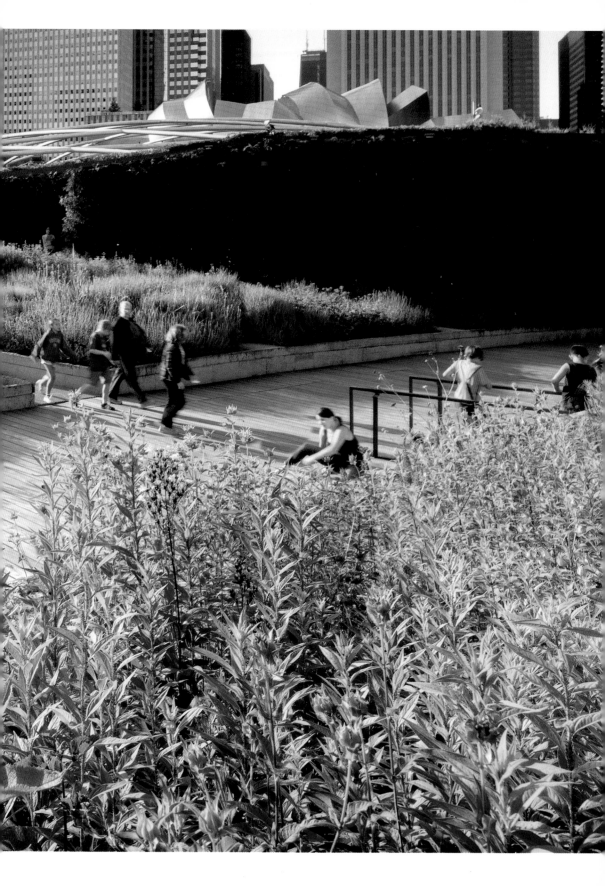

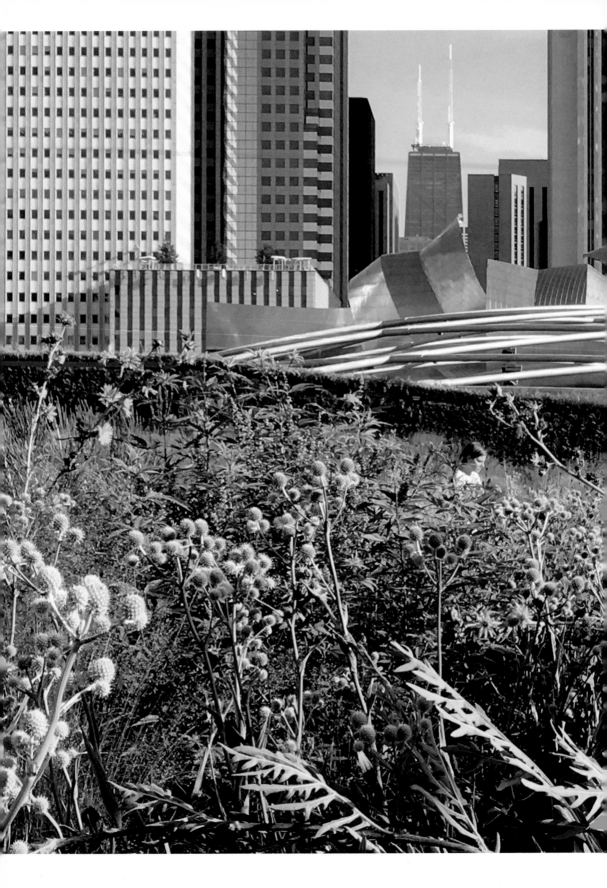

FURNITURE
2004–2012

As the design for Lurie Garden was in full swing, Edward
Uhlir, the director of Millennium Park, commissioned GGN
to design a bench that would reflect the contemporary look
of the park and be adaptable to a variety of settings. The
Maggie bench was developed and named for Maggie Daley, wife
of Chicago's then-mayor, Richard Daley, in honor of her years
of service to Chicago and in celebration of her recovery
from cancer. The Charlie table was soon designed as a second
contribution to the public realm.

Building on the success of the first two pieces, a team of GGN
designers, led by Kathryn and Rodrigo, worked to create a
family of park furniture, UrbanEdge, fabricated and distributed
by Landscape Forms. As a collection, the furniture pieces bear
similarities, but each retains its own character and is suitable
for different scales, from the intimate garden to the social
parklet to the large-scale recreational landscape.

The challenge for furniture and landscape design is that both must respond to the scale and form of the human body, must be comfortable as well as beautiful, and must be elegant regardless of budget. The Maggie bench and Charlie table were created so they could comfortably occupy historic settings while retaining a modern aesthetic—a goal extended to the entire UrbanEdge line.

As with a landscape, multiple iterations and discussions helped the team arrive at the right scale, proportions, and form. Initially the team made scale clay models, then full-scale iterations of the Maggie bench, until they arrived at an ergonomic shape that would provide comfort for the broadest range of people. Imagining the eight-foot bench in a variety of urban contexts, they designed it with a simple, Gothic profile that fits historic districts but a single-cast aluminum frame that brings it up to date.

The Charlie table, named after Kathryn's brother, always active and moving, needed to be a comfortable and communal table that would fit into diverse urban public spaces, meaning it needed to be scaled for intimate groups while meeting accessibility guidelines. Kathryn began by exploring the various forms a table might take, looking for one that would be both distinctive and comfortable. After multiple iterations, they arrived at the oval shape for its simplicity and because it easily accommodates family seating that allows everyone to see everyone else.

With the table shape determined, they concentrated on the legs, emphasizing the way they responded to the dynamics of the oval table top. In the final construction, the painted steel table with its asymmetrical legs suggests a playful dance. The open ends also make them accessible.

Landscape Forms next invited GGN to create a new furniture line for which it would provide engineering support and manufacturing know-how. UrbanEdge furniture shares key characteristics of comfort, human scale, and an informal elegance. Even the names for those first pieces spawned others that feel comfortable and informal: the Gus planter, the Max trellis, the Jessie rail, the Ollie small seat, the Sophie large seat, the Bernie bar-height seat, and the Stella table. Gus was named after Kathryn's father, who was an avid gardener, and thus a container for good soil and plants seemed apt. The other names suggested members of a family: Jessie is tall and lanky, while Bernie sits at the bar; Stella is a beautiful, mature woman, while Ollie and Sophie are young and playful. Max the trellis just sounded right. As a family of furniture, each piece is designed to fit into leftover spaces, corners, and edges of the public realm where they might create eddies in the flow of foot traffic, or mark intimate spaces within overwhelmingly busy streetscapes.

Drawing on their experience designing public landscapes, the GGN design team paid attention to how the furniture would be used in public

PREVIOUS PAGES, LEFT *The Stella table's cast-aluminum base being welded together.* RIGHT *Enjoying the Maggie bench on a sunny day in the fall.* RIGHT, ABOVE *A sketch by GGN for the Charlie table and the final as placed in a Seattle garden.* RIGHT, BELOW *The sketch, by Kathryn, and mold for the Maggie bench, carefully scaled to fit the human body.* OVERLEAF *Photographs, a rendering, and sketches, by Kathryn, of the Urban Edge furniture line including Stella (a low table), Bernie (a high stool), and Sophie (a pivoting bench).*

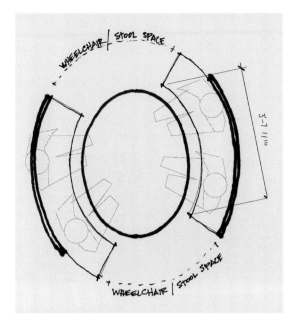

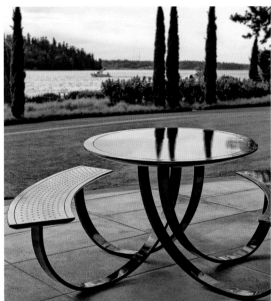

spaces. They looked to how people today play and relax. They realized how much people like to spin in chairs, crouch over tables, put feet up on planter boxes, and lean heavily against rails. In response, the design team created dynamic and kinetic stationary furniture. The chairs, for example, pivot on a central spine but are set off-center to allow for a variety of configurations.

While the family of furniture is relaxed and friendly, it's also inspired by the elegance and simplicity of formal furniture designs. Influences include modernist architects such as Ludwig Mies van der Rohe, Marcel Breuer, and Alvar Aalto. They also looked to the works of artists such as Toko Shinoda, whose paintings derive from the traditions of calligraphy as well as those of modernist abstraction. The play of symmetry and asymmetry, straight lines and curved lines, thick and thin, became important ways to think about furniture design. The furniture line reveals the importance of a design concept, craft, and the selection of material, as well as GGN's tenacious curiosity about how design can improve daily life for everyone, everywhere.

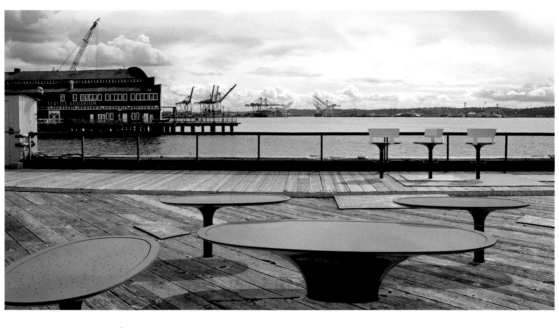

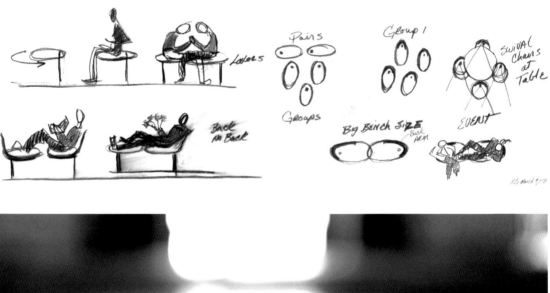

Lollers

Back no Back

Pairs

Groups

Group 1

Big Bench Size
Back Arm

Swivel Chairs at Table

Event

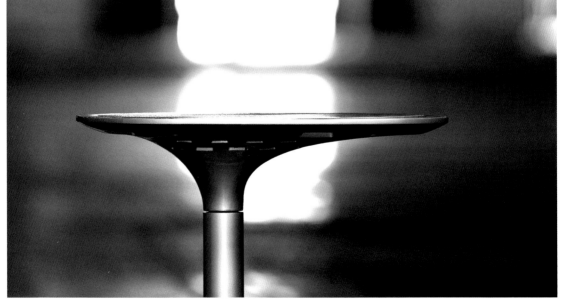

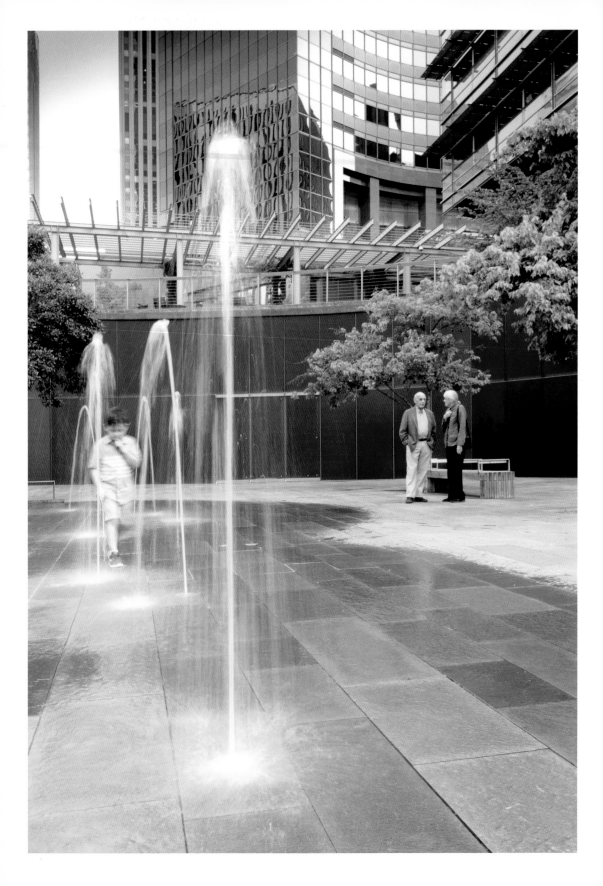

SEATTLE CITY HALL PLAZA AND CIVIC CENTER CAMPUS 2000–2005

The Seattle Civic Center Campus's steep topography created the opportunity to design public spaces based as a sequence of perches and terraces above sheltered plazas—areas that could take full advantage of views out to Puget Sound and the Olympic Mountains. The complex, comprising the Justice Center by NBBJ Architects and Seattle City Hall by Bassetti Architects and Bohlin Cywinski Jackson, is part of what was initially a three-block, 5.8-acre civic landscape at the heart of Seattle's hill climb district. Completed in 2005, the architecture and landscape blur boundaries, instantiating the values of an open, transparent, and accessible government.

By 2000 Seattle was gaining a reputation for cutting-edge design, as reflected in the then-underway new downtown library, an architectural experiment by renowned Dutch architect Rem Koolhaas and his firm, OMA. Just as the library revealed an increasingly cosmopolitan Seattle, the new Civic Center Campus was meant to suggest a progressive governance structure.

The charge to the design team was to create a campus that would speak to Seattle's past and future as well as a renewed civic leadership. GGN, with Kathryn and Jennifer as leads, created the landscape master plan. In 2002, Seattle's Justice Center was completed and in 2005, a new City Hall and civic landscape opened to the public.

An important collaborator on the project, Barbara Swift of Swift Company, partnered with GGN for site analysis, program development, and to facilitate the public process. GGN's design was centered on shaping a living room for the city—a space that would genuinely welcome the public and reflect an authentic Seattle. They needed to do all of this, of course, on an urban site that steeply sloped from east to west and would hold a series of significant buildings. Turning what threatened to be the biggest impediment, the slope, into an asset defined the character of the civic space and became a public amenity. The site now routinely hosts events from dances to farmers' markets.

GGN began the design process by identifying Seattle's place in the landscape. It did not take long to realize that what was most emblematic of the city was not its dense, built core, but rather the immensity of the water that surrounds and infiltrates it, framed by the sublime views of mountains in every direction. The mountain views are core to Seattle's identity. Whether Mount Rainier to the south, the Cascades to the east, or the Olympic Mountains to the west, natural landforms define the city as much as its trees and forests—the downtown is its own landscape of hills and valleys defined by steep streets and layered building facades. The position of the city within such a powerful landscape suggested the concept of the civic center as a microcosm of the city itself.

With these inspirations in mind, GGN explored the scale and experience of the site as comprising three separate entities: a hillside, a downtown, and a part of the urban grid. They considered how the public aspirations for the city might be revealed through the physical design of the campus. Unlike other parts of the city, the core of downtown was never flattened. The site is defined in large part by a fifty-foot grade change and an almost twenty-degree slope from east to west. In exploring how they might carve into the slope to form terraces and landings for the buildings, gardens, and plazas, the designers explored how the flow of pedestrians might accompany the flow of water down, through, and over such a landscape. Investigating the possibilities through both section and plan,

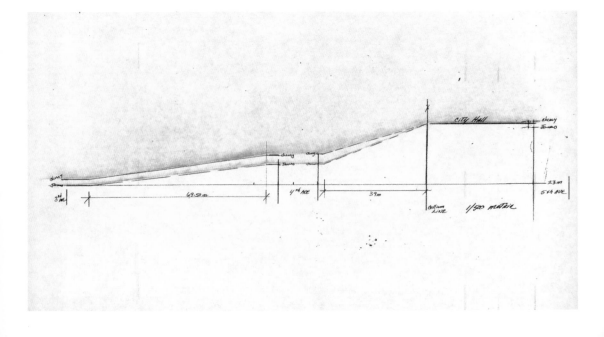

PREVIOUS PAGES *A quiet day on the plaza, with the water scrim and fountains turned on.* LEFT, BELOW *Study of the steep slopes of Cherry and James Streets, north and south of the site, created as a step toward developing a circulation diagram.* RIGHT *The City supports the space being used for a variety of functions, from dance to music to farmers markets.* BELOW *A festival hosted on the plaza; note how the red wall glows in the sunlight.*

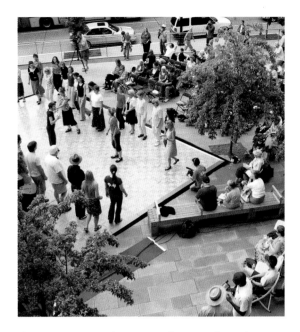

they addressed the engineering challenges of the steep site by acknowledging that while the buildings would by necessity have to cut deeply into the topography, the landscape could bridge and connect these artificial canyons.

As with most hill towns, architecture and landscape in Seattle have to work together, each allowing the other to perform in unique circumstances that reveal a mix of siting, grading, and material choices. Some design details are obvious, while others are subtler or even invisible to the unknowing eye. The front porch of the Justice Center, at

the top, opens to the west with a view first of City Hall and then beyond to the water and mountains. From there, garden terraces descend the hill. The grand stairs that begin at City Hall and descend to Fourth Avenue are a bold echo of the steep slope, while the terraces and plazas hold the architecture and provide a moment for pedestrians to pause and enjoy views of the landscape and city beyond. These stairs underscore the invitation to all in Seattle to discover civic governance and leadership.

The flexibility of the public spaces echoes the collaborative role of architecture and landscape

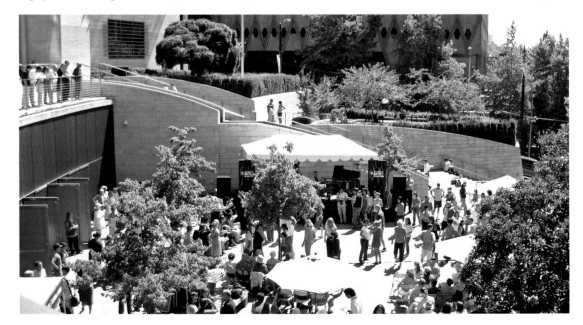

to create and shape spaces for human interaction and engagement. Glass panels of yellow, blue, and red are also woven through buildings and landscape in a variety of ways. The color scheme of glass panels conceived by GGN reflects the three branches of government as well as the daily passage of time with three primary colors expressed throughout the campus: at the top in front of the Justice Center there is the yellow of a sunrise, the blue of the midday sky graces the middle layer of City Hall, and to the west the red of a Seattle sunset over the water promises that civic leadership will engage a breadth of perspectives. Reflecting the importance of the water that flows through City Hall, the architects designed the grand stairway to parallel the water and a skylight overhead that mirrors the path of the water. GGN led the team to a collective decision on exterior materials. The simple palette of limestone used on the exterior landscape is carried through to the interior of the City Hall and Justice Center, including the stairways. These details merge buildings into landscape and exterior into interior, coming together as an

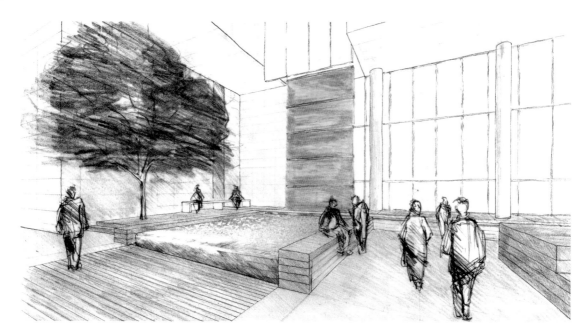

invitation to both civic space and participation in civic life.

Water is everywhere in Seattle, from Puget Sound and Elliot Bay to Lake Washington and Lake Union; multiple springs also emerge from hillsides. For the civic campus, water weaves the site and its buildings into one landscape, while echoing the larger bodies of water that define the Pacific Northwest. The water channel descending from the Justice Center to the public plaza at the bottom of the hill reflects the multiple characters that flowing water can engage. The Justice

Center's glass facade, emphasizing the transparency of justice, is visually divided with a vertical glass panel to mark the police side of the building and that of the courts. A bubbling dark pool lies just below the tall panel, of the same dimensions but laid horizontally. The water in the pool appears olive green when the yellow reflects on the dark blue surface below. As a still pool, it suggests a spring as a source of water for the larger civic campus. The way in which the water disappears as one crosses the road is an unfortunate consequence of not being allowed to bring

LEFT, ABOVE Glass panels in sunrise yellow (for the Justice Center), midday blue (for City Hall), and sunset red (for civic leadership) symbolize various layers of Seattle's government, each according to its place on the physical hillside. LEFT, BELOW With trees shaping the civic spaces, water serves as a connector. It emerges from the top (far right) and flows down and through the site to a pool at the bottom (left). ABOVE An early sketch by Rodrigo of how water emerges in a still, dark pool—mirrored by a vertical glass panel at its source. RIGHT A detail of the water feature, showing how it the cascade flows smoothly over the edge.

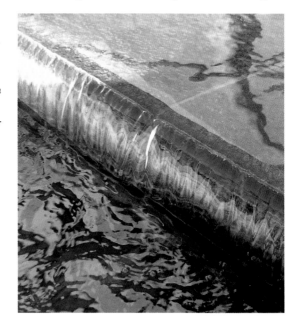

the water across the road under a simple grate, so it is suggested instead by the geometry and materiality of water in the curb line on each side of the street.

As the water reemerges within City Hall, first in a calm pool and then in a cascade that bubbles alongside the Grand Staircase in a broad rill parallel to the pedestrians' path, GGN's design evokes the streams in the nearby Cascades as they flow toward lakes and rivers below. At the bottom, the water spreads into a shallow scrim in a large public plaza. Here, the water is designed to be turned on or off—allowed to fill when the space is empty, or to recede when the space is full. The scrim and its plaza merge culture, art, and nature to make a place for human engagement with all three. The movement and dynamism of simple water transformed the challenging, steep slope into a remarkable design opportunity.

Trees are an essential element of the civic campus, serving multiple purposes. GGN established rows of street trees to frame the campus, following the city's tree plan, while the garden terraces are graced with specimen trees. The maple tree

that shades the overlook just below City Hall's entrance is one saved by Mayor Paul Schell after he saw it in an expo nearby. GGN helped save a hawthorn tree from the previous site; new ginkgoes were added to the plaza above and red maples below. Rather than hard fences, hedges of buxus, taxus, and ilex form a thick green wall that contains a discreet guardrail to keep visitors safe. From the interiors of the buildings, tree canopies serve as a middle ground to the distant views of Puget Sound and the Olympic Mountains. The impression is of intimate gardens with lush green plants, highlighted by fantastic trees, reminiscent of the forests and meadows beyond, all within the safety of City Hall.

The Civic Center also evokes the local culture. Seattle is known for its technological bent, particularly in computer science, as well as a legacy of artists who work in glass. The Pilchuck Glass School was founded here in 1971, and Seattle is still considered the center for glass art in America. This legacy, as well as the region's reputation for leading-edge technology, are echoed in the materials of the landscape and in the art integrated throughout the Civic Center Campus.

While the architecture includes installations of colored glass and glass art including the blue glass installation by Jamie Carpenter, the pieces that engage with the landscape are the most accessible and unique. At the Justice Center, the yellow glass panel accentuates the dark pool of water below. On the lower plaza at City Hall, GGN worked closely with BCJ to design the red glass panels and doors that line the back curved wall of the lower plaza and invigorate the adjacent indoor and outdoor spaces. The red recalls Seattle's remarkable, unique sunsets where the fading rays "slot" in between the mountainous horizon and the often-present cloud canopy. Identifying the right tone and depth so that they would retain the desired red across a spectrum of light conditions took a year of testing samples. Technology and art were as integral here to the merging of architecture and landscape as the shaping of the spaces and integration of the topography.

The campus has become one of the city's great meeting places, and it welcomes a diverse public to its plaza, terraces, and gardens as well as its open interiors. It is Seattle in all its topographic drama, an abstraction of the local mountains and rivers, and its celebration of the region's art and culture. The GGN team accomplished this by working with the site, rethinking its challenges as opportunities, and by listening carefully to the aspirations of the civic leaders.

LEFT, ABOVE *The plaza's garden terraces are defined by remarkable trees and bordered with thick hedges.* LEFT, BELOW *The popular Pike Place Market hosts a farmers market at City Hall every week during the summer.* RIGHT *An aerial view of the site showing City Hall Plaza in the foreground and the Justice Center behind.* OVERLEAF *A grand staircase carries visitors up the hill to the bustling Seattle City Hall while terraces provide space for a moment of pause or a place to admire the view of downtown Seattle.*

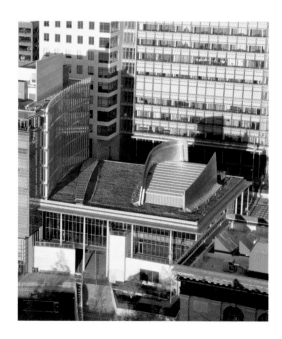

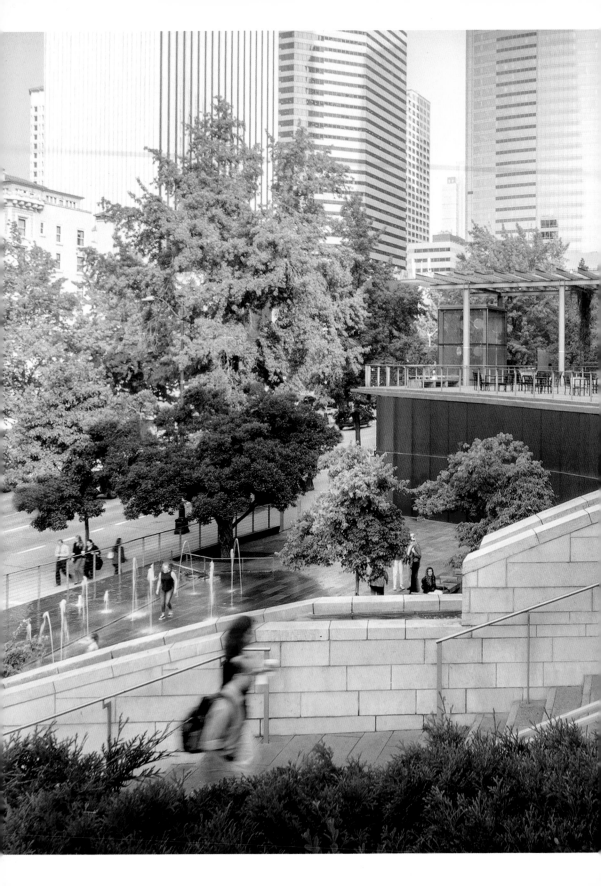

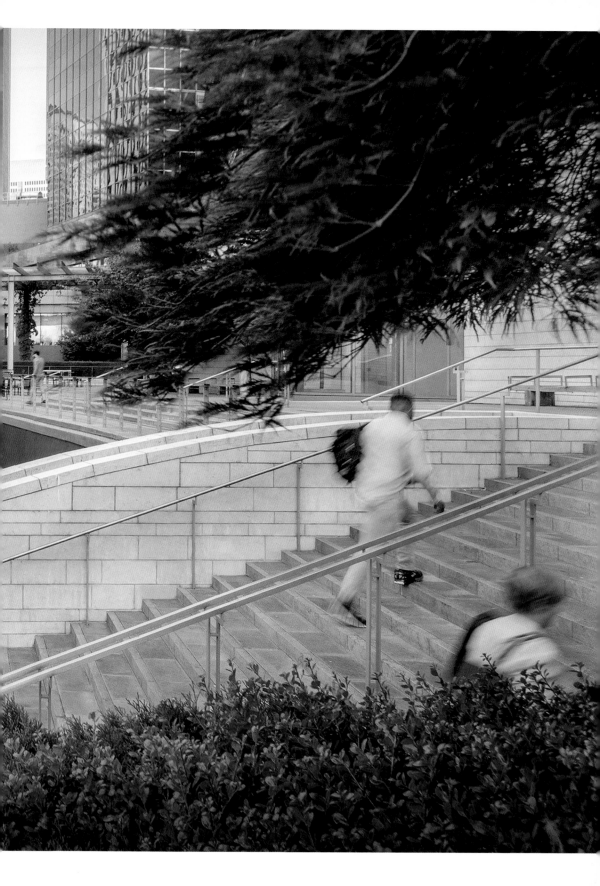

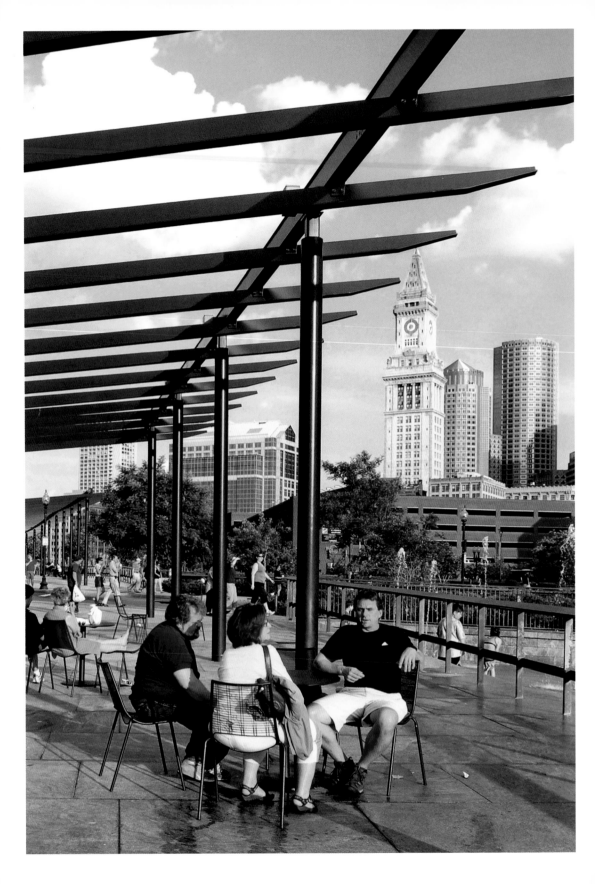

NORTH END PARKS
2003–2007

Boston's North End Parks lie along the 1.5-mile Rose Fitzgerald Kennedy Greenway, a narrow parkway built over the buried, downtown sections of Interstates 93 and 90. GGN's design for two adjacent parcels separated by Hanover Street created one generous urban park reconnecting the historic North End neighborhood to Boston's City Hall and civic center. It restores views and street connections that had been severed for decades by the elevated highway.

As expressed best by design critic Sarah Goldhagen, an important lesson to be learned here is that "good design is not a luxury." Today the parks, opened in 2007, are one of the most popular Greenway destinations, making the firm's competition win for the project a point of pride. They serve as a link and transition between the weighty civic scale and history of Boston and the dense-but-intimate character of the surrounding neighborhood. Completed in partnership with local landscape architecture firm Crosby Schlessinger Smallridge (CSS), the parks went on to receive the Tucker Design Award and Boston Society of Landscape Architects Honor Award for Parks and Recreation Facilities.

Framing the entry to downtown Boston's most densely populated historic neighborhood, the North End Parks are one of a series of green spaces built on the lid of Boston's Big Dig. Once the elevated Artery was torn down, the site instantly read as a void. However, GGN's designers, led by Shannon Nichol and deeply informed by the local knowledge of CSS's Skip Smallridge and Deneen Crosby as well as the historian Richard Rabinowitz, understood that this newly barren site had a long history of intricate local use.

Two significant design challenges defined the project from the outset. The first was the adjacency of the project to the monolithic hardscape of City Hall Plaza. Second, the intended park spaces were effectively two traffic islands. As a neighborhood, the North End had been walled off by the former Artery, which at once buffered it from urban renewal and isolated it from the bustle of city activity. The design challenge was to create a park that would serve current residents as well as welcome other populations into a contemporary public green space.

Maps of Boston in 1645 showed the site as a narrow piece of land between Mill Pond and the Cove, leading to Sudbury Street on one end and Mylne Field, which would become the North End, on the other. It was a low, wet swath between Beacon Hill and Copley Hill and so became the obvious site for a mill canal connecting the pond with the bay. Later it was a major circulation

route and, finally, a freeway. As land was built up around it, the site remained a crossroads. The Freedom Trail crosses the site, drawing thousands of tourists as they explore colonial-era history. The location's longtime function as both a bridge and a meeting place became a critical part of the conceptual approach to the new park's design.

The cultural narrative of the park serving to connect and bridge communities quickly became core to the emerging design; the park was to create a soft, green, broad landscape that would act as a threshold and transition space between communities whose hill towns and geologic landforms had long since been buried by modern infrastructure.

GGN focused first on ways to relink the historic streets. They began with the notion that Hanover Street might once again connect the North End with downtown Boston—achieved by conceiving of it as a bridge rather than a division. North Street, a local thoroughfare, and Salem Street, primarily a tourist route today, also had to be considered. These streets could be resurrected for pedestrians—residents as well as tourists—once again linking the two neighborhoods visually and physically. This strong core concept united the park's two spaces.

However, even reconnected, the scales of the two neighborhoods remained very different. The city side faces the immense Government Center and City Hall Plaza as well as the tourist

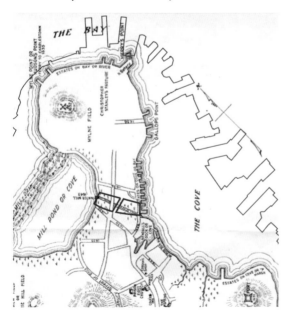

LEFT *The Parks sit across the width of what was once a narrow isthmus connecting the North End peninsula to downtown Boston. Land was added by filling in Mill Pond with soil from Copp's Hill and Beacon Hill.* RIGHT, ABOVE *The North End Parks sites, highlighted in white, show how the area was previously occupied by a raised freeway structure, the Central Artery, which divided the neighborhood from Boston's financial district and Government Center.* FAR RIGHT, ABOVE *Concept sketch by Shannon showing the special topographical history of the site as a low crossing in the city.* RIGHT *The Big Dig put the highway underground and created the Rose Fitzgerald Kennedy Greenway above ground, reconnecting waterfront neighborhoods with downtown Boston.*

attractions of Quincy Market and Haymarket. On the North End side, the park opens onto Boston's most intimate and historic residential neighborhood, with winding, narrow streets; valued and iconic structures such as the Old North Church (1723), and the Paul Revere House (1680) mix here with late-nineteenth-century architecture. In between were, essentially, two traffic islands between two off-ramp openings to the freeway tunnel, with multilane arterial streets running along each side. The critical design challenge was to ameliorate the jarring sensation

of being caught amid traffic between two scales. The solution came by acknowledging that the park would always be a space of transition as well as a destination in its own right.

To more fully understand the problems and the opportunities of the parks, GGN reached out to engage the North End community in the design process. Residents participated, attending multiple meetings to ensure their voices would be heard and reflected in the final design. They spoke proudly of their Italian community and the informal socializing that occurred in the public realm.

LEFT *Sketch by Shannon exploring the form of a continuous valley topography, to tie the two traffic islands together into one broader landform rooted in the site's past as a crossing over a marshy isthmus.* BELOW *The subtle grading of the "the valley" is seen in the sloped lawns and water scrims; these help the parks to feel more socially centered and intimate while orienting people away from adjacent freeway ramps.* RIGHT, ABOVE *Plaster model rendering the final topography of the new park and the relationships of streets as a bridge crossing over the lush valley and water.* RIGHT, BELOW *Trees define the park and its intimate spaces while screening the freeway, as lawns and the water scrims orient to views of Boston's civic center. Their placement was partially dependent on the structure of the roof deck below.* OVERLEAF *Water and shade encourage gatherings of family and friends on "the porch."*

They described the streets as their living rooms and the coffee houses as their gathering places. They imagined a park that might respond to their social and cultural traditions while meeting the needs of young families in the future.

In response to this strong sense of neighborhood and community, Shannon developed the concept of a "home and city crossing" to frame the design. The parks would be the North End's symbolic front porch. This recognized the site as a physical and social threshold for residents, as well as a welcoming space for civil servants working in the nearby local government offices and thousands of tourists walking along the Freedom Trail. All are offered a place to gather, to relax, to stroll, and to watch others pass by.

The starting point in making this concept a reality was forming the land to make the allotted space welcoming. Built as it was over the Big Dig, the parks needed to establish a physical presence as a green space, one distinct from the traffic that pulsed on all sides. Additionally, the arterial tunnel below created a grade change: the land sloped from 119 to 115 feet high from east to west. Paying

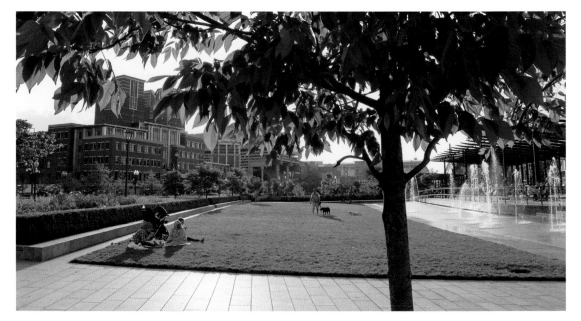

careful attention to sculpting the landscape, GGN explored a variety of options in both section and plan drawings as they sought to stitch two morphing, warped, valley parcels together into one complete whole composed of two separate parts. The suggested shape for the new landform was rendered and presented using plaster models, a unique part of GGN's communication process with clients and stakeholders.

As the concept for the modified topography took shape, it was increasingly oriented toward the city, like an open palm. The easternmost parcel's slope created an enclosed feeling, while the westernmost parcel, with its shallower slope, naturally led to a more open feeling. A subtle approach to shaping an existing landscape is a foundational component of GGN's design process. Subtle grading is at the heart of some of their best designs, even as it is often the hardest design move to recognize. Here as well as in other GGN projects, the form of the land itself defines the experience of being in the landscape; yet most of the public will assume that it has always been that way. For GGN, this is success: a space that feels

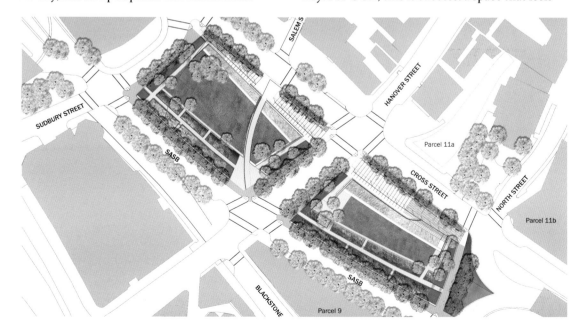

enormously comfortable, familiar, and intuitive, while simultaneously introducing new and sometimes even surprising elements.

Responding to the diverse uses of the parks, the GGN team envisioned steps with low risers and gently ramped sidewalks to invite access and to facilitate easy crossing. On the eastern edge, in front of the North End neighborhood, GGN placed a simple, elegant steel pergola, suggesting a broad and deep porch. The pergola functions as a vertical backbone for the site, lending it a sturdiness in the urban context. The public is drawn to this overlook, where they can view the adjacent lawn in one direction and the historic architecture in the other. Now, as in earlier eras, people take instinctive advantage of this protected moment in the landscape to pause and meet in their walks between home and city. To provide a visual barrier to the west, Shannon added four-foot-tall hedges of buxus that enclose beds of irises, allium, lavender, peonies, daylilies, and other perennial and bulb plants, to visually separate the park from the chaos and noise of the street. Magnolia, honeylocust, and ash are among the diverse trees that

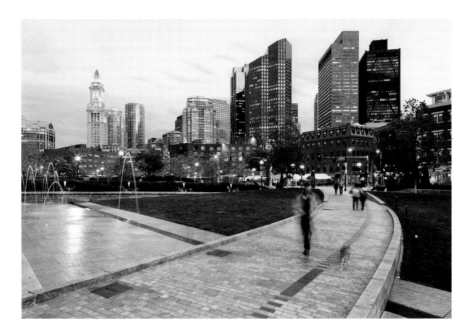

provide shade to the sidewalks and a vertical edge that encloses the parks.

Olmsted's Central Park taught designers that a great urban park must include a memorable story. GGN's design for the North End Parks reveals both a geological and a cultural history that would otherwise likely have gone unacknowledged by many. The first settlers created the fabled "city on a hill" in Boston; landform has always been at the center of the city's story. The reshaping of the land on this site yet again reflects a long history of building and unbuilding in the same spot.

Today's gentle topography, with the porch rising above to provide vantage points over this important American city, together with the welcoming lawns at the center, celebrate and include all of the site's incarnations.

To layer the site's history into the cultural narrative, a shallow water feature that parallels the "porch" harkens back to the parks' history from a century before, when a true canal connected Boston harbor to important industrial operations. Water has always been below the site, so it retains its place in the site now as well. First, it emerges

LEFT, ABOVE *What was once a highway is now a public land-scape as welcoming to tourists as it is to locals. Tree canopies and edge plantings screen a freeway tunnel entry in the middle of this view.* LEFT, BELOW *Views of the North End neighborhood recall the scale of Boston's historic streetscape.* ABOVE *At dusk, the focus on the skyline heightens as the Freedom Trail's red bricks fade. Embedded LED lights lend sparkling guidance on the pedestrian Salem Street, as local dog walkers and families use the path to move across the neighborhood.* RIGHT *Water attracts children and play while lawns encourage sitting and visiting with friends.*

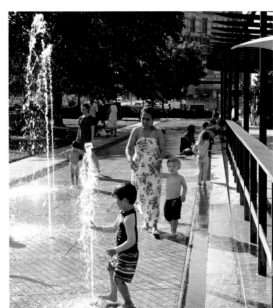

from underneath the porch and rolls out in a scrim. It conjures Mill Creek and Mill Pond—and the mill for which they were named, which was once an important landmark. The scrim is on one hand a formal piece, even classical in origin and suggestive of an Italian garden's elegant water elements. On the other hand, it is adapted to today's expectations: pared down, minimalist, subtly ornamented, and meant to host the bare feet of both children and grandparents on a hot summer's day. It's angled to reflect the sunset and shimmers like a golden necklace in the evening.

Like its predecessors, the canal is ultimately a place of play and engagement—the drama of the *giochi d'acqua* continues to delight modern visitors as the fountains surge and recede in patterns.

Reflecting Shannon's broad background research and engagement with the community, the parks' landform, garden spaces, interactive water elements, furniture, and plants echo both the historic and contemporary cultures that call the North End home. She found ways to celebrate the residents' traditionally vibrant street culture. Clearly defined lawns, for example, offer a

ABOVE *The dark, aged, warm materials of the neighborhood facades are recalled in those of the parks' brass and bronze details, chosen to link the new park to the legacy of the North End.* LEFT *Detail of a railing built from materials designed to reveal and celebrate use and time.* RIGHT AND FAR RIGHT, ABOVE *Large granite sidewalk slabs textured with hand-chiseled, diagonal grooves were historically laid over the vault spaces beneath the streets in Boston's North End. Machined, ADA-compliant versions were created as for the park's "front porch" and textured water scrim. These also allude to the grand hollowness of the Big Dig tunnel. Deneen Crosby, a principal at CSS, touches the historic sidewalk slab in a city storeyard, giving a sense of the ridges' scale.* RIGHT *The surface under the water provides traction while echoing the natural movement of the water that once flowed through the site's tidal marshes and, later, canals.* OVERLEAF *The North End Parks are used heavily by locals and welcome tourists walking the Freedom Trail, which follows the restored Salem Street alignment across the parks—after being blocked for decades by the raised highway.*

formality reminiscent of villa gardens. Today's Italian community continues the Old-World habit of sitting in proper chairs instead of directly on the grass, so she incorporated a mix of movable chairs and tables as well as fixed benches and leaning rails throughout the open terraces and under the pergola.

The parks extend the neighborhood intuitively into the greenway. Four-foot-wide granite slabs similar to the material used on the sidewalks of the historic neighborhood appear here, too, as if the rug that underlies the community has just been unrolled a little farther. Working in collaboration with CSS, they designed the Home Gardens to recall the Colonial Era and what could be discovered about the plants most popular then. Hedges enclose colorful arrays of spring-blooming daffodils and summer perennials. Shannon also called for popular perennials, including Russian sage, lavender, purple cone flower, iris, and daylilies. Several native trees and shrubs encircle the garden's perimeter.

The central artery (1951–1959) was built as the car came to dominate the city. The Big Dig

reflected a different moment in time, one when the pedestrian was again honored. Hanover Street now serves its original purpose as a bridge, moving people and goods from the neighborhood to the city and its markets. Intimate side spaces allow tourist groups to pause and listen and learn, while residents can pass by quickly on their way out and about; this small recognition of how different groups engage with the parks is essential so that they can adequately serve multiple uses. The generously proportioned sidewalks encourage evening promenades while the more intimate sidewalks are buffered by hedges, transitioning the walker from parks to street to city. Walkways are detailed as thin bridges over water where they cross the low point of the landform's valley. These moments are revealed by shadow lines and recesses as well as masonry details; the top courses sit as a slab above the courses below instead of relying on vertical curbs.

Long-absent streets now reinstated to cross this valley-like landscape function as bridges crossing the low, green ground. Hanover Street, the principal vehicular street dividing the two parcels, had been severed by the previous freeway structure. It's now detailed with bronze balustrades and lean rails, to encourage people to pause and enjoy the views. The landscape of each park is shaped as a shallow basin that focuses views toward the social center of each park.

The area's rich history is also reflected in interpretive elements, including the granite marking of the edge of the Mill Pond, descriptive quotes, a time line engraved in leaning rails, and an engraved stone map illustrating the site's changing landform. At one corner is the marker detailing the site of the first house owned by an African American woman in Boston, Zipporah Potter Atkins, in the 1700s.

Salem Street, again present in its historic footprint as a pedestrian byway, is detailed as a cobbled surface embedded in the softer green landforms, but it also crosses over the water feature. The Freedom Trail follows Salem Street across the parks, and the team interpreted its traditional end-on-end brick "line" by integrating red bricks into the cobbled pattern of the pavement. Sparkling LED lights were also sprinkled along the Freedom Trail route through the parks, making it appear as if fireflies guide the way for tourists through the quiet green space at night.

As Olmsted noted, great urban parks should encourage us to imagine the city and its urban landscapes in new ways. A park should be *of* the city and its residents, *and* a distinctive and inspiring place that fosters community. It should be a place where new visions can be tried, explored, and lived. For these reasons, GGN draws on the power of a restrained hand in the design. Making the most of the details and keeping the major moves clear allows visitors to add their own layer of context. Acknowledging both the human scale and the weighty history at once allows the designs to offer comfort and familiarity while inspiring the imagination to new heights.

The North End Parks engage what might have initially been described as conflicts: the desire to be historical and modern, to be residential as well as civic, and to serve as a home place as well as a destination. The design by Shannon and her team weaves these narratives together by drawing on the deep history of the landscape physically and culturally, listening carefully to the locals and their communities, and having the tenacity to imagine a future city where human and environmental health and well-being go hand in hand.

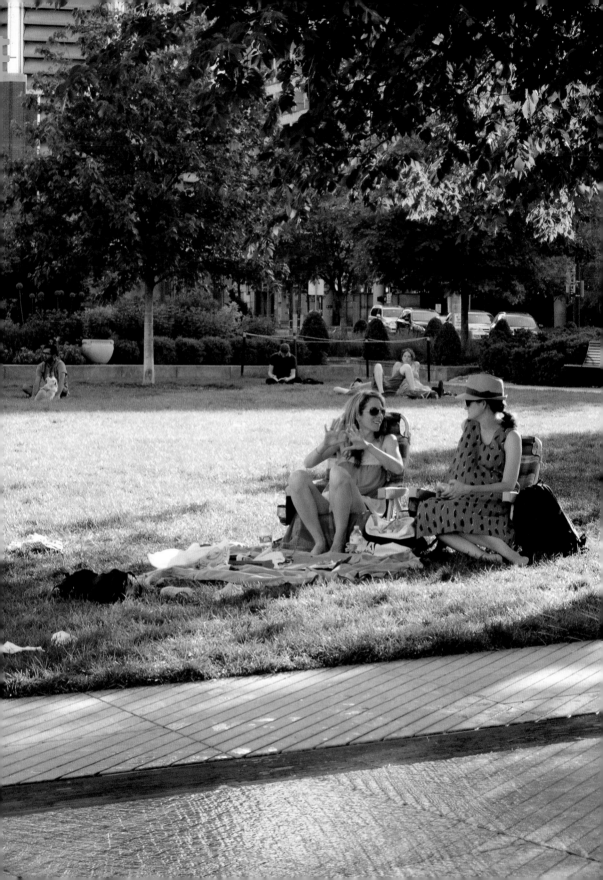

ROBERT AND ARLENE KOGOD COURTYARD
2005–2007

GGN's first project connected to a historic landmark is a well-known and much-used local garden, the Robert and Arlene Kogod Courtyard that sits at the center of the Smithsonian American Art Museum and National Portrait Gallery in Washington, DC. While the discussion of a roof for the courtyard began in 1880, it would take until the twenty-first century to achieve. In hindsight, this was a brilliant delay. Technology developed in the intervening years allowed Foster + Partners to design and engineer the undulating lattice skylight canopy that now so gracefully serves the museum complex. The courtyard below, designed by GGN, is considered a local treasure; it's one of the grandest interior spaces in the nation's capital.

The courtyard design by GGN offers a splendid space under the sky and yet is protected for year-round use as a gathering place and event space. It is minimally defined by generously proportioned marble planting beds holding shade-loving plants and trees. A quarter-inch scrim of water reaches across the full width of the courtyard, giving sensory delight to visitors and curators alike.

The Robert and Arlene Kogod Courtyard sits at the heart of an iconic work of architecture in the midst of L'Enfant's plan for the city. The structure now known as the Old Patent Office Building was designed by Robert Mills and built between 1836 and 1867; it's a model of Greek Revival architecture. The east and west wings were added and, in 1857, architect Thomas U. Walter oversaw construction of the north wing, designed in a bold neoclassical style. Designated a National Historic Landmark, the building was saved from destruction in 1958 by President Eisenhower, who transferred ownership to the Smithsonian.

In 2005, Foster + Partners approached GGN, with Kathryn and Rodrigo as leads, with a request to design a set of movable planters for the courtyard that they were in the process of enclosing with a new glazed roof. The project had been awarded to Foster + Partners in an international competition that capped a ten-year renovation project. The 28,000-square-foot courtyard was intended to serve as a respite for museum visitors as well as an event space for the Smithsonian.

The previous space consisted of a lawn with two significant elm trees and a pair of wrought-iron fountains; however, these had already been altered to construct a new auditorium. GGN immediately knew the scale was challenging, as it would feel like an empty ballroom when events were not happening. At the same time, the Smithsonian was under pressure from the historic preservation community to recover some of the integrity of the original space. GGN, the Foster + Partners team, and Smithsonian directors began to explore the potential of reintroducing a true landscape.

The space suffered somewhat from its own grandeur. It needed to comfortably host handfuls of visitors during regular museum hours without feeling cavernous and barren, but the large, wide-open venue was equally an asset for programming and fundraising. The GGN team sought to resolve the scale and character of the building facades with the experience of moving through the space as a pedestrian, and to provide a landscape that would make the most of its unique setting. They faced a series of challenges, such as a lack of significant daylight and the floor's limited weight-bearing capacity. The courtyard design also entailed reconciling the distinct building textures and character of each facade fronting the courtyard. Tackling these various components and characters called for an approach that could envision the courtyard as a mediating, harmonious space.

PREVIOUS PAGES *Children delight in the water scrim that reflects the undulations of the roof's structure.* LEFT *The central courtyard under construction as plans were being made for the new roof and garden.* RIGHT *The National Portrait Gallery with its strongly classical facade.* BELOW *Sketches by Kathryn exploring how to create a coherent ground plane given diverse entries, elevations, and competing axes.* OVERLEAF, TOP LEFT *Early study by Rodrigo of the linear spatial composition for the courtyard.* OVERLEAF, BOTTOM LEFT *Once the initial spatial rules had been established, the team explored a vareity of responses to organizing the courtyard's most prominent elements.* OVERLEAF, TOP RIGHT *An analysis of the historic courtyard revealed the spatial complexities that arose from its asymmetries. The new design sought to maintain the diversity of spaces this asymmetry created.* OVERLEAF, BOTTOM RIGHT *Access and cirulcuation routes as well as sun and shade studies informed the location of the marble planters. All studies on pages 104–105 by Rodrigo.*

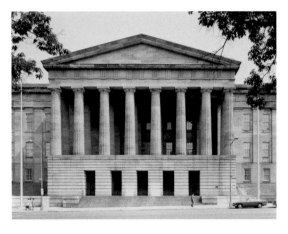

It was the buildings' unadorned, simple, stately Doric columns that ultimately inspired GGN's design language. Intrigued by the columns' restraint and the former positions of the wrought-iron fountains, the team explored ways of establishing a more human scale in the immense courtyard, keeping in mind that any new interventions on their part would also need to relate to the grand new roof installation. New north-south access needed to be balanced with east-west access. The eventual water scrim pulled visual interest to the east and west while also amplifying the importance of the nearby sandstone facade by reflecting it.

The designers began with the most basic problem: establishing and engineering a coherent ground plane. The four courtyard entrances were each at slightly different elevations. To meet the thresholds of the southern and northern entries, the slope was judiciously graded with attention to accessibility. In addition to the differences in elevation, there was the way in which the ground met each of the four building facades. An early decision was made to pull in any design elements

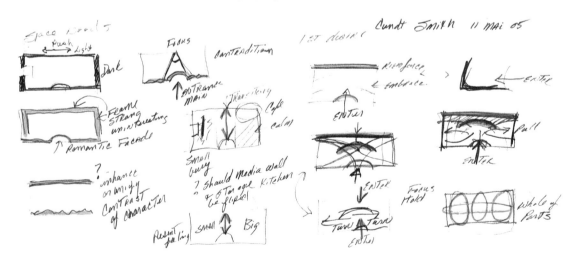

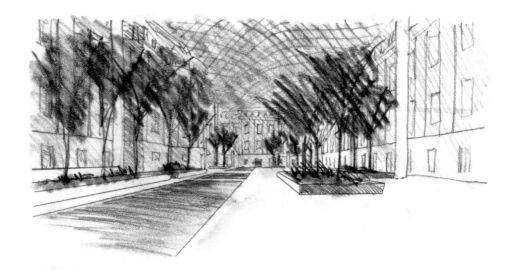

from the building foundations, allowing the precise meeting of facade and ground to be visible. It was determined that no new figures introduced to the courtyard should obscure the first-floor windowsill heights, again to emphasize the strength of the building facades and to retain their influence over the space. With the character and form of the ground plane and enclosure established, the team could begin to compose the contemporary elements that would shape the spaces within.

The courtyard design needed to afford a flexibility of spatial configurations—by day, the space would mainly be café patrons, but by night it needed to accommodate large special functions. It would need to feel full when empty, and empty when full. GGN turned again to art for inspiration—and found it in the 1969 painting *La vierge*, by Aurélie Nemours, a Parisian artist who created geometrical compositions that often played with ideas of perception. The painting, although based on asymmetric individual elements, creates a symmetrical whole. GGN hoped to achieve a similar sense of space that could change depending on the viewer's perception of it at any given moment.

GGN explored a variety of spatial compositions, including the original layout of two fountains placed on both sides of a central space, dividing the space into unequal thirds. Investigating possible configurations in sketches as well as sun and shade studies shared, the team arrived at a design that would relate to the asymmetrical original orientation, but would use new marble planters to create a dynamic push-pull within the core of the courtyard. The northeast area, which receives the most sun, was designated to host the café. The designers planned a water scrim to extend across the entire courtyard, functioning as an east-west cross axis, tying the various pieces together. In addition, the scrim occupies vast floor space by day when it's flowing, mediating the scale of the grandiose courtyard, and becomes a de facto ballroom floor at night when it's turned off.

The final composition was created with eight asymmetrically placed planters carved from brown-veined white marble, the same stone used for the museum's lobby floor. These are filled with low green plants and thin-trunked trees. One additional marble plinth serves as a seating

area and stage. Crafted by Coldspring Granite Company in Imperial Danby marble, the planters appear at once welcomingly soft and reassuringly solid. They are carved to rise at an angle from the Mesabi Black granite floor, then curved as veneer over a metal frame. Each of the planters is nineteen inches high—the height of the surrounding windowsills, and a good seating elevation. They vary in widths, offering platform seating that accommodates anything from a single visitor to a small gathering or family. The joints between each of the stone blocks that comprise the planters are crisp, thick, and substantial, suggesting that the mass and weight of the planters have locked them in place permanently. The planters break up the courtyard's vast floor plane and also define a variety of intimate spaces within the larger expanse.

In addition to aesthetics, however, the planters' composition had to take into account the depth of soil needed to hold trees, even small ones. The team had to carve out ten-inch hollows in the floor slab under each planter; this allowed for almost thirty inches of soil, the bare minimum for small trees. Natural

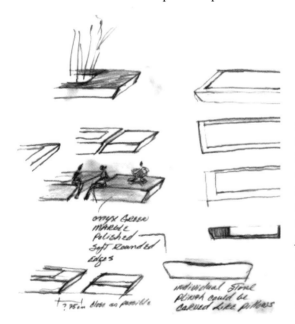

ABOVE *A model of the substantial blocks of marble that make up each bench; note the purposefully thick joints.* LEFT *Sketch by Kathryn of the marble planters, highlighting their human scale and the importance of carved stone to suggest a permanence appropriate to the historic buildings.* RIGHT, ABOVE *A sketch by Ian Horton shows how trees are underplanted with a "green rumble," carefully scaled to the larger space and the marble planters.* RIGHT *The final layout for the courtyard's most prominent elements builds on the iterative investigations of scale, geometry, and function. The planters, water scrim, and café tables and chairs fill out the space comfortably for visitors while maintaining enough open space to capitalize on its grandeur.*

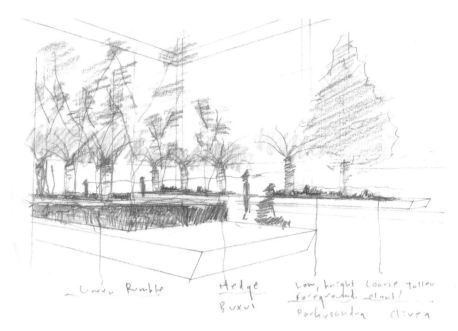

Cover Rumble Hedge Low, bright Coarse taller
 Buxus foreground plant?
 Pachysandra Clivea

light was also a challenge—filters in the roof tiles that control summer temperatures mean that the courtyard only receives twenty-five percent of the daylight of an outdoor space. Clearly, the design called for a careful selection of plant species that could thrive in low-light conditions. After extensive research with plant expert Dan Hinkley, the team chose black olive trees (*Bucida*), thickly underplanted with a "green rumble" of camellias, ferns, and pittosporum among other shade-loving plants. Two thirty-two-foot-tall ficus trees from Berylwood

Tree Farm frame the entrance, responding to the scale of the grand architectural facades and recalling the historic elms that had once graced the courtyard but had since been removed.

To counterbalance the asymmetrically positioned planters, the water scrim extends in four linear sequential pieces across the breadth of the courtyard. A shallow ribbon of water set just inside the southern entryway also implies a threshold. The grading that had to be undertaken to connect the various entrances and accommodate accessibility makes the scrim possible: water

trickles lightly across the slight slope, catching reflections of both the contemporary roof and the historical south facade. Adding a flow of water, even a slow one, is another design decision intended to add dimension and life to the otherwise imposing courtyard. Because the water's depth only ever reaches a quarter inch, it invites children and adults to dip a toe or simply walk through and track the water as it moves across the black pavers. This understated feature adds delightful sound and light as well as important spatial definition.

The museum's programming needs called for the design to embrace significant flexibility. This is answered in several ways: a marble stage at the northern edge of the courtyard serves as a podium for impromptu acts as well as a generous platform for intimate gatherings; lighting can be altered to curate the appropriate moods for events, and colored lights, moving patterns, or images can be projected onto the gray walls of the rather stern facade running east-west on the northern side of the courtyard. Finally, the water feature can be turned off and tables or formal arrangements

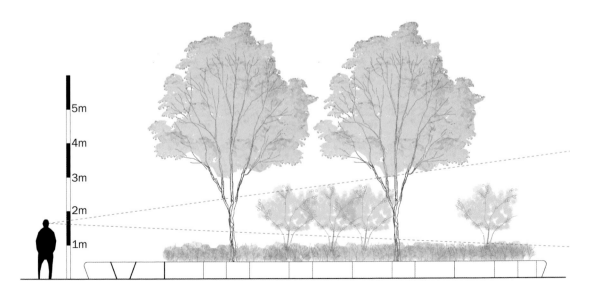

5m
4m
3m
2m
1m

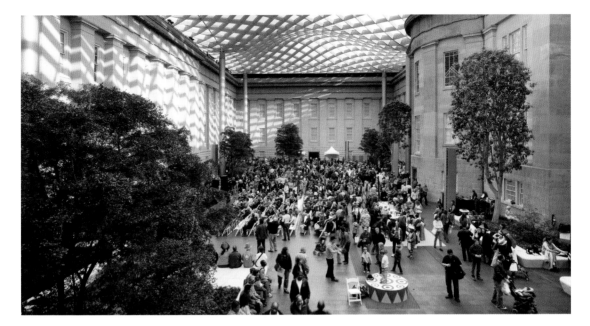

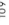

of chairs set directly on top of it. Because the planters are arranged toward the perimeter of the courtyard, the center remains open.

These complex and potentially conflicting functions spurred the team to rich design responses. The space evokes a fullness and elegance whether filled with people and music or populated by just a handful of visitors. It's become such a successful meeting place that the museum has adjusted its open hours to coincide with the local theater district's performance schedule, so theatergoers can gather there prior to a show.

Today the Robert and Arlene Kogod Courtyard is considered one of the largest and grandest interior public places in Washington, DC, equally beloved as a quiet place to meet neighborhood friends. This ability to design spaces that are "empty when full, full when empty" has become a signature quality of GGN designs. The successful collaboration here set the stage for GGN to work with Foster + Partners and SmithGroupJJR on future projects.

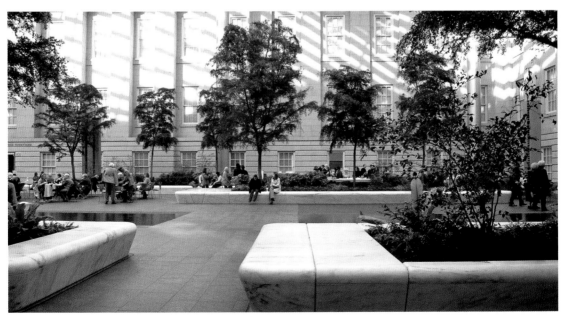

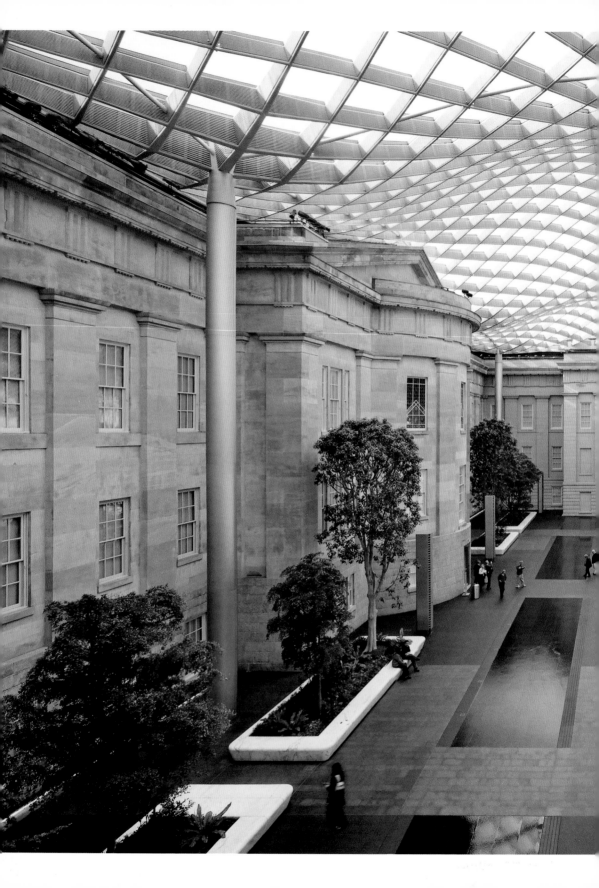

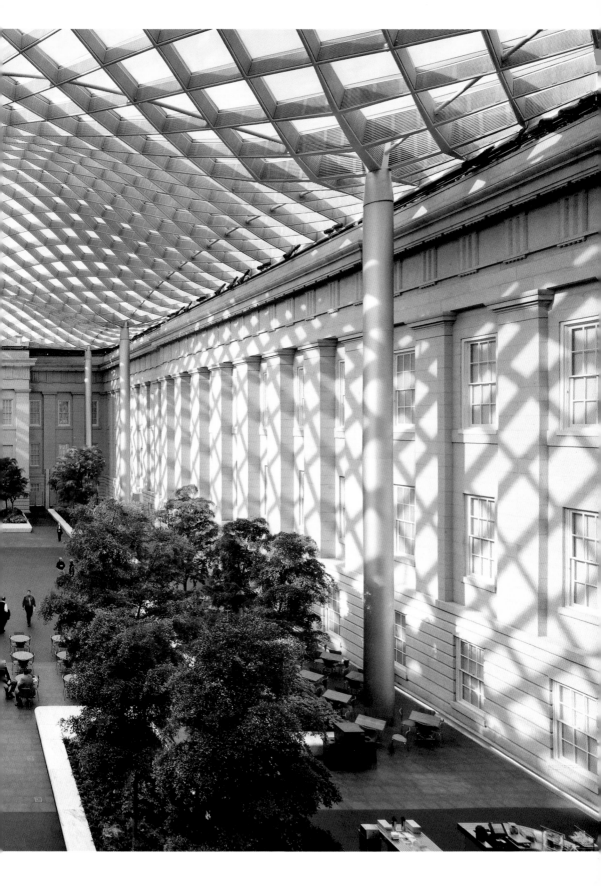

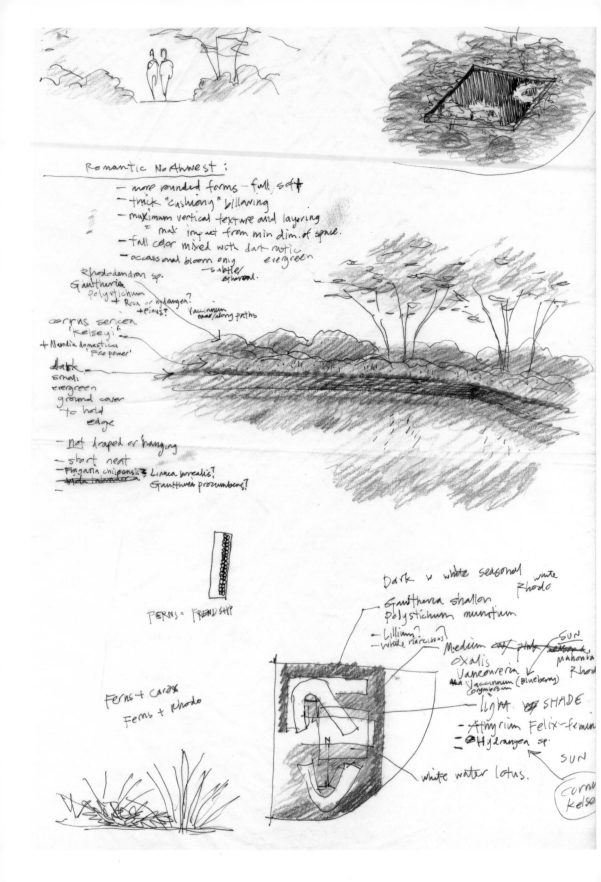

Romantic Northwest:

- more rounded forms — full, soft
- thick "cushiony" billowing
- maximum vertical texture and layering
 = max impact from min dim. of space.
- full color mixed with dark rustic
- occasional bloom only evergreen
 — subtle/
 ethereal.

Rhododendron sp.
Gaultheria
 polystichum
 + Rosa or hydrangea?
 + Pinus? Vaccinium near/along paths

cornus sericea
 'Kelseyi'

+ Nandia domestica
 'Fire power'

dark
small
evergreen
ground cover
to hold
 edge

- net draped or hanging
- short neat
- Fragaria chiloensis? Linnea borealis?
 Viola labrador? Gaultheria procumbens?

FERNS = FRIENDSHIP

Ferns + carex
Ferns + Rhodo

Dark w white seasonal white
 Rhodo

Gaultheria shallon
Polystichum munitum

- Lillium?
- white narcissus
 Medium cut pink Sun
Oxalis Mahonia
Vancouveria Rhodo
 Vaccinium (Blueberry)
 corymbosum

— light shade

- Athyrium Felix-femin
- Hydrangea sp.

white water lotus.
 SUN

 Cornu
 Kelse

BILL & MELINDA GATES FOUNDATION CAMPUS
2009–2011

The narrative that threads a landscape together can take multiple forms, from literal and physical to abstract or metaphoric. The Bill & Melinda Gates Foundation Campus was designed to display the character of the setting in a way that would reveal the site's place in the city and encourage the public to explore it. It was also intended to serve as a story of revitalization and renewal that reflected the foundation's mindful approach to solving problems at many scales.

The campus presents itself as a locally rooted environment for global dialogue, a space whose form suggests the power of what can be achieved when we dare to reimagine a place and its community. Located just northwest of downtown Seattle, the campus is the product of an exceptionally close collaboration between GGN, NBBJ Architects, Sellen Construction, and civil engineering firm KPFF.

This site began as a large parking lot on an awkward space at the convergence of three major vehicular routes: Fifth Avenue North, Mercer Street, and Washington State Route 99. Adjacent to Seattle Center, with its landmark Space Needle and Frank Gehry's Experience Music Project (now the Museum of Pop Culture), it seemed difficult to introduce another building and landscape that could successfully compete. As an empty parking lot, it could easily be mistaken for a tabula rasa. The GGN team, led by Shannon, Grant Stewart, Bernie Alonzo, and Shoji Kaneko, immediately recognized its potential to reflect the site's rich geological and natural history. They imagined a landscape deeply rooted in place, that would reflect the thoughtful culture of the Seattle-based foundation.

The new campus was to lie directly over what had once been a dark-watered bog in a wetland meadow, a type of landscape important to the natural history of the Seattle region. The area drained into nearby Lake Union through marshy streams. In this ecology, water was always present but floods only occurred in rare instances. Although dark and still, the bog offered habitat for a broad diversity of flora and fauna and served as a regular stop along migratory routes for waterfowl.

The team also discovered a history of engineering and development that had altered and modified the site and its context over the past century. It had escaped flattening during the Denny Regrade—an immense effort between 1902 and 1930 to level Denny Hill, which was considered an obstacle to growth and transportation in downtown Seattle. As the leveling of the hill did not lead to significant development until the twenty-first century, the site had become increasingly isolated. A fifty-foot drop in grade between the southwest and northeast corners was an additional consideration for the new development.

Water also took on a significant symbolic role in the design from the first brief. Given the Gates Foundation's global work in communities of need, Shannon knew that water should be introduced here as it is seen by so many: as a scarce resource. It needed to appear as a gift in the landscape. She wanted to avoid using water in an ostentatious or decadent way, so she worked to refine how water could become an appropriate expression of "humble and mindful," a mantra of the Foundation's work. Water needed to appear as a revered and stable element, one that would be honored and carefully protected.

The natural history of the land became a springboard for revitalizing the site as an allegorical reflection of the aspirations of the Gates Foundation, as well as those of Seattle as a city. Ultimately, it has become a gathering place that fosters shared visionary aspirations: Seattle's civic leaders creating a more ideal public realm, and the Gates Foundation improving people's lives.

To explain her conceptual narrative of the land and its water, Shannon used photographs of

PREVIOUS PAGES *Conceptual sketches and notes envisioning the character of water and plantings, by Shannon.* LEFT *The site, a 13-acre parking lot, is awkwardly located between major thoroughfares and corner lots—the design team often heard comments in public meetings that "no one will walk there" and worked diligently to make sure that prediction did not come true.* RIGHT, ABOVE AND BELOW *Native and edible plants including camas and blueberries ground the landscape in its region and reflect the Foundation's mindset of empathy for all peoples and welcome for everyone.* OVERLEAF *The main ground acts as a suspended blanket spread over the rainwater pools, offering a place for gathering or a retreat to read a book.*

lowland bogs she had collected as inspiration. These images and the drawings they inspired drove the character of the landscape—its water and plants. The contour of the landscape would be retained, with the bog cut into the ground along precise edges, as if it were being excavated by one of the former engineers who had worked the site. The eventual design emulates natural history by evoking a sedge bog and wetland landscape. The bog could probably have stood convincingly as a main feature of the complex's landscape, but the design still needed to incorporate space for

community and employee gatherings. To address this, Shannon designed a light, thin, floating "blanket" over the water that offers a heart based in nature for the whole campus.

With the landscape concept described, attention returned to the buildings and their position on the site. Beyond expressing the local character of the site, the campus's architecture and landscape are intended to reflect the Foundation's mission. Initial plans showed a quietly gridded campus of simple, refined buildings. It was not until Melinda Gates and her co-chairs urged the NBBJ architects

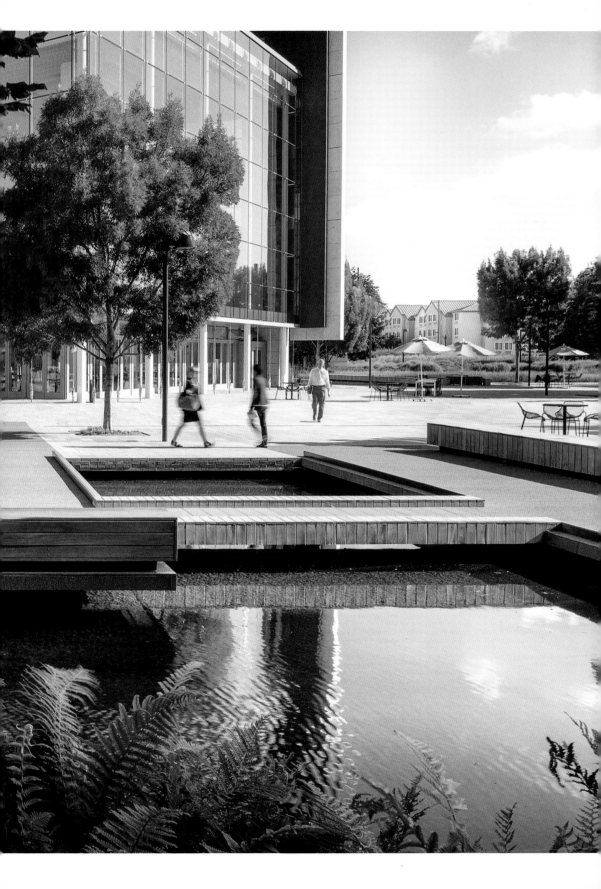

to envision something bolder that the final concept of a boomerang form for the buildings emerged, inspired by a map that curvaceously traced the places around the globe where the most vulnerable communities are supported by the Foundation.

GGN responded by suggesting that the buildings appear to float in the air above "local roots," a first-floor facade differentiated from the upper levels in a way that is intuitively urban, neighborhood-responsive, and native in its character. The "global vision" floors of the buildings above are in purposeful contrast, floating over the "local" layer of darker, gridded architecture that relates directly to the native bog courtyard. The campus celebrates the spirit and energy of over 1,500 local employees, while the dramatic arc-shaped buildings suggest arms reaching out to achieve worldwide impact. Furthermore, the campus buildings include over half an acre of green roofs, adding to the benefits of the neighboring 1.4-acre green roof on the Seattle Center garage and Gates Foundation Discovery Center. These green roofs are designed for optimal water absorption,

ABOVE *The boomerang forms of the three buildings float within the grounded landscape of the native bog, forest, and field.* LEFT *A thick edge of native shrubs, including sedges and reeds, border the rainwater garden.* RIGHT, ABOVE *Concept sketches by Shannon showing the three layers of the campus and how they relate to facets of the Foundation's unique culture of both local roots and global vision.* RIGHT *As the architectural concept gradually evolved to be more bold, the landscape correspondingly served a stronger role in grounding the Foundation in both the local environment and the neighborhood's urban grid.*

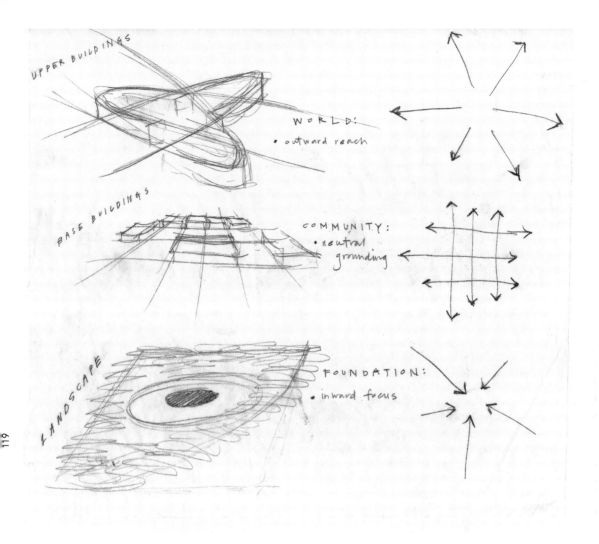

UPPER BUILDINGS

WORLD:
• outward reach

BASE BUILDINGS

COMMUNITY:
• neutral grounding

LANDSCAPE

FOUNDATION:
• inward focus

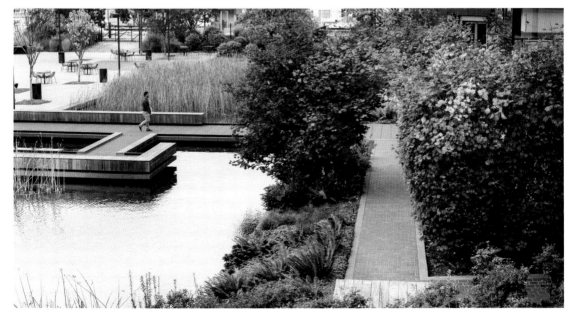

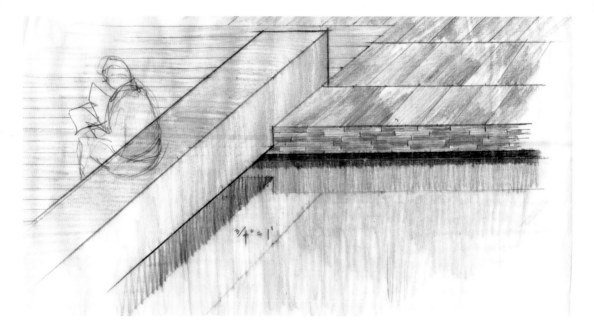

based on data and on-site mockups from the Seattle Green Roof Evaluation Project that GGN co-led with the engineering firm MKA. They are modeled to absorb ninety percent of the water that falls on them over the course of a given year. Nearly all rainwater from non-pollutant-generating hard surfaces is collected into the million-gallon cistern below the courtyard and used to feed the reflection pool, irrigate other plantings, and facilitate toilet-flushing. This attention to water collection is also evident in the bog that absorbs two million gallons of storm water a year like a thick green sponge.

To enhance the sense of groundedness in a landscape that is almost entirely built on introduced structures, Shannon returned to the concept for the bog and blanket design as critically important. She knew that to realize the idea, she would need to establish a thick, dark earth underfoot for the bog and then lay a clear and clean blanket over it for people.

For the bogs, narrow-leafed cattail and native bulrush were planted in large masses, while meadow-like drifts of thick grasses populate the sunnier areas of the site. In the shadier areas,

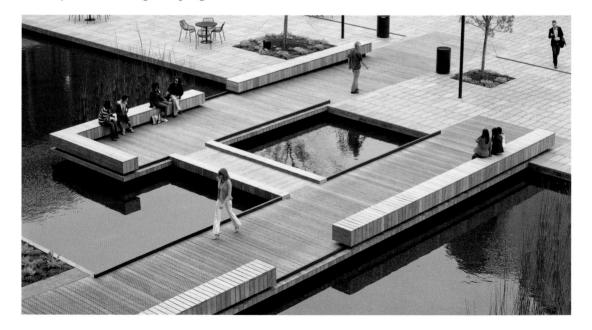

LEFT, ABOVE AND BELOW *The materials of the central "blanket" are scaled to the human body so that it can serve as a a space for contemplation, a place for friends, or a circulation route. The drawing at left, by Shannon, studied how to detail the juncture where wood bridges "press in" to the stone plaza's "floating" edge.* RIGHT *Bernie Alonzo checks the custom-designed form liner on site. Sellen Construction collaborated with GGN to test and optimize the forms for the most reliable release of the fine-textured fins, with minimal spalling.* BELOW *GGN designed custom form liners for the cast concrete walls of the campus. The texture was designed to pair with the humble roughness of the bog and regional landscape.* OVERLEAF, TOP LEFT *This entry planting welcomes the public with a year-round display of plants that are ethnobotanically important.* OVERLEAF, BOTTOM LEFT *The changing seasons feature camas in spring and blueberry foliage and blonde grass in autumn.* OVERLEAF, BOTTOM RIGHT *Public spaces include generous benches tucked into the planting beds. Shown here is the large green "welcome mat" garden of native ferns.*

thick drifts of native and non-native ferns, evergreen huckleberries, and forest groundcovers congregate. The ratio between open and planted water was guided by bird-habitat criteria and optimized to create the most immersive experience of texture and light. And in the spirit of "humble and mindful," edible plants appear, including blueberries, native evergreen huckleberries, native thimbleberries, and over 10,000 native camas bulbs. Custom form liners emulating deep vertical striation marks that appear naturally in many types of rock were used on the faces of dark concrete retaining walls along sidewalks and at water edges to imply cuts through a single, dense, wet slab of peat. Black basalt, a locally salvaged material, was used as a lining to give the water a deep, reflective character.

To craft the multipurpose gathering space at the campus's heart, the GGN team designed the thin, light-toned "blanket" of paving to appear to float over the bog. Its paving pattern is inspired by strip-weaving, a traditional craft in many cultures around the world. The edges of the blanket-walkway are designed to appear as if the thin

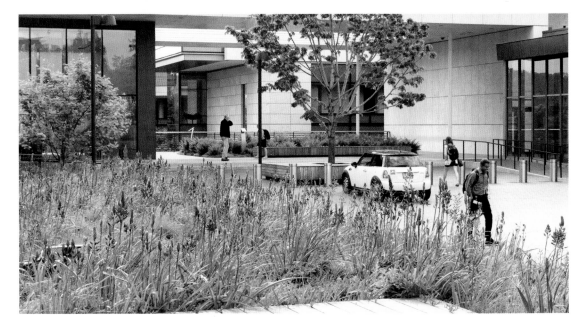

stone is suspended taut, like fabric, over the pool. The impression is that the central heart of the plaza floats, detached from the ground on all sides.

To connect the floating blanket to the buildings, the design team developed a series of boardwalks to be placed over the thick, deep "earth" of the landscape and water. The boardwalks were originally clad in cumaru wood, made slim and flush with the adjacent paving by the use of low-profile Unistrut supports on the roof deck below and custom-fabricated metal frames and sleepers. When some of the cumaru showed symptoms of

not having been fully cured to specifications and thus slippery, the wood-clad boards were replaced with precast concrete decking boards sourced from the marine dock industry. This solution kept the GGN-designed board grain, bridge profile, and detailing intention, while providing a completely stable and high-traction material on the bridges for all seasons.

The solid ground that surrounds this entire riparian scene is framed as a veritable forest in its own right, which provides dappled shade and appears as an extension of Seattle's surrounding

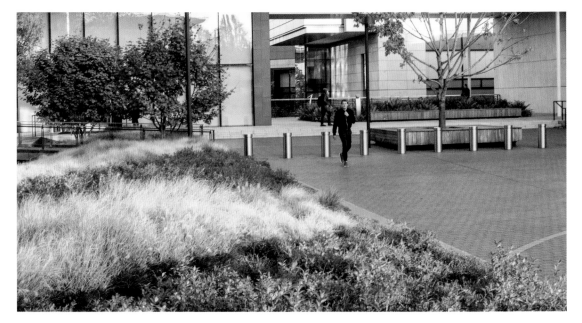

green landscape. Thresholds into the buildings will eventually be almost entirely shaded by forty-three native big leaf maples, forty-six vine maples, and thirty-six drought-tolerant 'Raywood' ash trees—chosen in part to provide an intriguing contrast in texture. The canopy is thickly underplanted, offering a deep, shady lushness that also contrasts with the openness and sunny character of the central plaza. Movement from the shelter of the building, into the forest landscape, across the tranquil bridge, and to the floating plaza comes from an intuitive, almost subconscious, choreography.

Working in collaboration with the architects, the GGN team sought to engage the architecture in the landscape's narrative of thoughtful, purposeful groundedness. The team worked within the NBBJ-designed building podiums, which provide linear street edges along Fifth Avenue and Mercer Street; sidewalks and both the vehicular and pedestrian entries were also aligned to the street grid and adjacent buildings.

The public realm enclosing the campus is carefully scaled with places to walk, sit, and gather. It also features selected works of public art. Low retaining walls hold the sidewalk edges, even as the buildings are set back. Lush gardens emerge from the narrow spaces between the retaining walls and buildings, while looser, larger gardens line the entry path for pedestrians. Tightening the spaces on the ground plane around streets—

counter to the convention of office parks having lots of "generous green"—implies a more urban character. This large campus thus is both a generous landscape and one that fits comfortably in a dense and compact city environment.

In constrained urban projects, the rigidity of city grids is often a challenge. For the Gates Foundation headquarters, as noted by landscape critic Betsy Anderson, "[T]he real, profound public gesture of the design has nothing to do with becoming another architectural icon in the neighborhood. Rather, it is found in the quiet, anchoring effect of the campus on the urban fabric, its relationship to the shifting street grid, and its emphasis on the individual pedestrian."[6]

From the public perspective, the Gates Foundation campus appears relatively porous, allowing views in even where physical access is limited. Additionally, the Foundation Discovery Center offers a place to learn more about the organization. In one corner, a café and outdoor terrace invite public visitors to enter and rest while enjoying a view of Seattle's iconic works of architecture: the 1962 World's Fair Space Needle and Frank Gehry's fantastical Museum of Pop Culture. In the end, it is the careful attention to the potential of design to inspire and edify, the power of a strong concept grounded in its locale to shape a meaningful place, and the respect given to the public realm as a part of the city that makes this design so successful.

SPREADING WINGS AND EXPLORING NEW TERRITORIES

In 2003, wanting to return home to the Washington, DC, area to raise his family, Rodrigo Abela arranged to work from afar. While initially a temporary agreement, it was soon clear to the founders that a satellite workspace in DC made sense. Between 2006 and 2007, Rodrigo became a principal, and subsequently GGN added three additional principals: Grant Stewart, Keith McPeters, and Bernie Alonzo. Each of these experienced designers contributed to the shaping of GGN's work, including designed landscapes for the Bill & Melinda Gates Foundation, Connecting Downtown Cleveland, and the University of Washington projects.

GGN never focused on any one school for new designers. As Jennifer, Kathryn, and Shannon lectured at schools and served on design juries, they kept their eyes open for creative and thoughtful designers, sometimes oddballs or those who pursued multiple interests. They were fascinated by a diversity of skills and backgrounds, hiring architects, urban designers, and graphic artists, as well as landscape architects. New members would include Jordan Bell, Tess Schiavone, and Emily Scott, who also joined in 2007.

By 2012, Jill Fortuna, Rebecca Fuchs, Fred Jala, David Malda, Chihiro Shinohara Donovan, Makie Suzuki, Yuichiro Tsutsumi, Kara Weaver, as well as Cheryl dos Remedios to oversee marketing and communications, had become members of the GGN team, each of whom remain with the firm in 2018. Poised for the future, the firm would take on progressively complex projects, partnering with important architects including Foster + Partners, Bohlin Cywinski Jackson, and Olson Kundig. The satellite workspace in Washington, DC, moved to the hip neighborhood of Georgetown. There were small but essential urban projects, including 1401 Wilson Boulevard in Arlington, Virginia (2013), as well as large-scale plans such as the Centennial Park Master Plan for Nashville, Tennessee (2010), and Seattle's Pike-Pine Streetscape Design Vision (2013).

The firm continued to gather professional recognition and awards, including the 2011 Smithsonian's Cooper Hewitt National Design Award for Landscape Architecture. They had success with design competitions, including contests for the Vancouver Community Connector in Vancouver, Washington (2009), and for the Union Square–National Mall renovation and reimagination (2012). Titled "Unified Ground," GGN's winning submission for the National Mall was chosen by a prestigious jury and garnered critical national acclaim.[7] The design was developed collaboratively by Kathryn and Rodrigo with David, who had recently joined the firm, and with Carl Krebs and Peter Cook from Davis Brody Bond Architects. The jury noted the remarkable ways in which the design engaged visitors with an impressive, monumental scale reflecting our democratic aspirations while providing comfortable places for a range of experiences and voices. It was a bold design defined by visual restraint, grounded in the history of the site while clearly contemporary. In fact, it was just such a restrained attitude toward design that would shape much of the firm's work in the coming years, as they increasingly focused on projects that called for a grounded approach to urban sites, minimal design moves, and a focus on the craft of details.

PREVIOUS PAGES, LEFT *Jordan Bell, Kara Weaver, and Rebecca Fuchs across the street from GGN's office on a presentation day for the Pike-Pine Renaissance Streetscape Design Vision. The team designed the T-shirts and project logo as part of their spirited commitment to the project.* RIGHT AND BELOW *Views of the proposals for Unified Ground, a competition for Union Square in Washington, DC. A central water feature criscrossed by diagonal paths would function regularly as a 2-inch-deep reflecting pool, but could be drained quickly to accommodate assemblies. As a composition, the design would add an urban vitality to the landscape while integrating the site into the monumental core.*

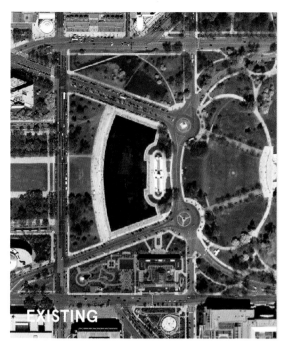

EXISTING

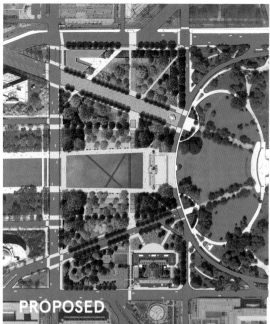

PROPOSED

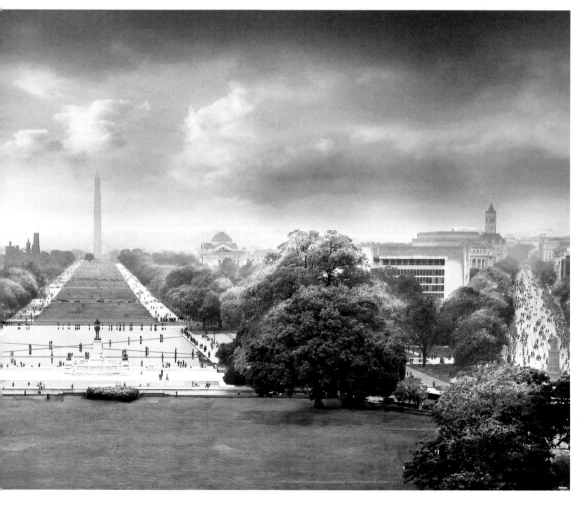

LEFT *Rodrigo working with Lesley Conroy at the DC workspace.* BELOW *David Malda participates in a design critique.* RIGHT *Kathryn drawing with the Yakima Plaza team.* FAR RIGHT *Keith McPeters leading a Year of Drawing discussion; he presents the resonator guitar as an artistic tool in his analogy to the versatility of the pencil in design.* RIGHT, BELOW *The Civic Park at Hemisfair team of Andres Andujar of HPARC, Tess Schiavone, Irby Hightower of Alamo Architects, Omar Gonzales of HPARC, Grant Stewart, Annelise Aldrich, David Malda, and Kathryn Gustafson. Collaborative work includes extensive discussions and a table filled with sketches, models, and trace paper.* OVERLEAF, TOP LEFT *Model exploring the spatial character of the topograhy for the Vancouver Community Connector. Kathryn led the development of the model.* OVERLEAF, BOTTOM LEFT *Plan for the Vancouver Community Connector revealing the role of trees in defining and connecting spaces across the freeway lid.* OVERLEAF, TOP RIGHT *Voelker Park, a proposed 300-acre park north of downtown San Antonio, as envisioned in a scaled plan drawn on an aerial photograph, 2007.* OVERLEAF, BOTTOM RIGHT *Voelker Park meadow that would connect the park to the greenway.*

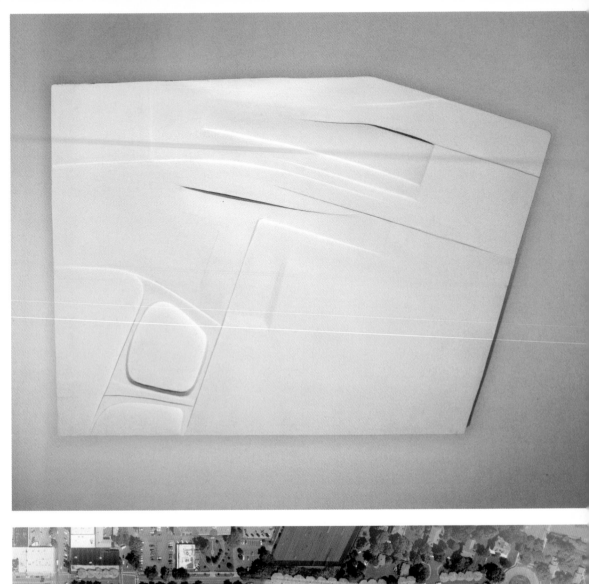

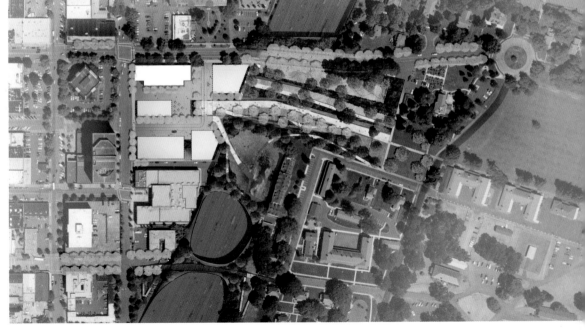

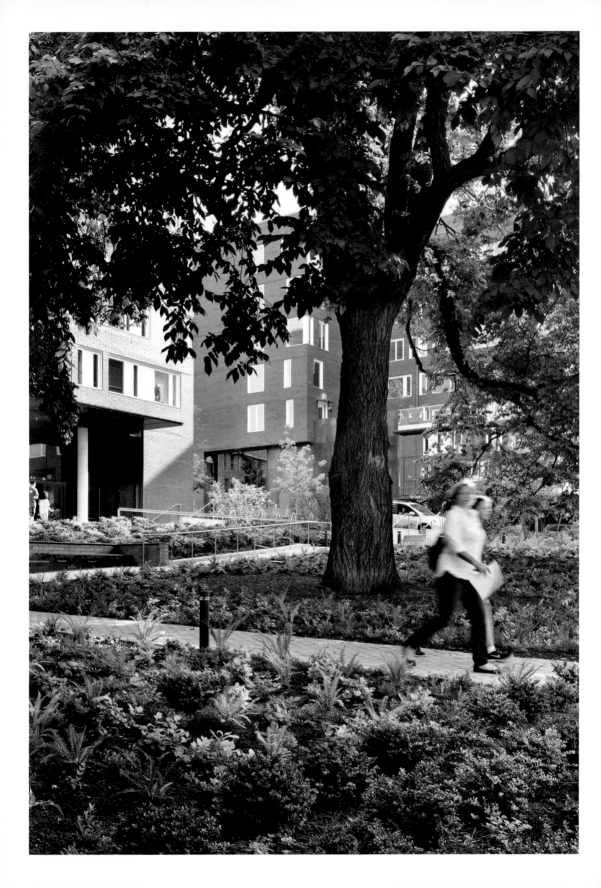

WEST CAMPUS
RESIDENCES &
STREETSCAPE
2009–2012

As the University of Washington in Seattle renovated and expanded its central campus and residential communities, it needed to integrate more robustly with its urban context. Partnering with Mahlum Architects for the buildings, GGN led the design for the landscape as well as the streetscape of the West Campus, an area that had become tired and neglected. The design team developed a strategy that integrated the amenities of a small urban neighborhood and invited the whole community to connect. The project offers a model for how an urban university can strengthen its periphery through improved urban design.

Encompassing four city blocks, the West Campus Residences and Streetscape project included a series of new dormitories interlaced with gardens, courtyards, and roof terraces. At the core is Elm Plaza, a garden designed around a 100-year-old heritage elm. Public amenities added to establish a healthy public realm include bus stops, cafés, and a grocery store. A green street that "gives priority to pedestrian circulation and open space over other transportation uses"[8] is being developed through the West Campus project. The design was a catalyst for further campus development as well as the emerging Innovation District.

Many urban universities are working to build healthier, more resilient, and increasingly productive landscapes to nurture the campus experience while better integrating the academy into the city.[9] The University of Washington (UW) campus, originally located in downtown Seattle, moved to its current site in 1893. A new campus was conceived by the Olmsted Brothers in 1906–1909, followed by a series of master plans and expansions that, until 1953, remained primarily within the original boundaries. The traditional orientation inward was maintained with the major exception of the strong central vista that spans over the city and beyond to a sublime view of Mount Rainier.

In the years after World War II, the university expanded and Campus Parkway was completed as a gateway between the city and the campus. The Parkway was then lined with university buildings including dormitories, a law school, and administrative offices. The West Campus Living Learning Community, begun in 2009, offered an opportunity to improve the urban fabric and livability of the neighborhood along Campus Parkway. Today, West Campus is home not only to students, but to restaurants, cafés, a grocery store, and a startup hub, all part of what is imagined as expanding into an Innovation District.

Partnering with Anne Schopf of Mahlum Architects, Jennifer Guthrie was lead designer for the GGN team, working with Tess Schiavone and Ian Horton, to develop an urban campus that would be productively integrated into the neighborhood while offering the amenities of a residential campus. They aligned the buildings with the city grid, and intentionally kept the structures' massing porous to provide public access through and around the buildings. They threaded the area with spaces scaled for diverse activities. Finally, they obtained alley vacations for public benefit so that they could design a new circulation system of paths alongside gardens, courtyards, and terraces.

With the buildings sited, Jennifer established a framework for the campus grounded in three landscape traditions: the academic quad or yard, the garden, and the urban grid. The quad landscape appeared, abstracted but familiar, in a variety of courtyards and terraces interspersed through the urban campus. Gardens also crop

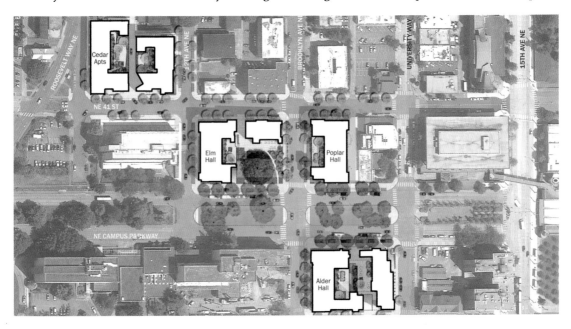

CAMPUS PARKWAY: BEFORE

PROPERTY LINE

ORIGINAL CURB LINE

OPAQUE BUILDING FACADE
• No interior/exterior relationship

UNHEALTHY TREE
• Exposed tree roots
• Compacted soil
• Trip hazard
• Roots displacing adjacent paving

NARROW SIDEWALK
• No social gathering space
• Encourages foot traffic in planting strip

NARROW TRANSIT SPACE
• Crowding at bus loading area
• Danger of arriving traffic

11' | 6' Sidewalk | 9' Planting Strip | 4' Paving

up throughout the neighborhood, creating intimate spaces within the larger residential campus. The urban grid frames the whole landscape, providing a clarity and legibility to the intersection of the campus with the public realm.

Elm Plaza, on the corner of Brooklyn Avenue and Campus Parkway, is at the heart of the district. The university's decision to preserve its namesake tree rather than remove it to create space for more housing units emphasizes how much it values the public realm as a part of a vibrant campus. Today, the magnificent elm tree represents the

generosity of spirit and rich history that are such integral parts of many learning landscapes. The redesigned space relates to the city in its generous orientation outward as a public arena that still clearly belongs to and creates a residential community. It offers a clearly defined space where city and university mingle, mix, and intersect as individuals and as contributors to placemaking. This is critical in a neighborhood where the university has not always been viewed as a good neighbor.

The health of the ninety-foot-tall American elm (*Ulmus americana*) with a canopy spanning

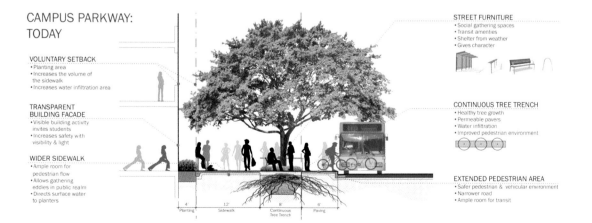

CAMPUS PARKWAY: TODAY

STREET FURNITURE
• Social gathering spaces
• Transit amenities
• Shelter from weather
• Gives character

VOLUNTARY SETBACK
• Planting area
• Increases the volume of the sidewalk
• Increases water infiltration area

TRANSPARENT BUILDING FACADE
• Visible building activity invites students
• Increases safety with visibility & light

WIDER SIDEWALK
• Ample room for pedestrian flow
• Allows gathering eddies in public realm
• Directs surface water to planters

CONTINUOUS TREE TRENCH
• Healthy tree growth
• Permeable pavers
• Water infiltration
• Improved pedestrian environment

EXTENDED PEDESTRIAN AREA
• Safer pedestrian & vehicular environment
• Narrower road
• Ample room for transit

4' Planting | 12' Sidewalk | 8' Continuous Tree Trench | 6' Paving

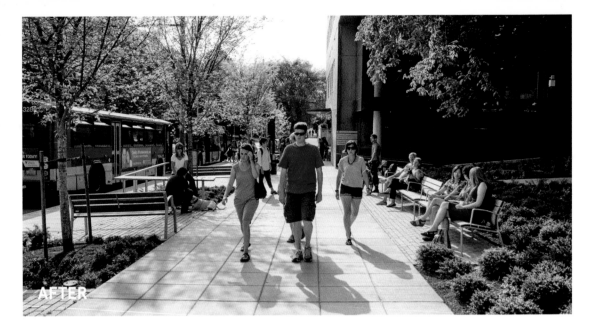

AFTER

eighty-five feet was carefully assessed to ensure it would survive the disturbance from new construction. Although no records exist, the tree was likely planted not long after the campus was established, and has survived despite having stood for decades in the middle of a gravel parking lot. In the new design, the tree offers a trace of the past, when city streets often featured allées of elms. The team appreciated how the tree embodied ecological literacy by simply surviving to such a mature age, after its species almost disappeared in America because of Dutch Elm disease. By extension, this venerable specimen filled the space it inhabits with an air of wisdom.

After determining that the elm was in good health, the team sought to strengthen the experience of the magnificent tree and to draw attention to its uniqueness. GGN designed a row of reclaimed wood slab benches embedded in the upper retaining wall, facing the garden of hellebores, azaleas, and ferns that would grow under its shade. A restaurant and café, a gym, and student rooms are also sheltered by the broad elm and its

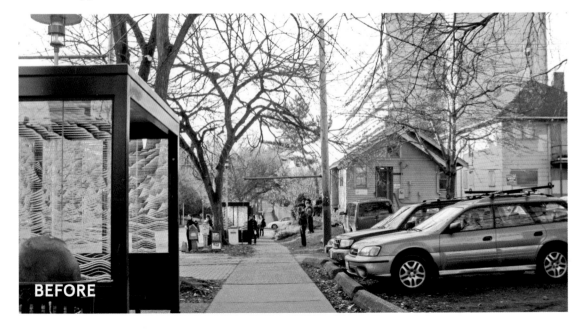

BEFORE

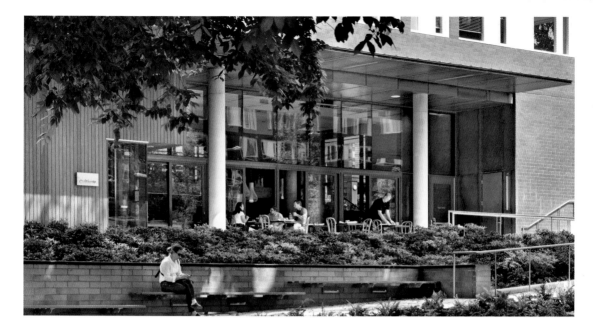

garden. The designers shaped the space surrounding the large tree to serve as a gathering place, a landmark, and a welcoming threshold in the busy urban neighborhood.

Acknowledging the street as part of the public realm of the city was equally important. The neighborhood had been neglected over the years, awkwardly dotted with surface parking and minimal sidewalks. GGN's approach was to identify ways to improve the public experience by re-establishing city standards and then implementing small improvements to catalyze large returns.

Sidewalks were a productive place to start. Working with Mahlum, the team chose to set back the dormitory buildings to allow for lush planting zones, which would give some definition between private and public realms. By narrowing the unnecessarily broad roadway, sidewalks could be widened to create a more generous scale, fostering use by more people and for multiple activities. The new sidewalks also accommodate continuous tree trenches with large, open planting areas and permeable paving to promote healthy tree growth and collect rainwater. The sidewalks were

PAGE 134 *The magnificent elm tree anchors the busy university plaza.* PREVIOUS PAGES, LEFT *Site plan showing how the residential neighborhood serves as an extension of the University of Washington's urban campus.* PREVIOUS PAGES, RIGHT *Campus Parkway before (above) and after (below) in section, revealing the expanded space for people and for the trees above and below ground.* LEFT, ABOVE *A broad sidewalk offers social spaces for people to meet as well as to catch a bus, linking the academic community to the city.* LEFT, BELOW *The original sidewalk was undersized for pedestrians and was a poor growing environment for trees.* ABOVE *The upper terrace of Elm Court hosts a restaurant with outdoor terrace seating during the summer months.* RIGHT *The café includes outdoor seating with planters filled with lush Pacific Northwest plants that brighten Seattle's cloudy days.* OVERLEAF *A view across Elm Court to Poplar Hall, with its upper terrace for students. The overall space design allows for visual connections between the various common areas.*

transformed from a mere infrastructural after-thought into an enduring community asset.

The public buses along the parkways receive consistent use by students and locals going downtown and elsewhere in the Puget Sound. Rather than creating one small shelter at the stop nearest campus, GGN designed a more mixed and welcoming space. Benches, lean rails, and the bus shelter are all accessible for bus riders as well as people watchers. The furniture is also placed to protect street tree roots and the planting beds, in anticipation of heavy use. Additionally, they were able to detail improved tree planting beds below grade, drawing on James Urban's research on urban trees. Bike stands were added, and a bike rental program has been established on site. The details, the materials, and the siting are simultane-ously practical additions to urban life as well as echoes of the larger campus.

The garden patio for Alder Hall, tucked in between the District Market and Husky Grind (a full-service café) was also designed with the public in mind. The dining spot functions as an entrance to the residential spaces, and the patio features seats and tables that can be moved to fol-low the sun or seek shelter from the rain. Raised beds of lush green plants, many native to the Pacific Northwest, add to the delight of color and texture, as does the glow of the paver deck. The consistent materials of weathered steel, concrete, and wood inject an appropriately industrial, urban texture into a thoughtful design. This is an environment where students do more than just sleep and eat—they live, learn, and socialize with the larger world around them.

West Campus provides a welcoming threshold into the historic university. It created a series of gathering spaces for the community, inviting interactions for the all those who so choose. As completed, it demonstrates the remarkable potential a university holds for contributing to a vibrant urban neighborhood while retaining the traditional experiences of a residential campus landscape. It reveals how the campus landscape can embed ecological literacy into an established urban grid and become a truly public amenity— an amenity democratically accessed to increase the quality of life for all nearby residents.

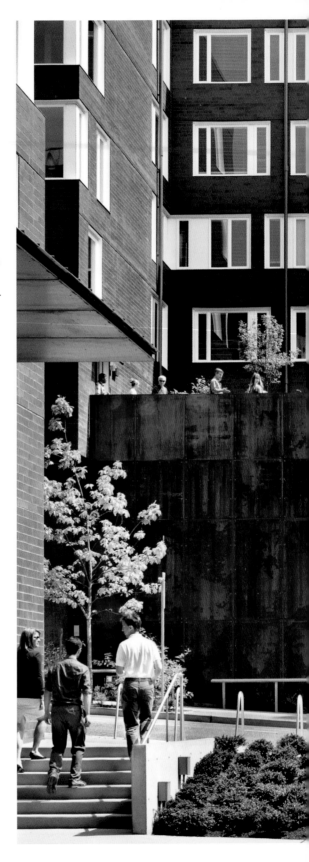

MERCER COURT
& UW FARM
2011–2013

As the University of Washington expanded its housing
options and more fully integrated with the surrounding urban
neighborhood, the landscape that defined it became increas-
ingly central to the success of the community. This 4.5-acre
site was initially slated to become housing for 900 students,
but when the dormitories designed by Ankrom Moisan and
Feilden Clegg Bradley were completed, they became so
popular that they had to carve out space for 1,200. When
GGN first encountered the project, programming had yet to
be established for the public spaces. The team sought solutions
that would enrich the mixed-use neighborhood of residences,
small industry, commercial, and public waterfront. The final
design also offers a unique integration: a student-led urban
farm that winds throughout the residential complex.

Mercer Court and UW Farm offer a unique version of a contemporary urban campus, one that celebrates urban agriculture. Adapted to fit into its city context, the design incorporates a significant slope while delineating a clear campus space on a site edged by a major bridge, a popular bike and pedestrian trail, another student residential unit, and a major thoroughfare—Northeast Pacific Street—that borders Portage Bay to the south. As a campus community, it also needed to be safe and welcoming and to promote shared institutional values such as environmental stewardship.

Historically, the site had been a bluff above the shore marshlands of Portage Bay, an extension of Lake Union and once home to members of the Duwamish Tribe. In 1916 Lake Union was connected to Lake Washington to the west, with Portage Bay at the center. The University Bridge was built in 1919 across the bay and the marshland was increasingly filled to create more solid land. Development of the bluff ensued, with small businesses and workshops popping up, for the most part housed in single-story buildings. Parking lots were scattered through the area and a railway ran along the north. More recently, the railway had been transformed into a bike and pedestrian trail linking the campus to neighborhoods along Lake Union and the UW campus.

The Mercer Court project was already under design when GGN was brought onto the team, which meant they needed to create a design within the established footprint. The dormitories span five buildings sited across the landscape— a series of five slim, elongated, light-filled forms. This configuration allows southern sunlight to fill the terraced slopes while framing distant views of the water and city skyline.

However, this also created pockets of negative space for the landscape. As Jennifer Guthrie, the lead designer, explored the plan, she was taken with how the architects had conceived of the new buildings as outstretched fingers on a hand reaching to the waterfront. This metaphor inspired her to create a design that was both inward looking, to create a heart in the site's "palm" that could draw community together while retaining open views to the water and city beyond. This idea did indeed shape the primary framing concept for the final design as a whole.

The GGN team expanded on the idea of the outstretched hand to assure that the landscape spaces would take full advantage of the site's assets, including views of the waterfront, the orientation of the sun, and easy access to the popular Burke-Gilman Trail. They explored historic photographs of the site and the views that revealed how much the site had been in the middle of activities, while often appearing as leftover space between roads, water, and development. The hand metaphor would bring a centrality and coherence to the space. Each of the landscapes between the fingers would not be distinct

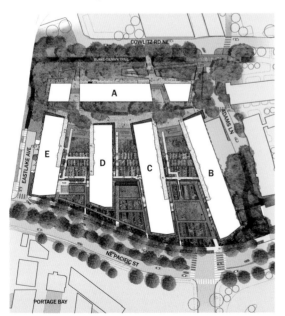

LEFT *The landscape for Mercer Court and the UW Farm connects and fills in the space between the "fingers" of the residential buildings, making productive use of the steep site.* RIGHT *A view from the top terrace to the UW Farm, which fills the lowest terrace along the street edge.* OVERLEAF *A view from the Burke-Gilman Trail through the uppermost residence building and into the heart of the campus community.* PAGE 148, TOP *A sketch by Jennifer explores the framed views created by the architecture and the role of the horizon band.* PAGE 149, TOP RIGHT *A UW Farm bed in the early spring in a part of the garden maintained by UW students.* PAGE 149, BOTTOM RIGHT *Students can play badminton on a lawn next to the farm beds on the lowest terrace.*

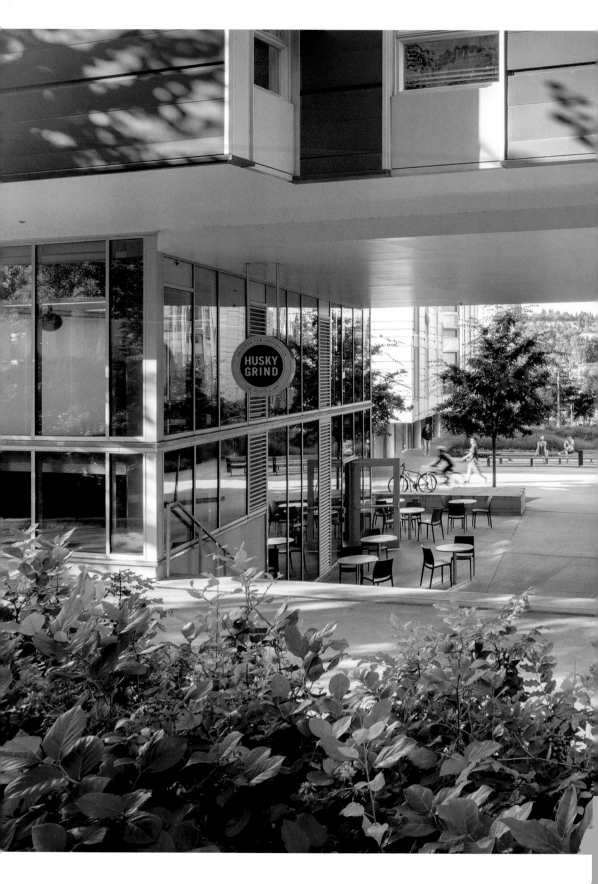

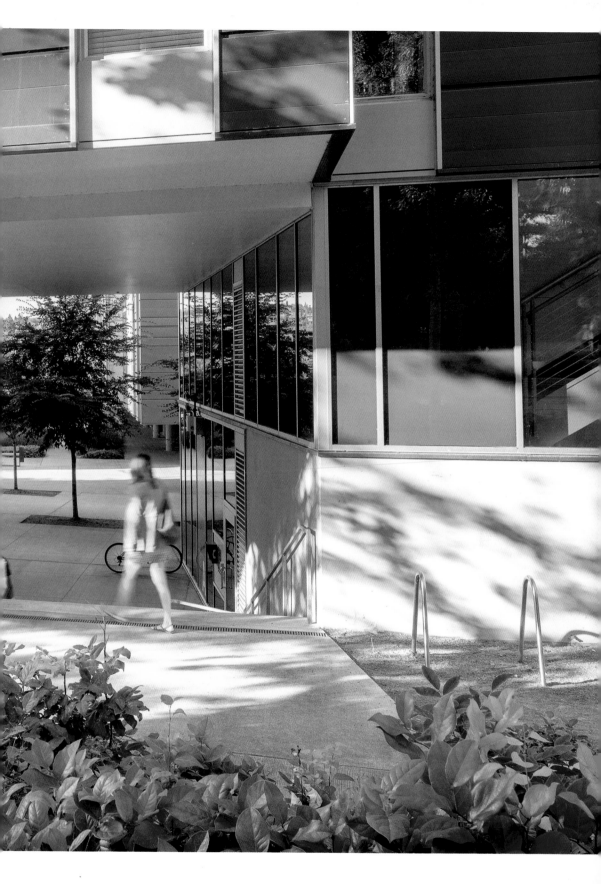

features, they would come together to form one community.

The moment when UW Farm became an integral contributor to and user of the landscape was pivotal for cementing this intent. The landscape design transformed the sloped site into a core advantage while suggesting a breadth and richness of expanse by also encompassing views beyond the campus's own physical borders.

The design is comprised of three horizontal bands: the Burke-Gilman zone, the Heart and Horizon, and the UW Farm. Each is defined in large part by its planting scheme. Each zone runs perpendicular to the buildings' loosely north-south orientation, weaving the "fingers" together into a cohesive landscape. The Burke-Gilman Trail, which runs along the topmost ridge, features lush shade and woodland plantings. Jennifer built on the informality of the woodland landscape—it serves as an edge to the historic campus as well a visual reminder of the railway's path before it was transformed into a trail. The woodland habitat encloses the trail in shade while harnessing its leaf canopy to provide some privacy for the adjacent residential entries. Punctuated within the enclosure are views of the water framed by openings in the buildings, a feature all parties agreed was important to retain. The Heart and Horizon Plaza band, at mid level, features a broad plaza with a robust character comprised of concrete paving, seating

steps, and low seating walls, all accomplished on a very tight budget that necessitated off-the-shelf materials. There are bike racks, wood benches, and movable furniture.

As a broad space, it risked feeling too large and therefore coldly institutional. The design team responded by building planter beds enclosed by seating walls, adding elm trees (*Ulmus* 'Morton') to the plaza. These elements together shaped a variety of intimate spaces with different sun orientations and scales to invite a variety of gatherings. Along the lower edge, Jennifer planted a horizontal band of pollinator plants, including lavender and caryopteris, and wove these with ornamental grasses between all the buildings. This band of purple ties the courtyards and walkways together as one broad sweep. Additionally, the band frames the bottom of the expansive waterfront view. Warm wood benches serve as gathering nooks, facing the view in a manner that reminds the pedestrian this is a residential campus. From this ledge, a series of stairways navigate the forty-foot drop through the agricultural terraces.

At the south side of the site, connecting four of the five fingers, the UW Farm comprises the urban agriculture band. Run by student volunteers, the raised beds, terraces, and vine walls support a variety of food-producing plants, including fruit trees, fruiting vines and shrubs, vegetables, and herbs. Together these banded landscapes

merge the fingers into a whole palm, taking full advantage of the slope and celebrating the water views. At the same time, the bands create diverse spaces for students and community to gather, contemplate, and even farm.

The UW Farm is the most invigorating element of Mercer Court. This is remarkable, considering it was not even part of the initial plan. However, Jennifer had heard that the student-run Farm project was looking for a new site. It took some persuading of the leaders to bring the Farm into the project, as the site is a distinctly urban

setting and there was no large, contiguous field for planting as those involved with the Farm had hoped they would locate. Nevertheless, UW Housing and Food Services was enthusiastic, and soon so was the Farm group. The architects supported it as well by including materials such as dark clinker brick on the facade surrounding the farm beds, which absorb heat to promote plant growth. By the end of the design process, UW Farm leaders had committed to the installation of garden beds comprising almost half an acre. The new UW Farm Clubhouse at Mercer Court, a

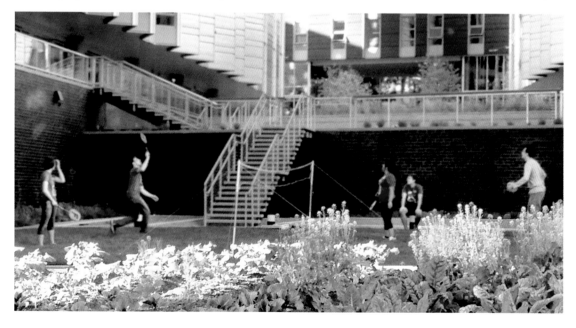

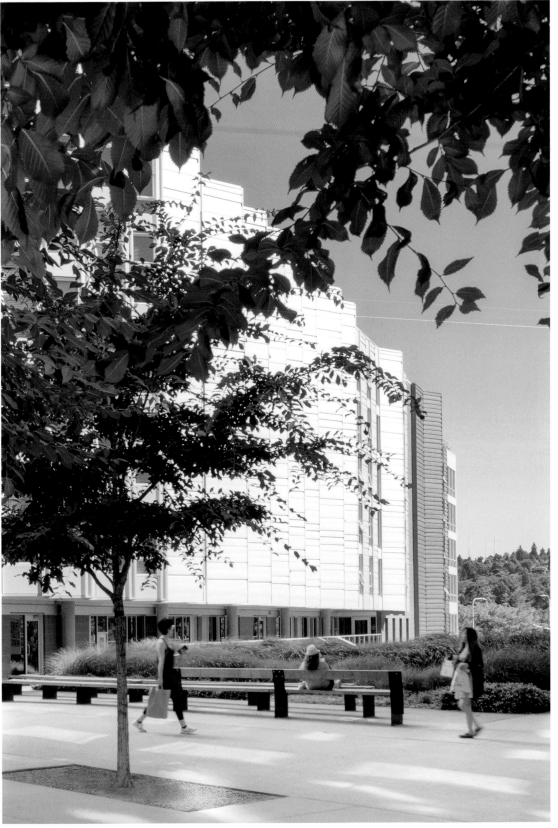

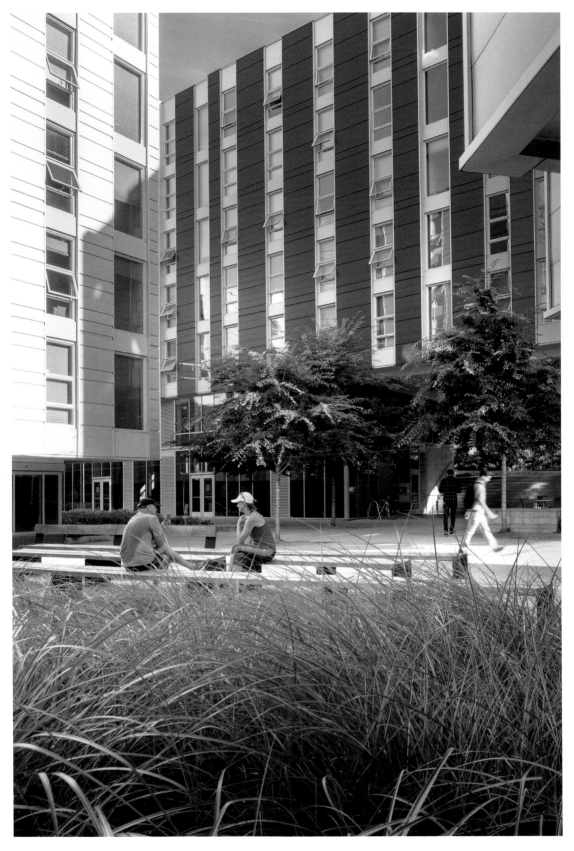

central meeting location, is a place to store farm equipment, and a community space for planned activities.

The garden and farm beds are built on terraces descending the slope, making them visually and physically accessible to students living in the residential units. All the changes of a farm landscape over the seasons, from bare winter to lush summer, become part of daily life for everyone in the community. While the project team provided a soil and water source, farm leaders installed irrigation systems for both hand and drip watering and established the planting plan for the garden beds. The project team provided herbs and pollinator plants as well as fruit trees that line the building's facades.

Interspersed in the farm landscape are recreational spaces that bring students up close to the gardens. Small lawns offer a place to play a game of badminton or read in the sun, bringing quintessential options for socializing and study deep into the campus. At the bottom of the site, a sidewalk along Pacific Avenue connects the development to the main campus to the east, and

to northern Lake Union to the west. It is also an invitation to the public to engage with the farm landscape and maybe wander up into the residential community—part of the excitement of a truly urban university campus.

To support the farm, a salary for the director of the garden is funded through the School of Environmental and Forest Sciences, with additional support from Housing and Food Services and the School of Public Health. Today, food grown on three sites, including Mercer Court, is integrated into the campus dining hall programs.

PREVIOUS PAGES, LEFT *The heart of Mercer Court offers space for studying and meeting friends as well as circulation to get from one end to the other. Seating offers views of the water and hills beyond, connecting students to the city of Seattle.* PREVIOUS PAGES, RIGHT *The landscape's trees, grasses, and benches create a human scale in Mercer Court's central space.* LEFT, ABOVE *Lavender is harvested for various uses, creates a "Husky purple" horizon, and also provides a wonderful scent and texture in the spring and summers.* LEFT, BELOW *Sunflowers growing in a UW Farm bed; the flower delights the eye with its bright color and can be harvested for its seeds as well as provide food for birds.* ABOVE *Colorful lettuce grown by the students is then used in the student dining hall.* RIGHT *Cabbage is another colorful crop cultivated by the student farmers.*

CITYCENTERDC
MASTER PLAN AND PLAZA
2005–2013

CityCenterDC, a ten-acre LEED-ND Gold site in the heart of Washington, DC, was a pilot project for the LEED Neighborhood Development program, the first national program for neighborhood design recognizing smart growth, urbanism, and green building. As one of the largest downtown projects in the country at the time, it came with a complicated history: the site had held a behemoth of a convention center that had blocked several streets and intersections dictated by the city's original L'Enfant plan. GGN, in partnership with Foster + Partners (led by Armstrong Yakubu) and Shalom Baranes Associates, concluded the new master plan in 2000 under the direction of Hines (led by Bill Alsup, Howard Riker, and Mike Greene). Phase one of the design was completed in 2013 and phase two is ongoing. The development provides commercial and office spaces, a retail core, high-end residential units; phase two will include a hotel. The landscape features a diverse network of new public spaces, including pedestrian alleys, neighborhood streets, plazas, and a neighborhood park.

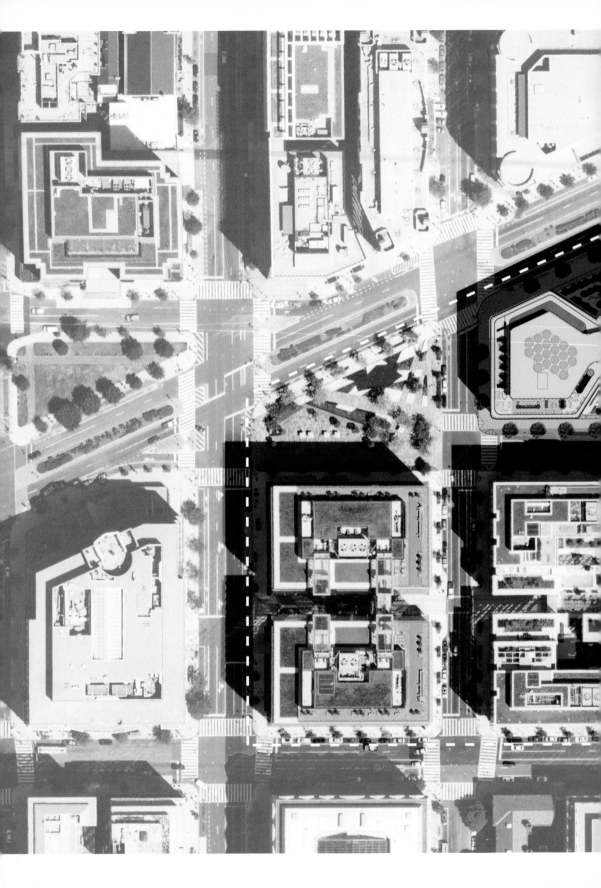

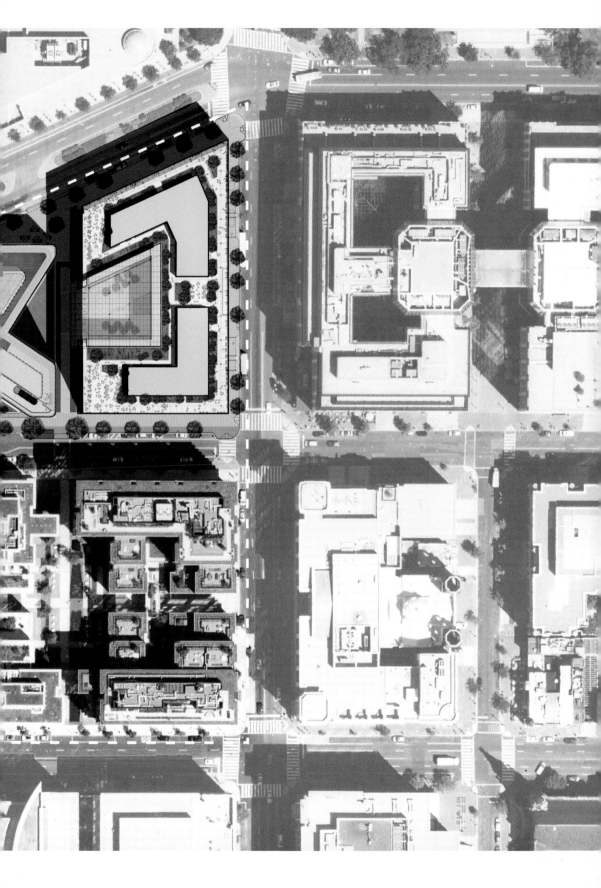

On a ten-acre site of the former Washington Convention Center, CityCenterDC lies in the East End of downtown Washington, bordering New York Avenue that runs north to Mount Vernon Square, and runs south to the White House. While the initial proposal for the master plan won the design competition, a more finished proposal was later generated featuring an expanded team, including GGN as landscape architects.

Armstrong Yakubu of Foster + Partners and the GGN team established a good rapport that would continue to grow in the years they worked together on CityCenterDC. The multifaceted project would encompass a pedestrian-oriented, mixed-use scheme of offices, condominiums, restaurants, shops, and an underground garage. GGN partnered closely with the architects and engineers to take full advantage of what initially seemed to be a blank slate in the middle of a major American city—the demolished convention center that had been reduced to a surface parking lot. The design would need to address the scale of the mixed-use development as well as complex structural challenges. At the same time, it would need to allow the landscape to bind the project together into one vibrant neighborhood.

To honor pedestrian traffic and connect the site to its urban context, the first proposal by the team was to reintroduce the original street grid, and to create a secondary pedestrian scale with the former alleys as promenades through the complex. The idea was inspired by both European city street patterns and by the original eighteenth-century alleyways that once served as a network of access routes through the larger block. By reinscribing them, the alleys would bridge the historic and residential neighborhoods to the north and the commercial office buildings to the south. Palmer Alley, noted on the Sanborn map of 1888, was restored and extended to both ends of the block and I Street NW was reopened along the north side of the development. These moves set the project on track to revitalize the neighborhood by offering pedestrian routes, expanding the street front possibilities, and providing a more granular scale to the dense neighborhood.

Even with the reintroduction of alleys, there was concern that building in a solid mass to the edges of the site would create an inhospitable scale. The architecture team experimented with the forms of the buildings, finally devising a system of terraced setbacks for the ten-story buildings, enclosing a gathering space and plaza at ground level. This imbues the site with a heart where paths and programs cross and converge.

Furthermore, the project required parking and an acre of public open space. Taking advantage of the grade change from I Street up to H Street, as well as the construction that would need to be completed to open I Street again, I and Tenth Streets were regraded to accommodate an underground parking garage, with a nine-foot

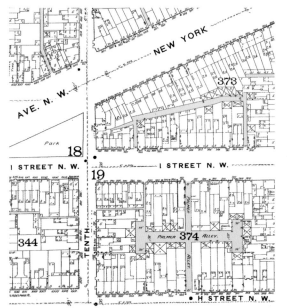

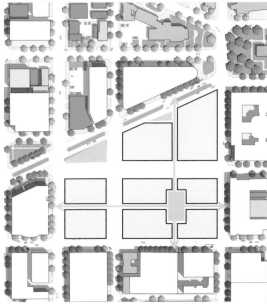

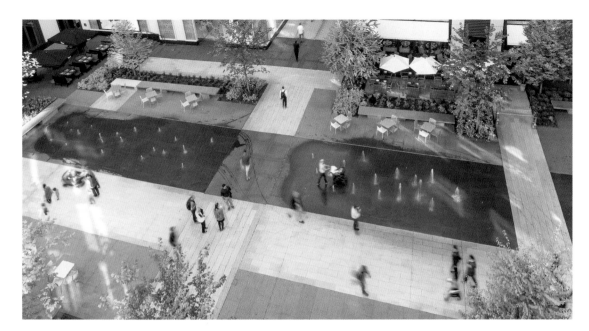

drop from the northwest corner of Tenth and I to the southeast corner of H and Ninth. They then carefully sited a minimal number of garage entries to avoid breaking up pedestrian access and the row of storefronts. Finally, GGN and the local landscape team established tree-lined avenues, complete with strings of globe street lights that tie it to the city while echoing the historic context.

With the master plan established, Foster + Partners and GGN turned their attention to the development of a site plan that would engage each of the elements in a coherent scheme. A primary challenge was how to shape the central gathering space that would serve as a heart for the development. The team explored possibilities, including walkways, water scrims, terraces, and walls— each of which would shape a variety of spaces within the complex.

The designers eventually developed a composition that interlaced the layers of alleys, crossings, and thresholds together, centered around a generous courtyard. The alley nicknamed "9 ½ Street" and the shopping hub Palmer Alley cross in the middle where the plaza opens up. In its intimacy

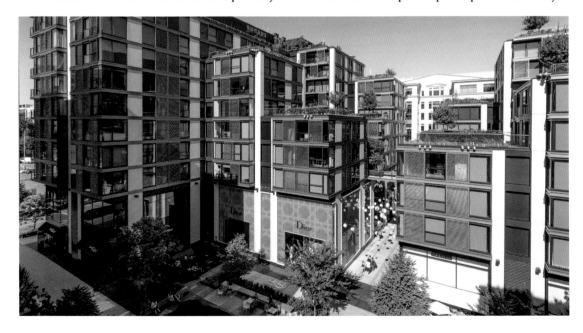

and simplicity, it is reminiscent of a European city square such as those in Barcelona and Paris. The plaza creates a heart for the neighborhood and a resting place for shoppers and tourists.

As a design concept for the plaza, GGN found inspiration in Gee's Bend quilts, which are created by women who live or have lived in the African American community of the same name in Alabama. Their designs are modern and traditional at once, qualities GGN desired here. The overlapping and intersecting patterns of the quilt pieces create depth, texture, and scale in a manner that could be translated to constructed ground. Rectangles overlap, generating a dynamism and human scale abstracted in the paving patterns as well as in the ways the terraces, walkways, and water scrim intersect. The stone pavers are set in patterns of color, from the soft gray of the main walkway to the warm gray of the terraces, and the deep gray of the scrim.

The plaza was the first piece of a distributed open space network that would meet the city's requirement for one acre of public space. The alleys formed the second piece, with the Park at CityCenterDC serving as the culminating contribution to the public realm.

Within the central plaza, the team sought to blur the usually sharply demarcated lines between public and private landscapes in order to create a community living room. It is a generous realm for passing through, or for stopping to people-watch

from benches and perches or a market space. Shops, including restaurants and cafés, line the edges, with terraces for tables and chairs spilling into the square. Window-shopping is easy from the central walkway or adjoining terraces.

Plants were used to establish both the lushness of the garden in the city as well as to provide a human scale that would contrast with the buildings and urban context. Yellowwood, elm, American hornbeam, and katsura trees were planted and garden beds of clipped hedges of buxus, sarcococca, and ilex define the various terraces. Evergreen azaleas create a low flowering hedge, adding seasonal interest and delight. The smaller trees and low heights of the garden plants as well as the intimate proportions of the terraces define a scale appropriate to the human body, in

PREVIOUS PAGES, LOWER LEFT *The masterplan (right), inspired by the scale and grain of the historic street grid (left), reintroduced an alley system to create a more intimate pedestrian scale.* PREVIOUS PAGES, UPPER RIGHT *The pattern of the central plaza's paving appears bolder when wet.* PREVIOUS PAGES, LOWER RIGHT *A view of the surrounding residences and plaza.* BELOW *The interlocking design of the paving (right) was inspired by a Gee's Bend quilt (left), designed and sewn by women who live or have lived in the African American community of the same name in Alabama. Sketch by Kathryn.* RIGHT *The alley as it crosses 9 ½ Street.* OVERLEAF AND 164–65 *View and site plan for the central plaza, showing its connections to the streets to the south and north. Sketch by Kathryn.*

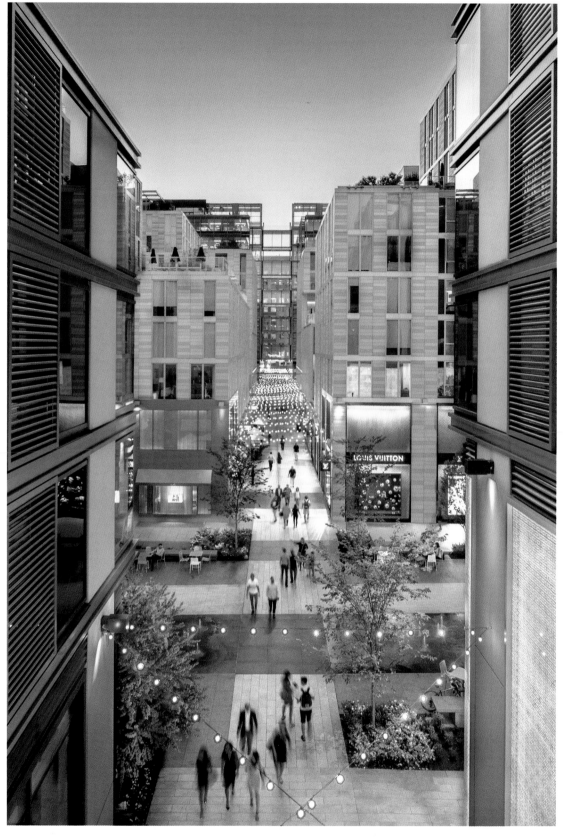

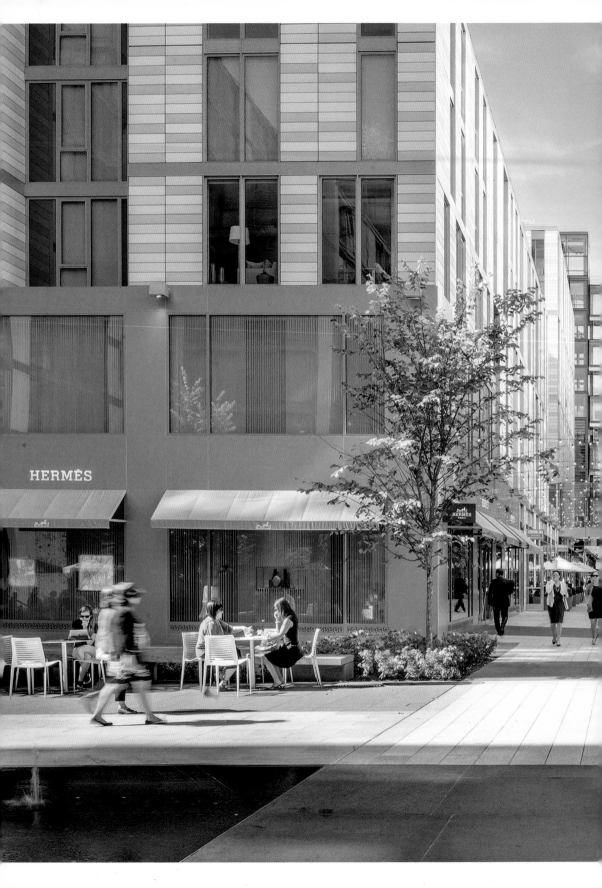

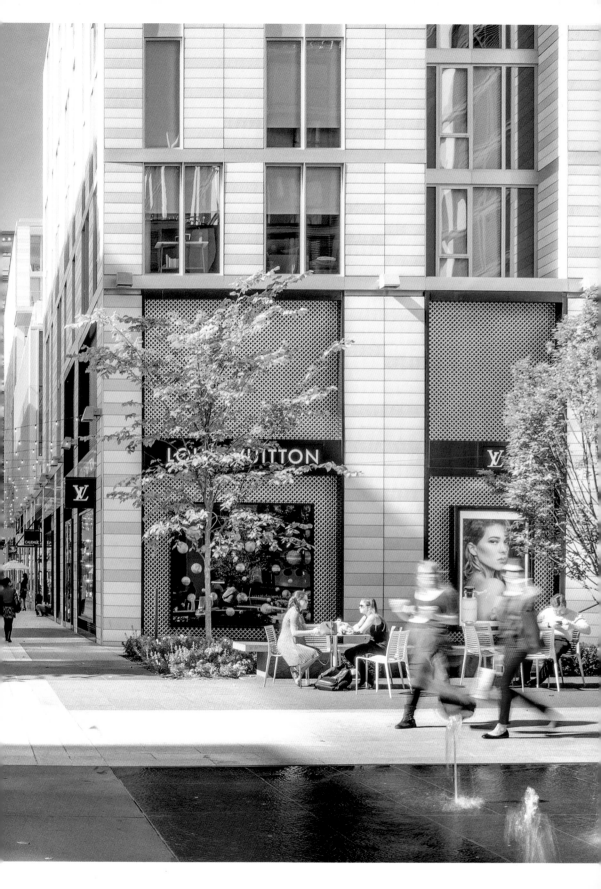

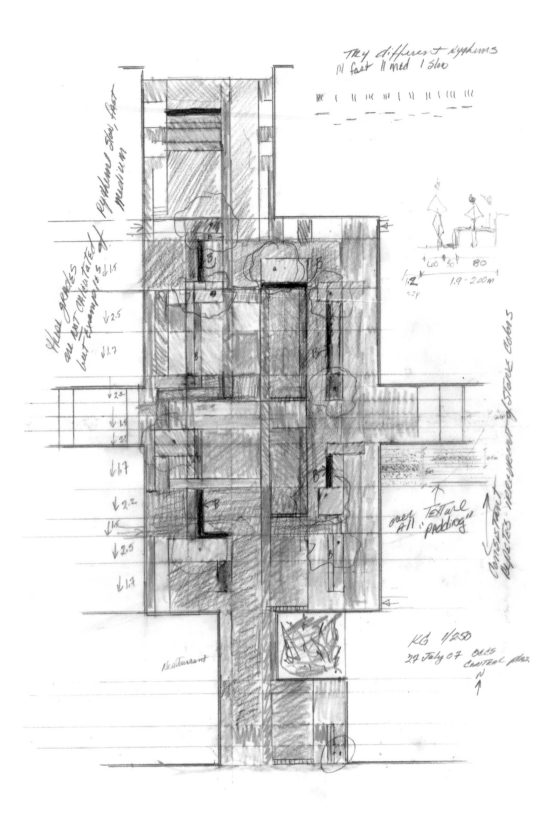

TRY different rhythms
/// fast // med / slow

Rhythmic slow, fast
medium

Real grades
are not articulated
but Exaggerated ↓ 2.5
↓ 2.5
↓ 1.7

↓ 2.5
↓ 1.5
↓ 2.5
↓ 1.7

↓ 2.2
↓ 1.5
↓ 2.5
↓ 1.7

Restaurant

over TEXTURE
"padding"

Consistant
recurrence of stone colors

over 155

"1.2" =24

60 30 80
1.9 - 2.00m

KG 1/250
27 July 07 Oslo
CENTRAL plaza

N ↑

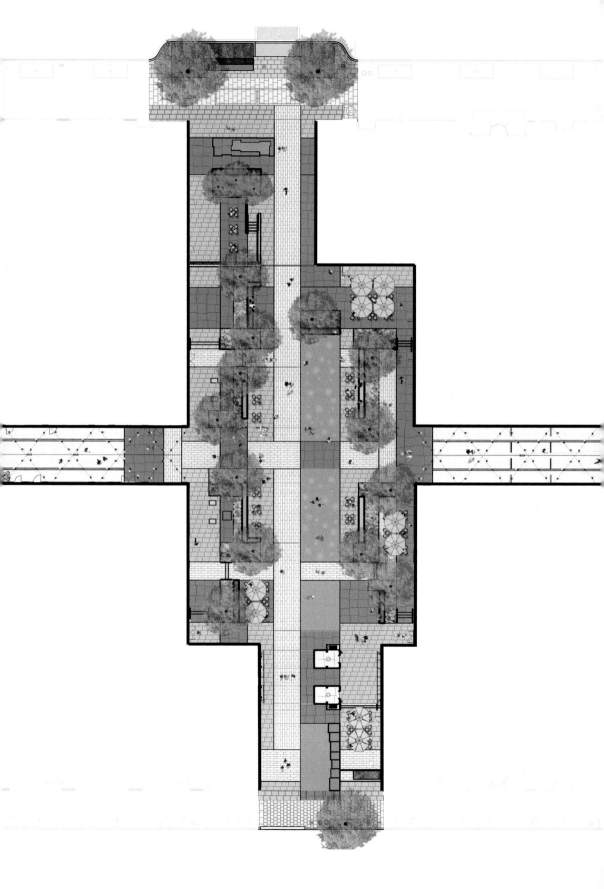

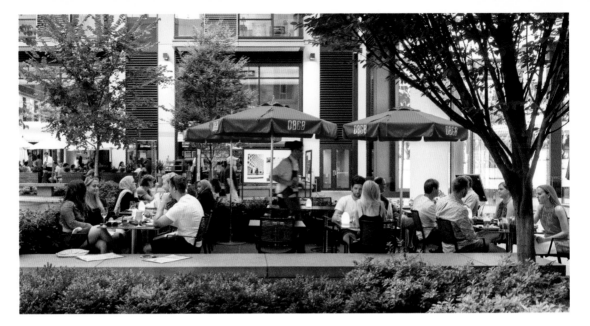

a manner suggesting the scale of an intimate garden. Additionally, they suggest an informality in what could easily have become an overly commercial space. The area is equally welcoming to those who might lunch at a restaurant terrace or bring a bag lunch and sit on the plaza.

To strengthen the human scale of the space and connect the street entrances, Kathryn suggested using a water scrim that would stretch along the main promenade. The water scrim as a surface delineates the space, breaking down the expanse of paving that might have overwhelmed. And the water enlivens the space with sound and texture. Careful attention to detail makes the running water seem to almost pause as it moves languidly across a very gentle slope. Jets of water appear to randomly spring from the surface, recalling the dynamic forces of hydrology originally at play in this historic city of marshlands and swamps. The water scrim can be turned off for events or cold weather. The dark stone paving that is used for the fountain surface is also used for benches and low walls. Promenades are comprised of lighter, brighter paving in a quicker pattern. These

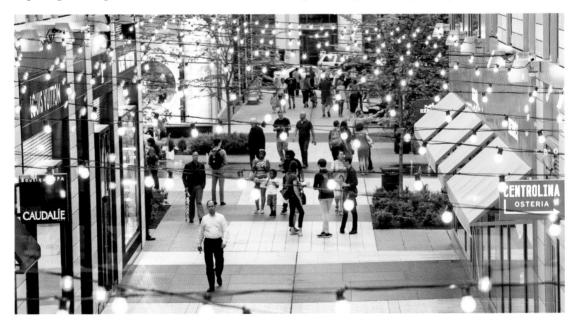

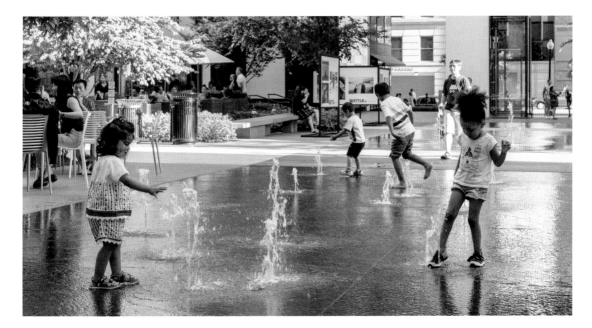

contrasts are immediately evident both from the ground and from the adjoining buildings, again giving the space a playful character.

With the central plaza clearly defined, the challenge was how to transition from the outer streets to the alleyway and central court. The main entrance alley opens for a mid-block entry on both H and I Streets. In thinking about how visitors or residents would move from the immense scale of the street into the alley without an abrupt and jarring break, the team decided to section the primary H Street threshold into two parts, allowing the scale of each to be a transition zone and meeting point. The H Street gateway is centered on a glass "jewel box" containing two elevators surrounded by a dramatic, large-scale video installation designed by artist David Niles, a digital video pioneer. At the street edge, the water scrim emerges, drawing the visitor inward. The water reappears on the other side of the glass elevator, stretching toward the edge of the central plaza.

On I Street the scale is ameliorated by a rectangular pool of water offering a meeting point as

well as a transition from the garden terraces to the public sidewalk. Three white-flowering redbuds suggest the garden character of the plaza ahead. On the sidewalk edge, GGN ensured that attention was given by designating generous planting beds that also abate storm water runoff for the street trees along I Street, emphasizing the role of the garden in bringing humanity into the city.

GGN created the infrastructure for changing events, seasonal activities, and performances. The team also proposed the lighting infrastructure to activate the air and sky. The lights contribute to the flexibility of the design by illuminating the interior alley in the evenings and darker winter months.

CityCenterDC is a neighborhood serving a residential community while expanding the public realm. It is scaled to mediate between the larger buildings and avenues to the north and the historic character to the south. The plaza landscape and master plan connect these, allowing spaces for pausing or perching as well as for moving and passing through.

PAGE 166, UPPER LEFT *Café and restaurant seating in the plaza provides a buzz among the trees and shrubs.* PAGE 166, LOWER LEFT *The alley serves as a shopping street and also as an elegant promenade.* PAGE 167, UPPER RIGHT *Children delight in the fountain on a hot summer day while caregivers visit with friends on benches and at cafés.* PAGE 167, LOWER RIGHT *Contrasting colors and scales in the stone paving provide scale and texture for the space.* PREVIOUS PAGES *The subtle pattern of the pavers is particularly evident from above.* RIGHT *The ornamentation of the alley is determined by the owners, and is changed seasonally for variety.*

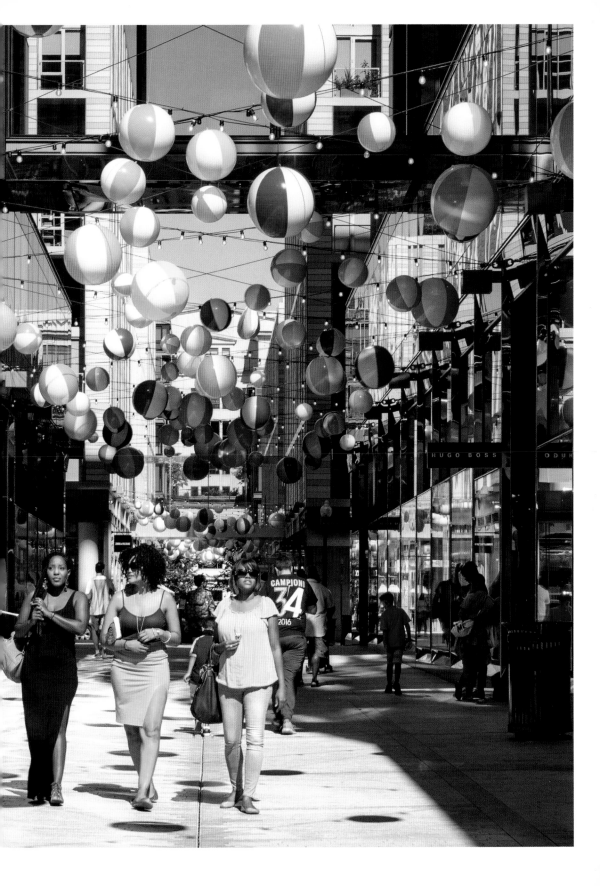

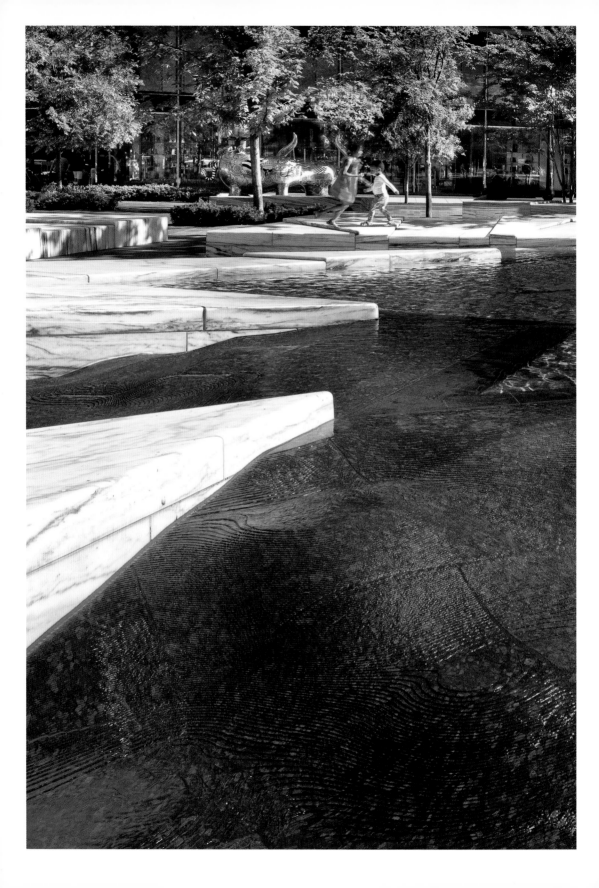

THE PARK
AT CITYCENTER
2006–2013

The Park at CityCenter, opened in 2013 and occupying
approximately 29,000 square feet, sits at the major intersec-
tion of New York Avenue and Tenth, Eleventh, and I Streets
NW. It is a prominent part of the public spaces designed for the
new development by Foster + Partners and GGN. The neigh-
borhood park extends the CityCenterDC development out
into the surrounding urban fabric, marking a midpoint between
Mount Vernon Square and the White House along New York
Avenue. The park's triangular shape, as with its counterpart
on the opposite side of the Avenue, is created by the diagonal
avenues laid on top of an otherwise regular urban grid.

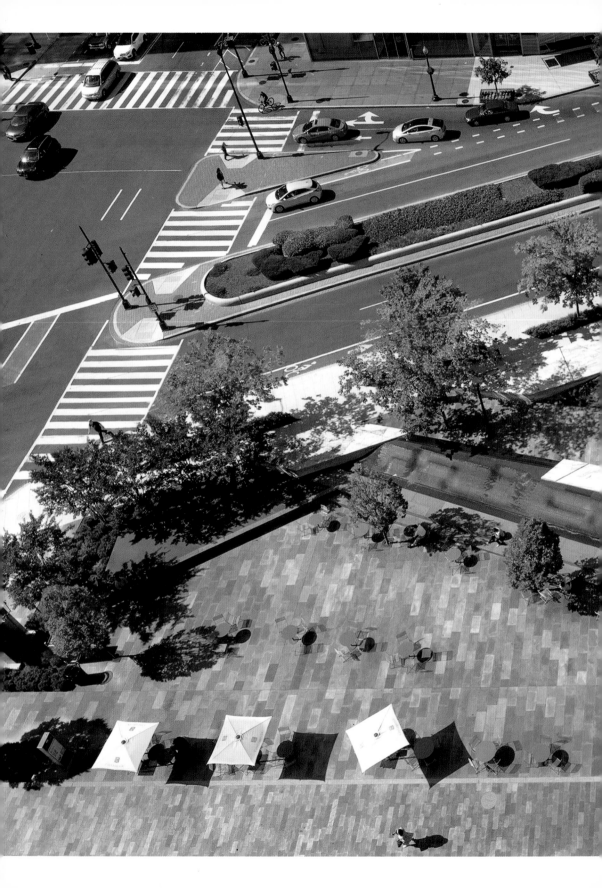

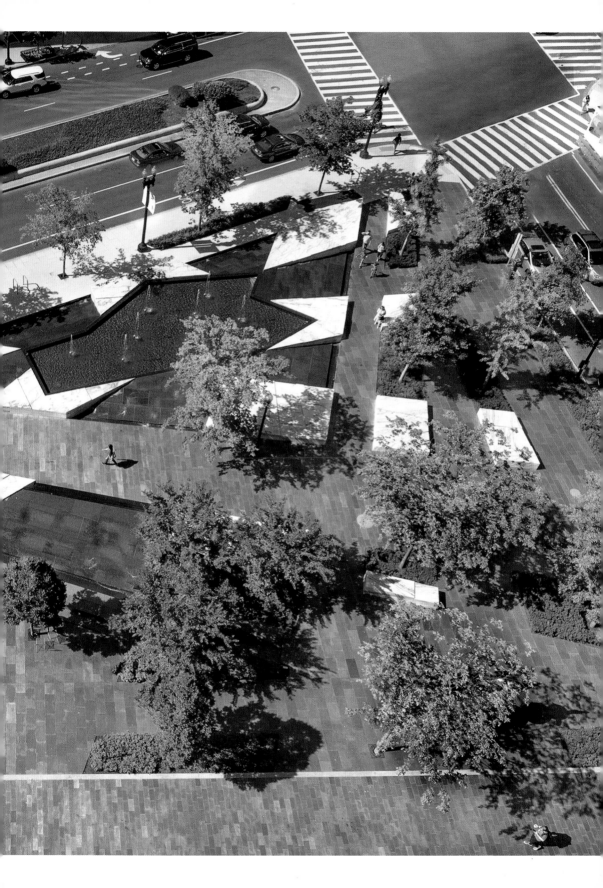

This park is positioned along the south side of L'Enfant's original New York Avenue, planned as a boulevard extending from the boundary of the new federal city to the shore of the Potomac River, with the White House at a central joint. As planned, this would have provided direct views from the White House to the river, as well as to the far reaches of the new city. While much of the avenue was indeed built, over time most of the blocks southwest of the White House were repurposed for the National Mall and other building additions. The northeast section of the avenue remains, however, as a contiguous stretch of the grand avenue.

The site—one of two small leftover spaces, or triangle bowtie parks, created by the diagonal avenue running through a square-based city grid—inspired the park's language and form. The CityCenterDC Master Plan reestablished the urban grid to meet New York Avenue, reinscribing the intersection with I and Tenth Streets. Today the extension of I Street to once again cross Tenth and meet New York Avenue remains a primarily pedestrian zone, but is marked as a part of the city plan of gridded streets. With I Street renewed, the challenge was how to tackle the bowties—spaces big enough to serve the public realm in a productive way but impractical for building. The program called for the site to accommodate events of up to 2,000 people while also serving as a neighborhood park most days. The broader

goal, however, was for it to define a space that embraced the vibrancy of the pedestrian-oriented retail environment while also acknowledging the monumental nature of New York Avenue as a main approach to the White House. The challenge was to find a balance between open and full, intimate and grand, casual and formal.

The site's triangular shape was the first hurdle to be transformed into a generative concept. Initially working across both sides of New York Avenue—as there were two identical sites—GGN sought to accentuate the scheme's overlaid diagonal character. They were searching for a design that could be echoed in both without being overly formal or restricted. They also wanted a design that would be distinctive to the new park as part of the new CityCenterDC neighborhood.

GGN worked through multiple iterations of drawings to establish the strongest possible entry into the park from the avenue, as this seemed the most potent meeting point. They also needed the space to be able to stand its ground along the busy avenue and beneath the large buildings, and to relate stylistically to the north entry to CCDC's plaza. After exploring a multitude of ideas, from circular pools to oval fountains to an exploding star, GGN decided to incorporate triangles as a primary motif. This idea was most grounded in the existing form of the site as well as its place in the capital. They began at the center of the top corner, what

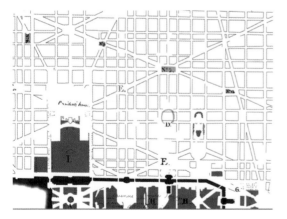

E. *Five grand fountains, intended with a constant spout of water.* N.B. *There are within the limits of the City. above 25 good springs of excellent water. abundantly supplied in the driest season of the year.*

12/08/00

seemed the most natural entry point—and, interestingly, where the L'Enfant plan had called for a fountain. They drew lines radiating outward from that point, as an organizing principle that would carry the energy of the figure out into the larger context of the city. What emerged is based on abstract, sharp fragments expressed as pieces of a star aligned with the central point. This logic was translated into a pair of fountains that emanate outward from a central source, set in the larger of the two fountains. The strong and highly geometric fragments define gathering

spaces and meeting points such as marble seats, platforms, and a loose perimeter grid of trees. The play of lines and alignments transformed what many would assume to be the site's most awkward feature—its triangular shape—into its signature strength.

Continuing to build on the abstracted explosion of lines, the designers explored the site's interior topography, defining a series of intimate spaces within the park that would juxtapose the openness of the site with its immense context on the busy avenue. The fountains enclose the park's

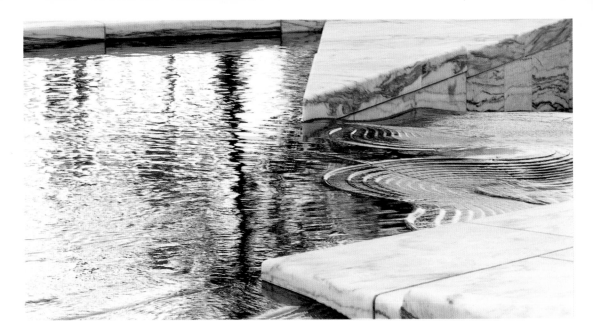

two gathering spaces and define meeting points. Trees delineate the outer edge of the park, while contributing a loose grid and comfortable regularity to its interior.

Given the dramatic setting, the fountains could not be diminutive—they needed to relate to a city already loaded with important monuments. This announcement of their presence begins with the sound of rushing water over black granite and the elegance of the smooth, contrasting, veined white marble. While in traditional fountains water shoots up and flows down, here the water flows outward, toward the pedestrian, toward the city, following the lines of the original "explosion."

To configure the fountain's surface so as to give the water texture and scale, the GGN team employed three-dimensional printing for the models. They began by asking themselves what water "wants" to do naturally. It bubbles, gurgles, streams, and flows down mountains. A surface was created that would act like layers of stacked granite with a soft blanket laid over it. Once the team arrived at the form that would create the experience they were imagining, they built the

LEFT, ABOVE *Water flows and cascades out from the fountain's central basin along the undulating surface to the edge.* LEFT, BELOW *To design the fountain's rolling surface, the team began with 3-D computer models and studies, then fabricated it with CNC milling.* RIGHT *The surface of the marble fountain had to be meticulously planned to cause the water to move as desired. Study by Tess.* BELOW *Stainless-steel globes act as water jets in the center of the fountain; they capture sunlight by day and, at night, reflect the lights of passing cars.* OVERLEAF *The fountain's textured surface helps the water to shimmer and flow toward the visitor before it falls gently over the terminal edge.*

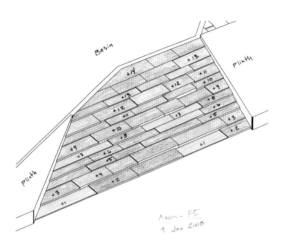

actual fountain, although refinements were made to assure that water flowed outward at all points.

The play of water is reminiscent of ripples of moving water in the Blue Ridge Mountains, where streams run over granite, forming pools and small waves. At the center of the larger fountain is the heart of the water as it moves energetically outward. Jets send the water in expanding circles that then flow down the dark granite surface at angles determined by the subtly mounded and ridged surface. At night, the polished stainless steel globes that push out water reflect the lights

of passing cars, adding a magical element that revels in the urban site. At the edges, water reflects trees and marble in its surface, then quietly seeps over, to disappear in the ground. This dance of water and light is perpetually engaging to visitors.

The materials used to bring the park to life are also essential components of the design concept. GGN worked closely with Hines to identify and procure the right selections, from the Mountain Green marble to the Flammet pavers that shimmer blue-green in sunlight. The marble that shapes the dry edges of the fountain contributes

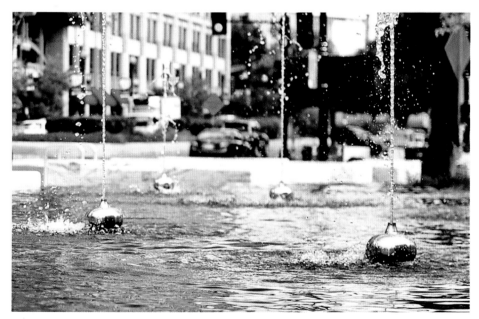

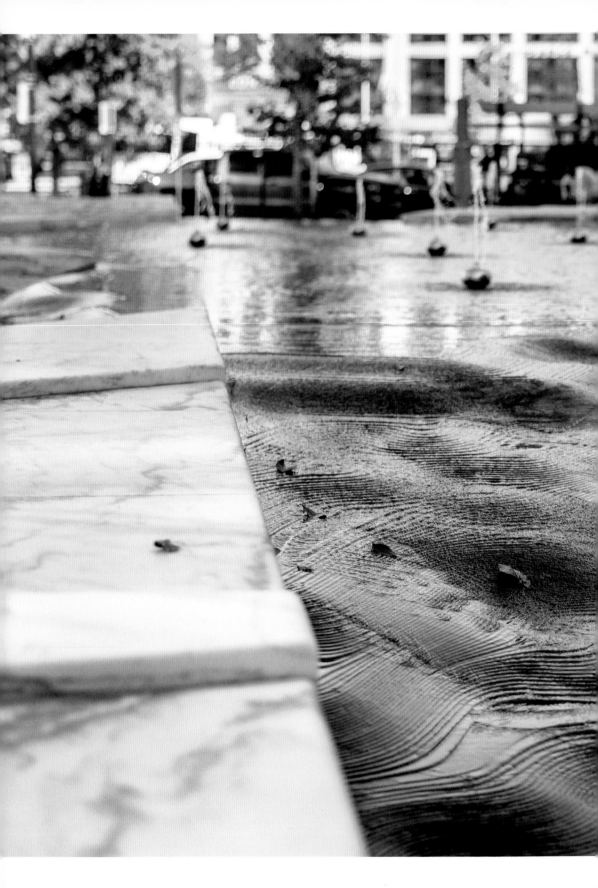

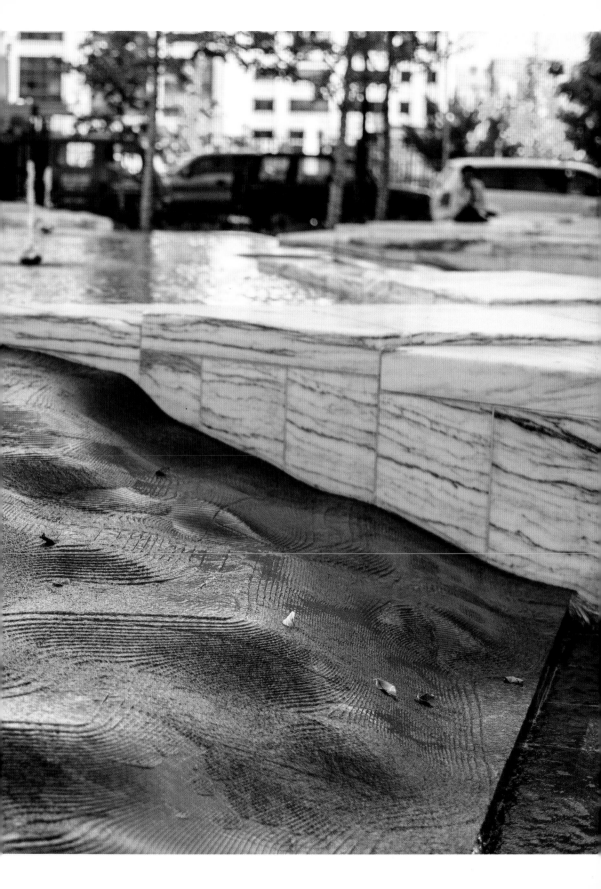

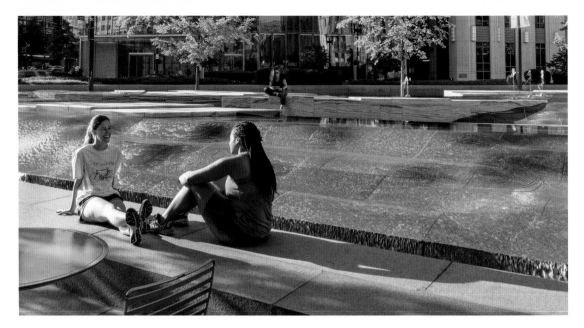

an elegance that echoes the marble used on important buildings and monuments throughout the city. Where it is used for seating, the marble is cut into solid blocks with rounded edges that welcome sitting. Expansive marble platforms to the east suggest larger seating or perhaps a stage.

Ground surface paving is always important to the human experience—and to creating a sense of place and shaped space. The I Street sidewalk is laid with city-standard concrete with stone curbing, while the street and park are paved with Flammet stone. Paving is scaled to suggest the slow-moving flow of people, which is repeated in the slow-moving water at the edges of the fountains. All of this responds to the programmatic desire to create a public realm that would feel both of the city and part of an intimate neighborhood.

The plantings are carefully considered. GGN established a grid of trees straightforwardly aligned with I Street. As the visitor moves deeper into the park, however, the grid turns at an angle and begins to align with the diagonal thrust of the exploding triangle as well as that of New York Avenue. Around each tree is a generous planting

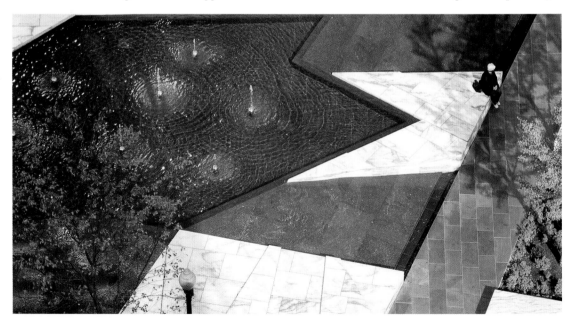

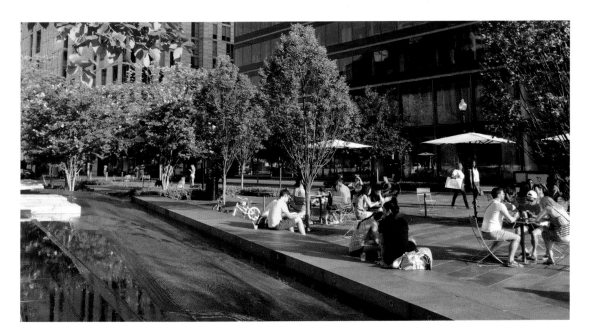

bed that is healthy for the tree and helps temper the heaviness of the stone paving. Movable furniture, placed between and around trees, is painted in a champagne hue that adds a warm glow to dots of sunlight in dappled shade. GGN worked with and reflected the densely urban nature of the park while also creating a space distinct from its context. It is a green space that doesn't revert to lawn but feels satisfying by virtue of the scattered, but intentionally placed, trees. It does not pretend to be a green oasis; rather, it applauds and commemorates the urbanity of Washington, DC.

LEFT, ABOVE The park offers many spots to visit with friends next to the relaxing sound and cooling nature of the water. LEFT, BELOW The marble and paving details endow the fountain with human scale while the monumental size of the overall structure relates to other grand features in the capital city of Washington DC. The white marble also remains cool even on the hottest days, encouraging lingering. ABOVE The fountains shape the park's generous spaces, offering delight in the play of light and movement, while the sound of the burbling water mitigates the noise of the traffic. RIGHT Seasonally, farmers markets and café chairs are popular additions to the park. OVERLEAF The dappled shade provided by trees, along with the sounds of flowing water, create a powerful respite from Washington's humid climate.

The composition of the park appears to emerge almost spontaneously from its site. The form and scale of the setting inform every other detail introduced by GGN. They took what the city offered—marble as a material, diagonal thrusts of street plans, and crisply geometric parks and public gathering spaces—and translated it into a fresh language for its current population. From the offices above, the park at CityCenterDC appears as an artful study in abstract composition, a dynamic swath of marble exploding away from the rush of avenue traffic. On the ground,

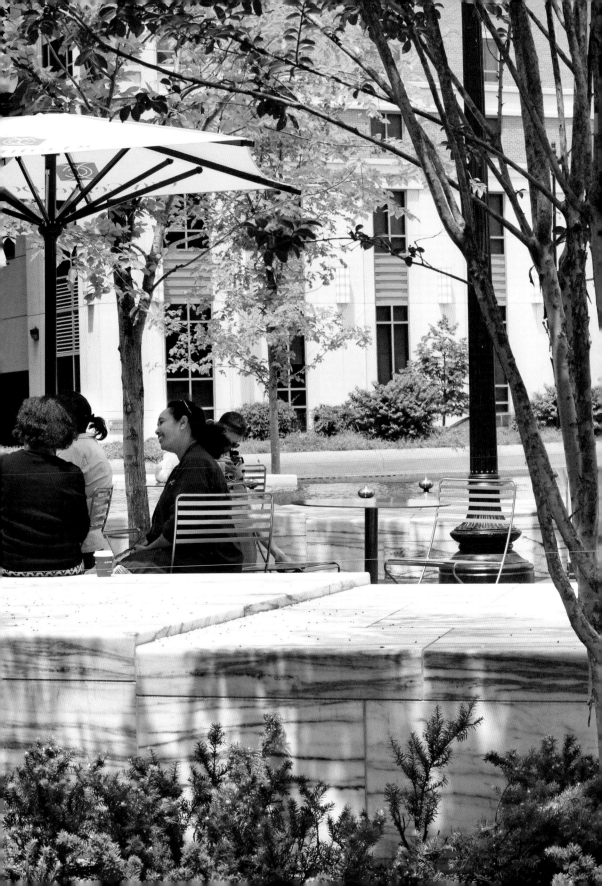

the park is a welcoming and vibrant space that can be enjoyed by an individual in a moment of pause or by a community practicing yoga.

The design for the park by GGN reveals an inherent respect for engaging in a thorough design process and a regard for the scale of pedestrians braving a large metropolis by foot. This process relies on the elements already provided by the existing site while bravely imagining alternative futures. It is a process that emerges from a partnership with architects, engineers, and the developers, after many conversations about large goals and many iterations to perfect details. GGN continues to work on the larger CityCenterDC development, as additions continue to be made. A hotel will include small gardens that echo the other public spaces, the plaza, and the park. An extension of the alley will bring pedestrians into the new landscape, and a new building on the northwest corner will complete the master plan.

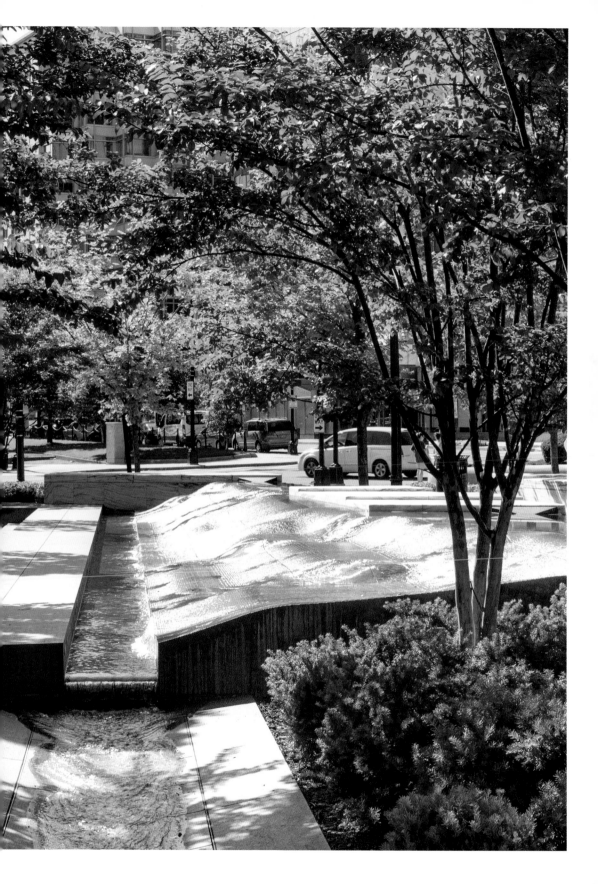

PIKE-PINE
RENAISSANCE
STREETSCAPE DESIGN
VISION
2012–2013

In 2012, the Downtown Seattle Association commissioned GGN to create a detailed master plan for how to best take advantage of opportunities for streetscape improvements that might reinvigorate the city's downtown core. The firm's proposal—completed in 2013 in partnership with Framework for urban design consulting and Toole Design Group for multi-modal design—is at its essence a narrative about downtown designed to guide the city as it identifies future opportunities in the public realm. Grounding their proposal was a privileging of the pedestrian experience, whether by improving inter-sections and crosswalks or through sidewalk standards that would strengthen the distinction between north-south avenues and east-west streets. The plan also expresses the best aspects of Seattle through design, echoing the belief that the firm's home city can be a place that hatches ideas other cities later enact or emulate.

Seattle is a relatively young city, and one that has been defined in many ways by its Pacific Northwest location. It sits in a regional landscape of mountains, forests, and water. Spectacular views, access to abundant natural resources, and a generally progressive spirit have contributed to the city's growth over the past century and a half. On the other hand, the city is faced with challenges, including steep slopes and bluffs, a lack of flat and/or solid lands along the waterfront, and a history of endless discussions rather than authoritative decision making.

The assets have generally been taken for granted, with only a few efforts to really celebrate them, including a plan for parks and parkways by the Olmsted Brothers in the first decade of the twentieth century. In the 1980s, a series of viewpoint parks were created to ensure public access to the remarkable natural vistas. As for the challenges, Seattle has applied notable ingenuity. In the first half of the twentieth century, this included cutting down whole hills and bluffs that impeded vehicular circulation. In the latter half of the century it included new types of parks, including Gas Works Park, the first postindustrial landscape to use bioremediation to reinvent itself as a public park, and Freeway Park, the first park built on a highway lid.

In 2012, the Downtown Seattle Association was looking to develop a master plan to build on the city's innate strengths while also applying innovative thinking about ways to make the whole district more coherent and more stimulating for residents and visitors. They used a $150,000 grant from Seattle's Office of Economic Development to commission GGN to make recommendations about how to increase the pedestrian-oriented character of sixty-five acres of downtown Seattle.

Shannon Nichol and Keith McPeters led the GGN team. The response they curated was both mindful and creative. It began with GGN team members engaging in an extensive inventory of the whole downtown area, from its materials to its views, as well as its opportunities and challenges. From there the team developed a narrative of the city's assets and demonstrated how these could be enriched through a series of innovative but subtle responses. Rather than demanding that the city create entirely new streetscapes and introduce novel objects, their master plan reimagined what was already there, turning attention to the details and how those might be rethreaded together. Such thinking tapped into a central tenet of both GGN and contemporary urbanism: to repurpose or upcycle. The challenge in many urban-renewal or urban-refresher projects is to turn a perceived problem into an asset—or as Shannon noted to a reporter, "pump it up and run with it."

The team, with David Malda in the lead of analysis, took a deep dive into the history of Seattle's streets, avenues, and sidewalks from

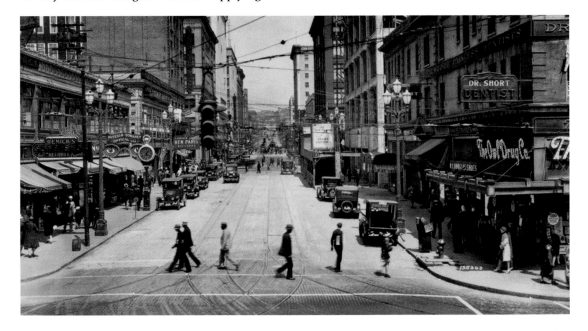

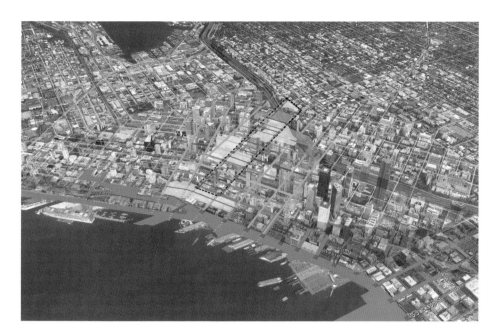

the earliest settlements in the 1860s. By focusing its study on the background of the established downtown grid, they discovered a remarkable dynamism of the streetscape. The Wild West streets created in the 1890s, with boardwalks and porches, transitioned to big-city streets filled with light poles and signs and lined with parked cars by the 1930s. Cars became more important, and the pedestrian experience was increasingly limited by the 1960s, with a return to more intimate and people-friendly streets with trees added in the 1980s. There was no one historical framework or

point of reference to be replicated or celebrated. Instead, each generation shaped the thoroughfares as fit their needs. This opened the door to asking what Seattle values today. What would Seattle's future streets look like and how could they reflect the city's culture and physical setting?

The emerging vision was to unite the Pike-Pine corridor, comprised of two major streets at the heart of the retail core. The guidelines rejected what Shannon called the "donut" approach, in which each block is wrapped in a distinct design as if it's an isolated project and the other side of

PREVIOUS PAGES, LEFT *Looking down Pine Street to a view of the sunset over the water.* LEFT *Photograph circa 1920 shows Pike Street at a time when the street was a shared space, a grand view corridor, and a highly pedestrian-oriented collage of interesting texture.* ABOVE *This plan categorizes the streets into two different types: hill streets in orange, avenues in green. GGN also suggested extending the project's scope across Interstate 5 to better connect the Capitol Hill neighborhood to the waterfront.* RIGHT *A concept sketch by Shannon showing the goal of amplifying Seattle's walking connections, views of the water, and upland neighborhoods. This sketch applied the Pike-Pine Renaissance Streetscape Design Vision to a proposed streetcar line along First Avenue (shown in green).*

the street doesn't exist. Instead they thought of streets and blocks as together contributing to one larger urban fabric. However, this approach did not demand uniformity. To distinguish and embrace the diversity that already existed was to allow Seattle its own "weird, inconvenient, rugged, and irregular" flow of east-west hill streets, while tapping into the "leafy, traditional" elements of the north-south avenues.

To achieve these vibrant urban visions, the team proposed a series of incremental design changes, addressing what they called the "light layer" (street life), the "middle layer" (paving and furnishing), and the "deep layer" (walkable, multimodal right-of-way). The modifications and additions could be incrementally implemented, block by block. These suggestions and standards would help the district regain a visual consistency that acknowledges Seattle's dramatic topography, density of diverse amenities, and bold views of the wilderness beyond. Additionally, the plan would simplify stewardship and maintenance efforts.

The light layer focuses on seasonal and temporary events and street life as fostered by design. It demonstrates how residents and visitors can celebrate the walkability of downtown Seattle, even though that requires hefty hikes up and over the hilly topography. It is also emblematic of the idea of a restrained hand in design.

For fun, Shannon, a runner herself, proposed a 5k walking/running loop from Pike Place Market at the waterfront up the hill to Melrose Market on Capitol Hill. It would link the hip energy of Capitol Hill's Pike-Pine district with the historic vitality of Pike Place Market. The loop would be challenging, meant to test the runners who train locally. To encourage evening activities, the plan proposed a cable-suspended "cloud trail" of lights along Pike Street during the long, dark, and often wet nights of winter. These simple insertions would counter the gray and dismal weather that is so often associated with Seattle, instead turning it into an asset—the lights' glimmer and shimmer would be appreciable for many long hours.

To take advantage of the beautifully dry summer months, the team suggested an outdoor garden festival and competition, an extension of the Northwest Flower and Garden Show. The Pacific Northwest is a haven of outstanding gardens, remarkable for the breadth of plants that can thrive and bloom here, from peonies and rhododendrons to olive trees and redwoods. A garden competition might identify the best and brightest garden squares for display along Pike Street, enriching the views as one treks up or down the hill, an idea that excited many in the GGN office.

GGN knew that a growing number of families were living downtown, so they proposed building playgrounds as well as temporary installations. The play opportunities could attract children of various ages, making downtown a fun and safe place to be. These events and ideas increased

LEFT *This drawing shows Pike and Pine Streets as significant connectors through downtown, between Capitol Hill and the waterfront, in combination with a network of cross streets and alleys.* RIGHT *Sketches by Shannon exploring a variety of methods to improve ambience on a good public street. GGN proposed less emphasis on the expensive "middle layer" of custom paving and furnishings and more emphasis on pedestrian-friendly "paint and policy" street improvements, traffic calming, and "light layer" storefront activities and street programming.*

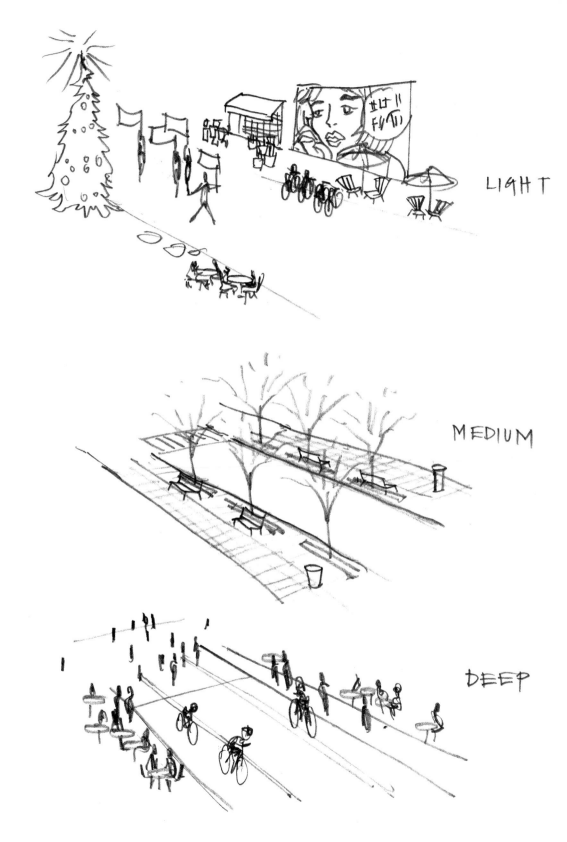

LIGHT

MEDIUM

DEEP

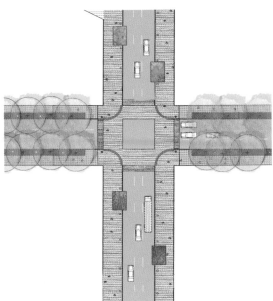

street life by not merely adding more, but by reimagining the ways in which the public realm is used and celebrated.

For the middle layer, GGN proposed changes that would directly impact the physical landscape, big moves that would frame the plan rather than a plethora of details and specifications. Many of the locals reviewing the plan had difficulty with what were apparently relatively modest suggestions; perhaps they wanted something grander. Over time, however, many came to see how the proposed changes could be implemented and enjoyed. The

patience and perseverance of the firm has been crucial, as has their creative definition of innovation: working with what exists. Flexibility in realizing the vision has also been extremely important.

The recommended schemes focused on the role of street trees, water views, and the experience of the walker rather than the car. The team walked every block to evaluate the health of the canopies as well as their impacts on the pedestrian experience, then developed a master plan. Beginning with Seattle's north-south avenues, the plan proposed adding trees along the routes, enriching the

ABOVE, LEFT AND RIGHT *Intersections would privilege the pedestrian on the east/west hill street through visually prominent, slightly raised crossings and walkways that calm traffic, which tends to speed intimidatingly along the level avenues.* LEFT *A sketch by Shannon exploring "plank" paving patterns for the proposed raised walkways.* RIGHT, ABOVE AND BELOW *A photograph of current conditions as well as a rendering showing how the proposed amendments would look and feel to pedestrians and cars at eye level.*

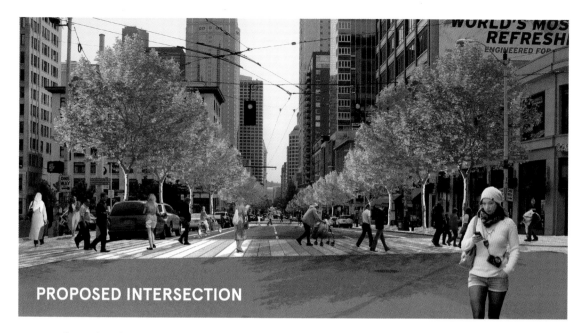

PROPOSED INTERSECTION

existing formal and grand character of the tree-lined avenues. The avenues would serve as an elegant wayfinding element that served as an immediate visual cue about which direction the street ran. Parklets could be added, amplifying the density of amenities. Downtown businesses are traditionally concentrated along avenues, as these are generally broader and therefore easier to walk along. Augmenting the tree canopy would enrich the experience of shopping and promenading.

On the other hand, along east-west Capitol Hill streets, the plan proposed to use shrubs and

existing trees more sparingly. Hill streets, they determined, need not provide a complete tree canopy, as openness and asymmetry can be a vibrant addition to a dynamic public area. The plan emphasizes the rugged urban character of the streets, as they navigate Seattle's famously dramatic slopes and reveal views of the water. Streets could be asymmetrically informal while avenues would be more symmetrically majestic.

While the big-but-subtle move to distinguish avenues and streets was key, there were also details to support the framework. A critical

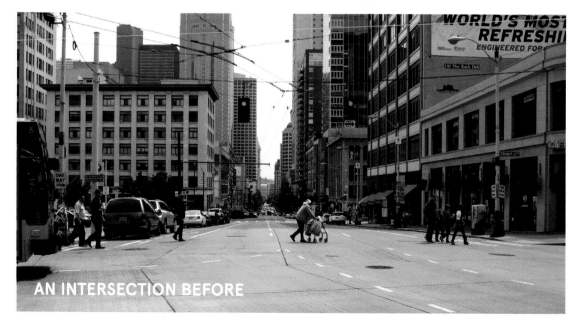

AN INTERSECTION BEFORE

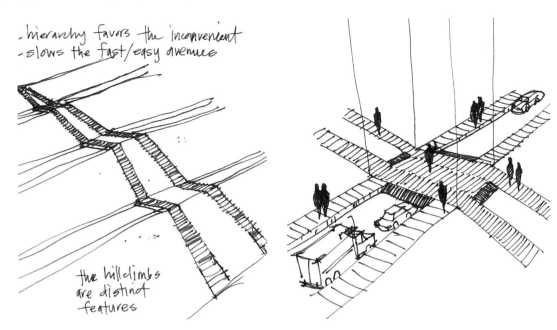

- hierarchy favors the inconvenient
- slows the fast/easy avenues

the hillclimbs are distinct features

element of the middle layer was a change in how intersections were conceived. As opposed to the fast-paced avenues, the hill streets were given priority as uninterrupted environments, from hill top to bay, emphasizing their role as connective tissue in the city. At the crossings, the road surface was to be raised to meet the sidewalk to create elevated intersections that would carry the pedestrian easily across, honoring the walker's route over that of the driver. Whereas typical curb cuts force pedestrians down to the level of the street, this embellished speed bump would keep

pedestrians at sidewalk level and on a pedestal— literally and figuratively. By prioritizing pedestrians on hill streets, the experience of walking up the hill from the waterfront would be seen as an established cultural norm or common activity, making it seem more welcoming and enjoyable.

The plan, again in the spirit of a tempered design hand, called for cleaning and improving the city alleys and adding lighting to the dozen or so alleys between Pike and Pine Streets. Seattle, like many large cities, is looking to turn gritty problem spaces into urban amenities. With such

Plan

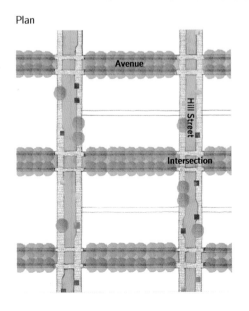

Avenue

Hill Street

Intersection

Avenue Detail

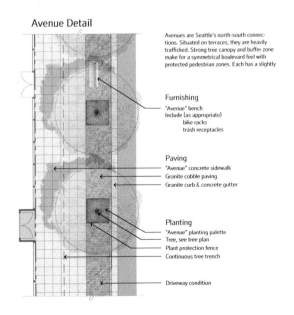

Avenues are Seattle's north-south connections. Situated on terraces, they are heavily trafficked. Strong tree canopy and buffer zone make for a symmetrical boulevard feel with protected pedestrian zones. Each has a slightly

Furnishing
"Avenue" bench
Include (as appropriate)
 bike racks
 trash receptacles

Paving
"Avenue" concrete sidewalk
Granite cobble paving
Granite curb & concrete gutter

Planting
"Avenue" planting palette
Tree, see tree plan
Plant protection fence
Continuous tree trench

Driveway condition

LEFT *Diagrams by Shannon revealing the distinct character of the hill streets in relation to the avenues and how they might intersect one another.* LEFT, BELOW *Plan of avenues with city standard 2-by-2 score pattern. Tree site details and broad sidewalks shown.* RIGHT *A sketch by Shannon exploring how lighting might enhance the new pathways for pedestrians.* BELOW *Hill street details and intersections, showing how the design honors the pedestrian over cars.* OVERLEAF, LEFT *Avenues before and after suggested design implementation. Insertions include the addition of trees with appropriately scaled planting beds and pop-up cafés, and also simply articulate the spaces for pedestrians and bike riders. Avenues tend to be level ground in the sloped downtown, so more furnishings are proposed.* OVERLEAF, RIGHT *Intersections before and after proposed changes. The alterations focus on a "middle layer" that improves and clarifies elements of the public realm.*

improved spaces, the light layer activities such as garden festivals or running loops would be that much more powerful in the urban landscape.

Throughout these alterations and insertions, the proposal formulated by GGN argued for a limited palette of materials. An initial inventory of the district identified a remarkable diversity of paving, plantings, seating, and trash receptacles that could be simplified to provide coherency. The simplified palette would ease maintenance and could favor local Seattle design and/or manufacture. The middle layer ideas coalesce into

streetscapes that can be read as one plan, one city, at the same time allowing for individuality when appropriate along the way.

GGN developed ideas for the deep layer to improve the pedestrian-friendly character of downtown Seattle. Drawing from the firm's experience working with city planning departments and their engineers and planners, the designers knew that to catalyze long-term improvements, they needed to offer a new vision for urban design. For Seattle to epitomize the urban experience, the policies and practices of how the streets

Hill Street Detail

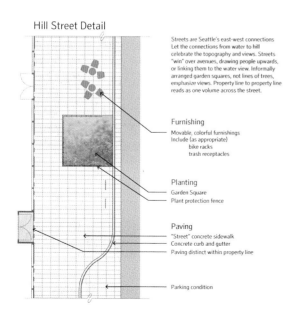

Streets are Seattle's east-west connections Let the connections from water to hill celebrate the topography and views. Streets "win" over avenues, drawing people upwards, or linking them to the water view. Informally arranged garden squares, not lines of trees, emphasize views. Property line to property line reads as one volume across the street.

Furnishing
Movable, colorful furnishings
Include (as appropriate)
 bike racks
 trash receptacles

Planting
Garden Square
Plant protection fence

Paving
"Street" concrete sidewalk
Concrete curb and gutter
Paving distinct within property line

Parking condition

Intersection Detail

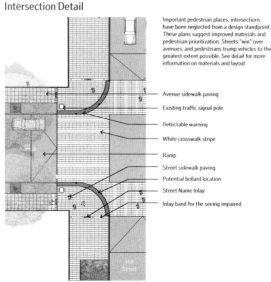

Important pedestrian places, intersections have been neglected from a design standpoint. These plans suggest improved materials and pedestrian prioritization. Streets "win" over avenues, and pedestrians trump vehicles to the greatest extent possible. See detail for more information on materials and layout.

Avenue sidewalk paving
Existing traffic signal pole
Detectable warning
White crosswalk stripe
Ramp
Street sidewalk paving
Potential bollard location
Street Name Inlay
Inlay band for the seeing impaired

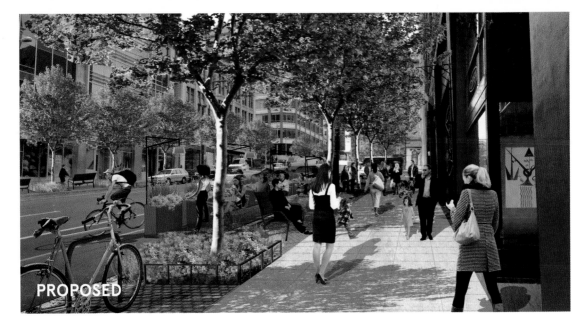

PROPOSED

and sidewalks were designed, maintained, and renewed would need to be as innovative as any other project in the progressive city.

GGN's proposal suggested how the city might prioritize pedestrians with a focus on multimodal neighborhoods. In the early twentieth century, cities were designed for the pedestrian. It was only with the dramatic growth of cars in cities that the automobile was privileged over the walker or bicyclist. The team was interested in how a twenty-first-century city such as Seattle might turn the tables. They recommended, for

example, that several one-way streets should once again feature two-way traffic, which generally moves slower. They encouraged the city to fully implement an existing bike master plan and introduce broader traffic-calming measures such as reducing speed limits throughout the city.

GGN built upon the existing features that already defined downtown Seattle to make it an exceptionally comfortable place to walk using subtle design insertions and moves. The plan's simple standards restore elements of Seattle's historic sidewalk details while emboldening the

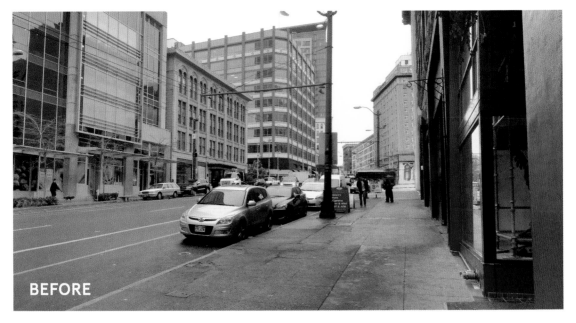

BEFORE

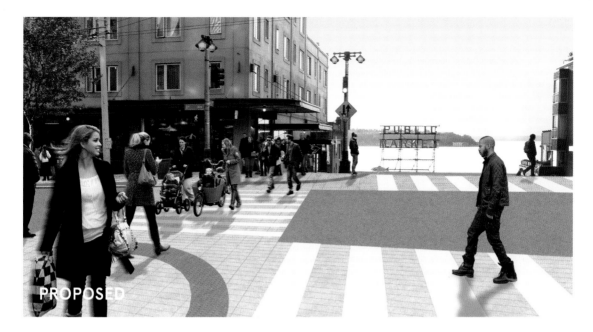

PROPOSED

contrasts between the city's two major street types: north-south avenues and east-west hill streets. The Pike-Pine Renaissance presented an opportunity to reclaim and leverage what could be the city's greatest asset: its public streets. With this window of opportunity to reset the vision for a coordinated public environment, Seattle could become a world leader in healthy-city design.

BEFORE

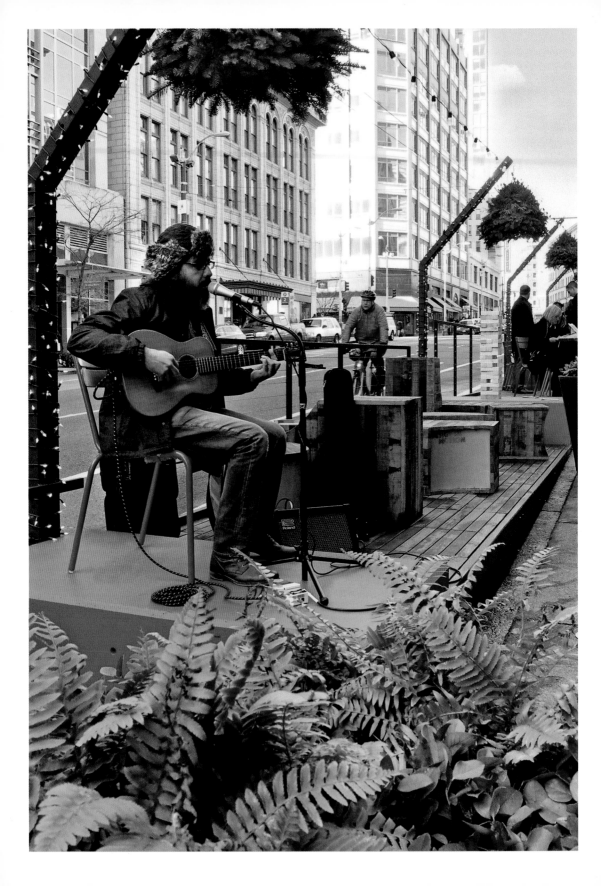

CHROMER BUILDING PARKLET & STREATERY 2014

Inspired by Seattle's celebration of vibrant pop-ups and by GGN's depiction of a more vibrant Second Avenue in its Pike-Pine Renaissance plan, Greg Smith of Urban Visions contacted the firm in 2013 with the idea of partnering together and with Krekow Jennings to realize the Chromer Building Parklet and Streatery in downtown Seattle. Located within downtown's most active pedestrian area, the 680-square-foot Parklet made from five parking spaces, which was completed in 2014, served as a local precedent for converting parking spaces into pedestrian space on a more permanent basis than a temporary pop-up, while remaining a flexible space that can be easily transformed. What transpired was design conceived as a simple, practical, and replicable system of modules that adapt to Seattle's variable slopes.

Greg Smith and GGN, led by Shannon, were enthusiastic about partnering to experiment with an alternative to the traditional public right-of-way realm. The challenge was that the existing city streets in downtown Seattle were missing the vibrancy of Pike Place Market and the adjacent retail core. The designers' response was a parklet that might generate a sense of human-scaled comfort and provide an active presence for the block. The project was to be designed as an open-source design precedent that might be easily copied. Shannon and Greg wanted to create a practical and very usable parklet—not a one-off sculpture that would win Instagram. Parklets are often viewed as trivial elements in the city, which galvanized the team's determination to make the most useful and essential parklet ever—one that would simply allow a part of the road surface to be usable and inviting for people on foot, easily installed and disassembled, using replicable, common materials and forms.

Imagined as a flexible framework, stage, gathering space, and café, the parklet idea was submitted to the City of Seattle after a new zoning rule passed that allowed more flexibility in the use of streets and sidewalks. Greg, like Shannon, has long been interested in how small investments in the public realm might catalyze larger improvements; he has been a vocal champion for improving downtown Seattle as a livable neighborhood rather than a drive-through district. Local business owners were enthusiastic, including the owner of Elysian Brewing, who wrote that the parklet would "help catch the eyes of locals and help feed growing excitement and sense of ownership for this redeveloping downtown block."

The GGN team drew on lessons from San Francisco's program as well as Seattle's zoning guidelines. Wheelchair access was important, as were the existing bike rack, light poles, and bike lane. However, it was not just the elements but the programming of the project that they knew would be essential to its success. Programming ideas came from local businesses as well as Seattle's civic leaders. Krekow Jennings, the builder, joined the project as a full collaborator and contributing partner as well as contractor, with a recognized background in supporting parklet projects and public art installations. They made strong suggestions for ideas that helped define the final details,

materials, and construction methods that give the final parklet its character.

The site chosen had an average slope of 4.9 percent, so a series of modular stages or platforms step down the hillside, enabling the easy rotation of furniture and other installations. The team used durable elements—metal frames, wooden decks, and concrete blocks—to create a series of flexible, level spaces on the street. One platform is a sculpture plinth and another is a music stage. Movable seating and tables and lean rails in varying shades of red create diverse places to sit and gather. Native Seattle plants enhance the space. Food trucks and nearby takeout contribute to increasing eyes on the street, as did the design of a lighting element that would make twenty-four-hour activity possible. The parklet was upgraded just six months after opening with the further designation of "streatery," serving as an outdoor café for the adjacent restaurant.

Innovative and sometimes temporary projects such as the Chromer Parklet are important ways designers experiment in public areas. GGN's interest in this work demonstrated their involvement in projects ranging from parklets and the Pike-Pine Renaissance plan to the Seattle Streetcar proposal. Each of these projects suggests the powerful potential of design to reimagine the public realm.

PREVIOUS PAGES *The modular parklet system designed by GGN in collaboration with Urban Visions and Krekow Jennings had the objective of presenting a simple, modular, economical, and flexible system that could be applied on various slopes and used for a variety of social and cultural purposes.* RIGHT, TOP *Demonstrating the potential of the modular café to replace five parking spaces with social and performance space.* RIGHT, MIDDLE *The parklet under construction; the concrete blocks frame parking spaces to transform them into people spaces.* RIGHT, BOTTOM *The parklet as built, with sections fit into the existing slope of the street in modules.* OVERLEAF *A variety of seating is provided; the railing clearly delineates the space as separate from the road.*

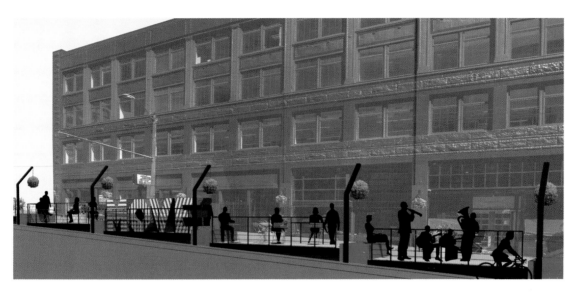

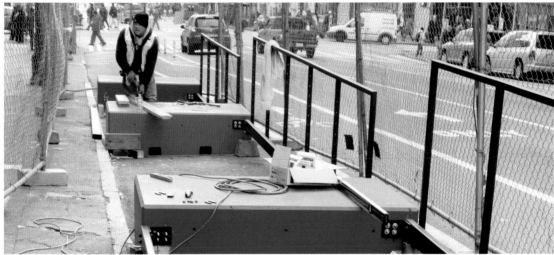

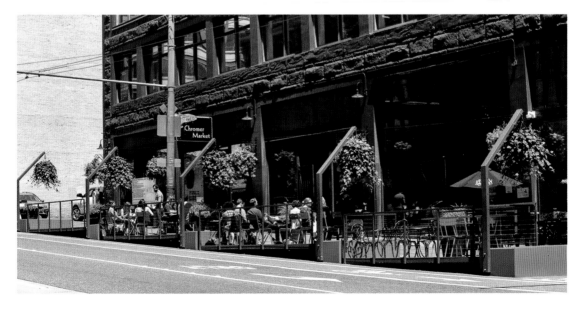

BROADENING HORIZONS AND REFINING DETAILS

Needing to expand again, GGN moved in 2012 to large open space spanning the seventh floor of a building just up the hill from the waterfront, near Pike Place Market. The new office was painted in bright white, with white tables and stools, and expansive windows that brought in fresh sunshine and air. In 2017 the firm included fifty employees between the Seattle and Washington, DC, workspace.

Shannon, Jennifer, and Kathryn, along with principals Rodrigo, Grant, Keith, and Bernie—and, by 2017, Tess and David—continued to expand their projects as they were increasingly recognized for their urban designs in the public sphere. They were winning both design and idea competitions that shaped the practice of landscape architecture across the country. With increasing recognition of their work nationally and internationally, the firm began to take on projects for United States embassies and other government posts in foreign cities such as Athens, Greece, and Ankara, Turkey.

As the principals lectured, served on panels, participated in design salons, and became board members of organizations such as the Landscape Architecture Foundation, the firm continued to seek out independent, curious minds and interesting designers to add to GGN's ranks. Two such finds included Tess Schiavone and David Malda, who had joined the firm as young designers and were later promoted to positions as principals. In just a short time, the office would embrace a diverse community of people, reflecting various talents, skills, perspectives, and approaches.

In many ways, the projects that follow are merely an extension of earlier work that views design as problem-solving through the making and shaping of space grounded in the particulars of place and culture and a long-standing commitment to a high quality of design. GGN's work is pushing the boundaries of design practice, as each of the design principals experiments with expanded models of what it means for landscape architects to simultaneously build collaborative relationships with partners and clients, while taking a leading role in imagining the future.

PREVIOUS PAGES *Yuichiro, Shannon, Keith, Laurel, and Makie in GGN's Terminal Sales Building office across from the Pike Place Market and Elliott Bay.* LEFT *Kate Mortensen at the front desk with a collection of plaster models of previous projects in GGN's entry space.* LEFT, BELOW *The firm's new, open office space features generous natural light.* RIGHT *Makie Suzuki leading a conversation with team members.* BELOW *Chihiro Shinohara Donovan reviewing the performance of GGN skate-detererant details at Kreielsheimer Promenade at Marion O. McCaw Hall.* OVERLEAF, TOP LEFT *Alex McCay, Patrick Keegan, and Chihiro Shinohara Donovan reviewing progress with Jennifer.* OVERLEAF, LOWER LEFT *Emily Scott working through a planting plan in the DC workspace.* OVERLEAF, RIGHT *Rebecca Fuchs drawing over a photograph, a technique the firm uses regularly to explore design scale and details.* PAGES 212–13 *A study by Tess Schiavone for a series of cast-concrete planter walls for a private native plant garden.* PAGES 214–15 *Jill Fortuna overseeing the early-morning tree planting at the NMAAHC.*

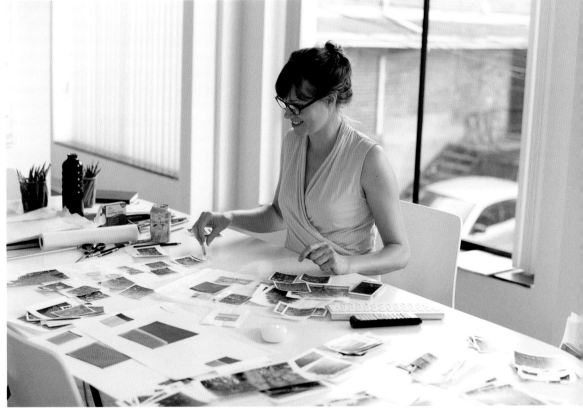

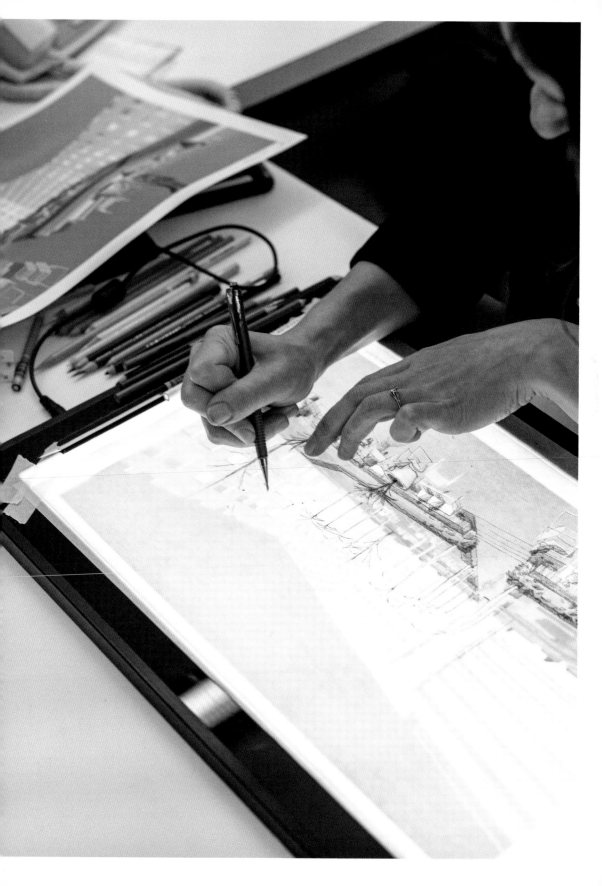

241.5
234.0

7.5

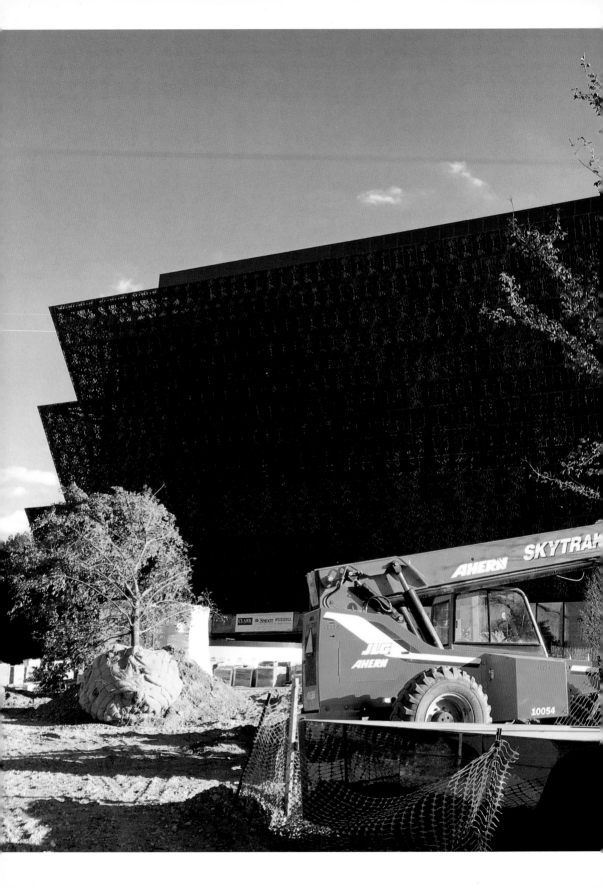

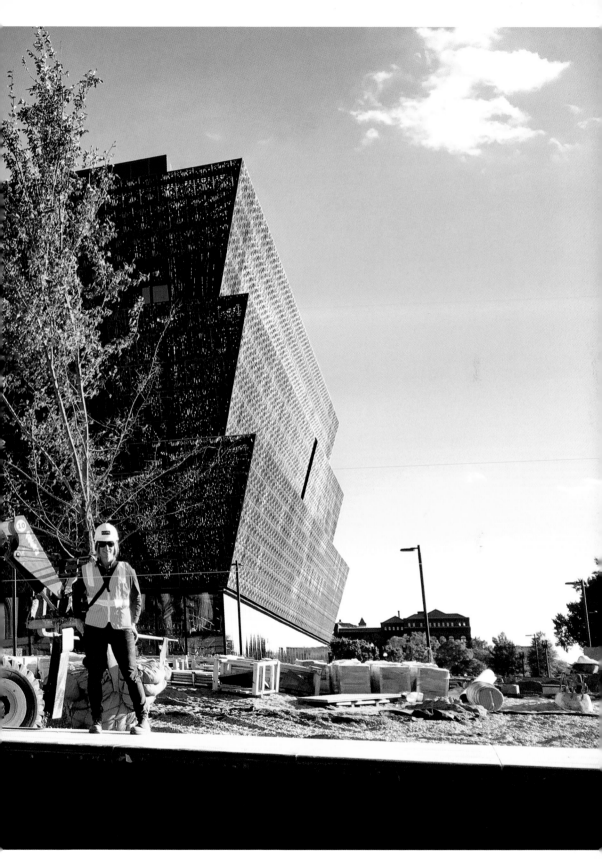

UNIVERSITY OF WASHINGTON SCHOOL OF MEDICINE
2013–2018

The University of Washington's School of Medicine campus
is located in a rapidly developing neighborhood of downtown
Seattle known as South Lake Union. The neighborhood
has emerged as a district for life sciences research facilities and
institutional campuses. The campus is being built in three
phases, beginning in 2008 and completed in 2018. Perkins+Will
served as architect—MBT had served as original architects—
and structural engineering was provided by MKA. Designed
by GGN, the life science facility celebrates the nature of the
Pacific Northwest and its landscapes.

As a biomedical research facility dedicated to improving the lives of people, it is important that the new urban campus for the School of Medicine (SOM) reflect similar values. GGN, with Jennifer as lead designer, building on a conceptual collaboration with Shannon, was commissioned to develop a master design strategy and vision for the complex that would be built over three distinct phases covering two adjacent blocks.

Although today the SOM campus shares the neighborhood with the immense Amazon development, when it was initiated, little else was in the district. The primary design challenge was to create a public realm to frame the buildings and invite the public into and through the campus. Bringing natural light and life into the campus was important, as well as retaining the cleanliness and clarity expected of a medical institution. As GGN developed the design, the layout was grounded in a simple cruciform configuration for each block, as an extension of the neighborhood's historic pattern of quiet east-west streets and active north-south passageways. This approach created a dynamic landscape that maintained the clarity of the existing city grid.

The initial proposal was framed by the concept of LIFE layers. The character of the street grid was retained based on an analysis of the directional differences in South Lake Union's once-industrial streets. Within the grid the north-south corridors and east-west paths were distinguished with a specific character. The north-south axis drew on the character of sunlight in the Pacific Northwest echoed in the open, airy, and well-lit corridors. There is a crispness to the details evident at the entrance boardwalk set in the first block, inviting the neighborhood into the campus. Designed as a boardwalk with precision-cut wood as a warm and inviting material, it is laid in a crafted pattern of boards that tightens as it nears the central crossing to create an intuitive meeting point. Along one side, a long linear wood bench is aligned with a background of miscanthus that partially obscures direct views into the laboratories behind. This provides porosity while also retaining the necessary privacy.

The east-west alleys have a distinctly different character, although the clean lines are retained. GGN's intention was to create a green axis celebrating health and abundance with the soil bursting with life and energy. The garden beds lift up from the ground to be retained by low walls that are raked and hammered, as if they had been excavated from the site. Nature is celebrated with an abundance of seasonal, shade-tolerant perennials and shrubs such as hosta, ferns, polygonatum, and sarcococca as well as katsura and styrax trees in the central court. Throughout there is a consistent, creamy warmth to the colors and texture.

The spatial and textural distinctions of the two corridor landscapes offer a complexity to the campus that is more interesting than expected

LEFT *The plan for phases 2 and 3 of the School of Medicine, showing connections to the urban grid and the role of street trees in linking spaces.* RIGHT, ABOVE *Sketches by Shannon exploring the contrasts between the intimate, green alleys and prominent "floating" courtyard-street at the center of the urban campus.* RIGHT *As built, the boardwalk edge reflects the refined character of the architecture and defines the public realm simply and clearly.* OVERLEAF, TOP LEFT *At the crossroads of the light boardwalk and the lush and green east-west alley.* OVERLEAF, BOTTOM LEFT *Grasses provide privacy for those inside the building while wood benches scaled to casual seating welcomes the public.* OVERLEAF, RIGHT *The boardwalk extends from the street into the middle of the campus as a pedestrian space used at all hours.*

each cell is darker toward center
tiff. plantings at each building
need to incorporate seating
"hide" entry paving from 8th.

very bold contrast — "meadow" destination

wood w/ moss (slippery)
stone (somber/grim "me
unless white

white stone
w/ shadows — easy on eyes
works day + night

white stone
w/ sparkles, too

from its simple gridded pattern. It creates diverse spaces as well as offering a richness of textures and colors. Shaping a public setting as well as circulation routes for SOM faculty, students, and staff, GGN has generated a network of paths and resting spaces that convey a real campus rather than a collection of isolated buildings.

While the ground is generally the focus for landscape architects, Jennifer understood the potential of the sky for this urban design. To enliven the air and space above, particularly during the short, gray days of winter, Jennifer and Shannon collaborated to come up with a way the lights might sparkle, suspended in the air as well as emerge from a "floating" platform. This was their first opportunity to design a light fixture, so they sketched and custom designed a web of fantasy floating globe lights that dangle in the air like raindrops in a spider web, providing night lighting as well as an abstraction of light clouds during the day. This lighting addition brought a human scale to the corridor and connected the lab employees with their surroundings as they could enjoy the skyscape out of their windows.

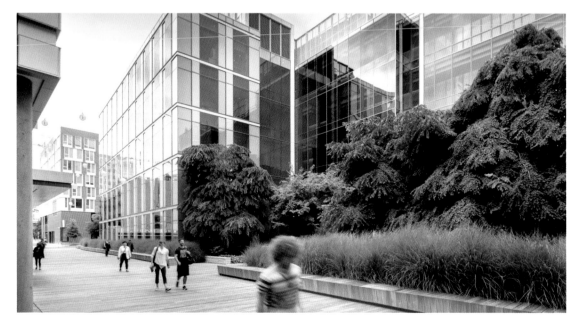

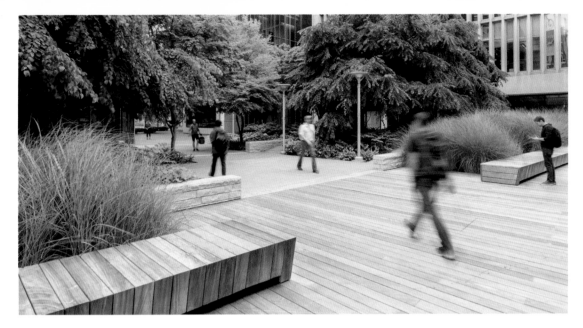

Along the second block, built in the third phase, the landscape will recall the first block while retaining its own sense of place. The north-south axis will tend towards a reflective and precise character while the east-west will celebrate the articulated and varied facade. Water will play a strong role, with fountains at the base of the faceted facade designed to be a "ribbon wall," echoing the movement of a waterfall. Hydrangeas will suggest foam and bubbles at the base, finishing the wall.

The architects' involvement with the landscape as it developed was critical. They partnered closely with GGN to help the entire campus feel porous, from the buildings to the hardscape. As with so many of GGN's projects, this is an urban landscape whose position in the city demands that it meet the needs of those working in the buildings as well the expectations and needs of the general public. The merging of private and public spaces in such a dynamic part of the city must be woven together gracefully. GGN's design manages this through attention to the conceptual layout and, as always, an understated design that highlights the inherent character of the place.

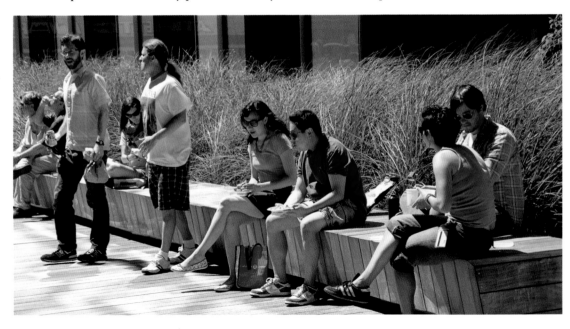

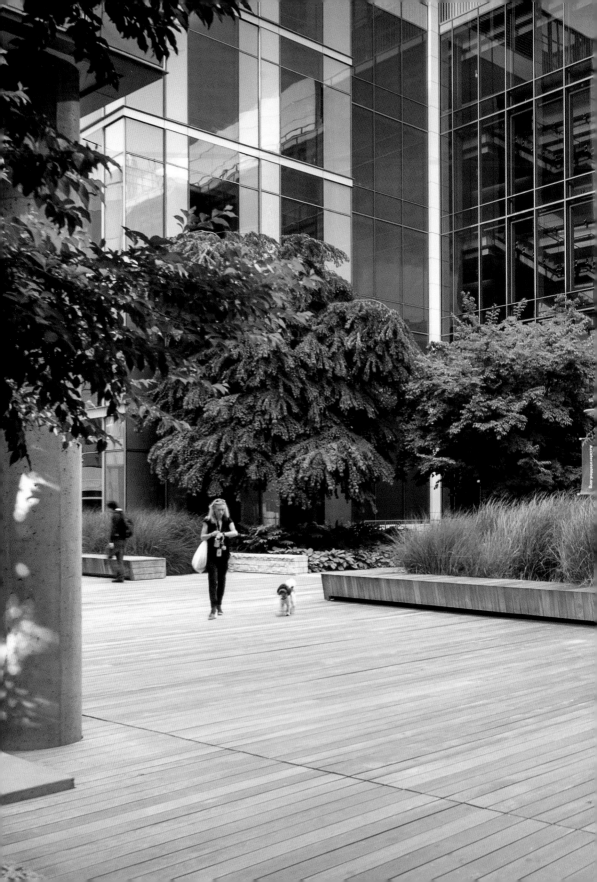

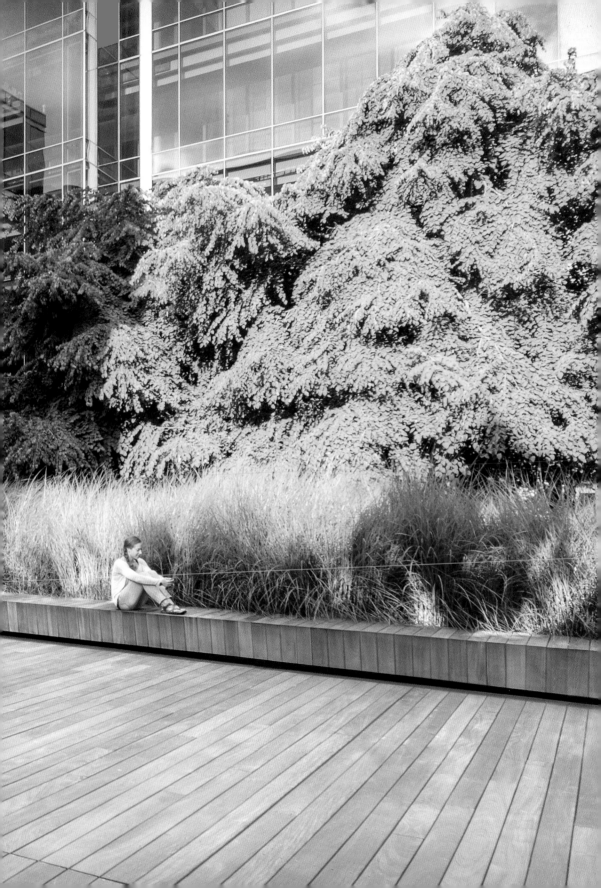

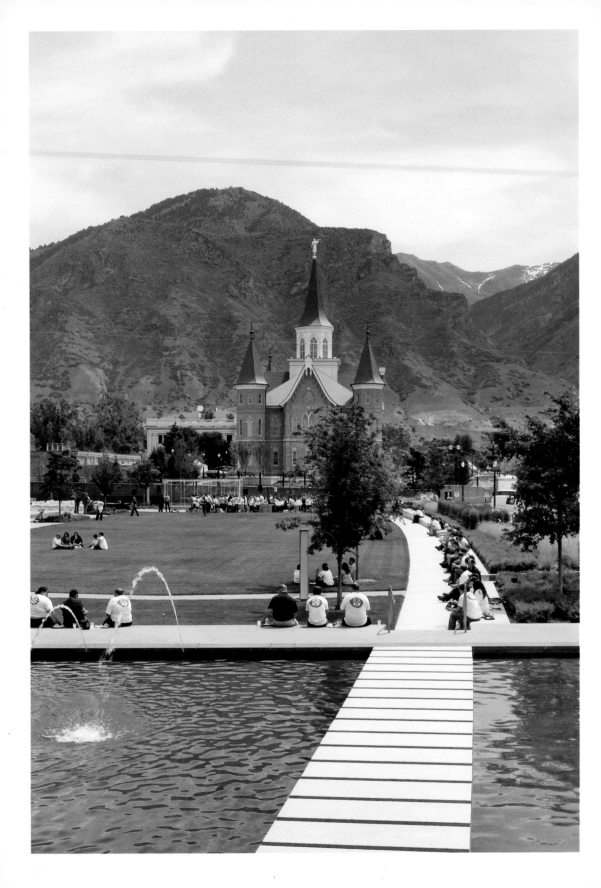

NU SKIN INNOVATION CENTER AND CAMPUS
2010–2015

The comprehensive design for the Nu Skin Innovation Center and Campus, with buildings designed by Bohlin Cywinski Jackson and NBBJ, builds on the corporation's key concepts of family, place, and innovation. First designed with BCJ as a single building and landscape to inspire and energize its workforce, it would grow into a larger development that serves as the campus today. What began as a landscape designed with BCJ for a much smaller site did an about-face just as it was drawing to a conclusion. The team designed and built what was intended to unroll as a twenty-year master plan in just two years in order to support the client's vision of bringing their entire Provo, Utah, workforce to one campus intended to celebrate Nu Skin's legacy of innovation and community-oriented mission as a force for good.

Established by Mormons as Fort Utah in 1849, Provo sits at an elevation of 4,549 feet along the Wasatch Front, on the edge of the Wasatch Mountains. Nu Skin was founded in 1984 by three local Mormon leaders to develop and market personal care products made with ingredients that are "all of the good, none of the bad," and by 2010 grew to be a global company listed on the NASDAQ. The campus landscape was meant to welcome and inspire the community while also serving as an amenity for the city of Provo.

The aspect of community gathering as well as a sense of civic duty led the Nu Skin leaders to commission the campus design. Nu Skin had been limited to a small campus when they decided to build the new innovation center. The project was another opportunity for GGN to work with the architectural firm of BCJ, previous partner on large civic-scale projects. BCJ realized a beautiful, glass-and-metal-encased innovation center housing research laboratories, conference spaces, and offices, with a retail storefront and café access on the street front. Jennifer Guthrie led the GGN team designing the landscape. The intimate attention to the public area remained an integral part of the Nu Skin approach to their growing campus. In the final plan, the landscape served as stable ground for gathering and collaboration while the architecture fostered the innovated initiative.

Soon Nu Skin leaders asked BCJ and GGN to develop a twenty-year master plan. With unanticipated and sustained growth, the plan was realized in just two years, by Jennifer's GGN team with Kay Compton and Bob Shek at NBBJ. They were tasked with imagining a landscape that would reflect the core values of Nu Skin's leadership, which maintains a focus on family, community, stewardship of place, and innovation. The programming for the campus mandated that it should welcome, inspire, and nurture the community, including everyone from their global workforce to casual visitors to local employees. The site would need to reflect the spectacular landscape and environment of Utah. It would also be required to gracefully host an annual gathering of Nu Skin's extensive sales force: up to 50,000 people every other year. Finally, the plan would need to fit into the city context of Provo, whose leadership was committed to using the campus for the benefit of the larger community.

Threading these objectives, the GGN team conceived of the main campus as a "bowl" that could contain a central gathering space and would serve as central, stable ground to support the company's innovative mission. GGN centered views on the Provo Temple, a cultural landmark, as well as the Wasatch Mountains, known for their seasonal character. The new campus holds the community while honoring the remarkable surroundings.

Procession and sequence were important, as the annual tradition of the sales force meeting is a choreographed event beginning when sales

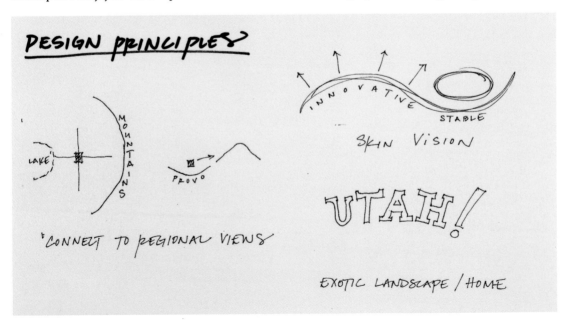

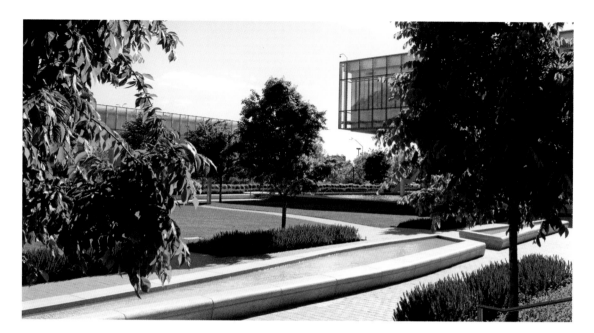

representatives arrive in Provo. Brought by bus down the main street, they enter the campus via a new entryway. Disembarking from the bus, they proceed along a broad promenade, where employees line up to enthusiastically greet them and share in the inspiration offered by the view of the new architecture, nearby lush landscape, and distant mountain range. Moving through the Innovation Center to the porch terrace, representatives face the central lawn that forms the heart of the campus, enclosed by four-season gardens and held in a gentle hollow of the landscape.

Besides accommodating this immense gathering, the campus also needed to function as a retreat, a social space, and a garden on a daily basis. It also needed to be flexible to allow for spontaneous and planned events from sports games to seated dinners and company-wide gatherings. Jennifer and team designed each element to be both robust and elegant. They created terraces that descend as seating steps, which can be used informally or formally as an amphitheater. The lawn, built over a parking garage, is welcoming as an oasis in the Utah Valley. Celebrating the gift of water, the top

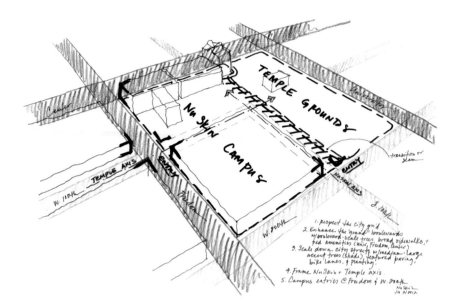

terrace holds two elegantly curving stones carved to hold water that falls into a pool at the ends. The water invites people to the edges, to sit and dip fingers. The water also cools the south-facing public area, offering a pleasant and relatively intimate space to gather. Throughout these elements, GGN paid meticulous attention to views both inward and outward, to build a sense of place both intimate and grand.

To address the urban context of the campus, GGN began by exploring how it might fit into the city and its relationship to the historic Provo Temple that sits next door. They focused on ways to strengthen the intersections of the campus to the public streets that framed the campus and the Temple grounds. The design work built on GGN's belief in the strength of simple and well-crafted designs, often more tempered than bold.

The Provo Temple and its formal enclosed grounds make up the eastern edge of the campus. The promenade is aligned with the city street grid running along the edge of the Temple grounds. Across the Nu Skin campus, a glass pavilion designed by NBBJ is placed on axis, with the Temple holding the western edge of campus.

Equally critical was how to ameliorate the scale of a superblock that comprised the campus in addition to the significant Temple grounds. The answer was giving a porosity to the edges. Along 100 South, GGN proposed planting street trees to create a shaded and pedestrian–friendly environment. It could, as Jennifer noted, be the best street in Provo for people. Additionally, GGN inserted pedestrian walkways and enhanced 100 South as a multimodal route. As designed, 100 South suggests the scale of individual city blocks without the interruption of traffic and is curbless to encourage sharing of the street. Further, the water that falls on the street is designed to drain to filtration planters—a consideration important to the skin care company. As a gracious pathway for employees, the new street model is being considered by the city of Provo for other locations.

PREVIOUS PAGES, LEFT *Identifying the design principles for Nu Skin in graphic form and in words, by Jennifer.* PREVIOUS PAGES, UPPER RIGHT *The channel defines the lower terrace, providing a graceful stone seating area as well as the cooling character of water.* PREVIOUS PAGES, BOTTOM RIGHT *Drawing by David Malda shows how the porch came into being as a multiuse space: as an informal stage or flexible gathering ground with the campus landscape as an essential backdrop.* ABOVE *A sketch by Jennifer showing how the new campus respects the city grid and frames views of the temple.* RIGHT, ABOVE *A sketch by David Malda showing the role of trees and water in the design vision, which focused on framing and reflecting the iconic temple and mountains.* RIGHT, BELOW *A view emphasizing the visual connections of the campus to its context.* OVERLEAF, LEFT *Detail of the pool edge and walkway; a thickly planted border in front of the pavilion creates a layered landscape that is at once intimate and transparent.* OVERLEAF, RIGHT *Peonies contribute to the sophisticated rainbow of colors that has become a feature of the Nu Skin gardens.*

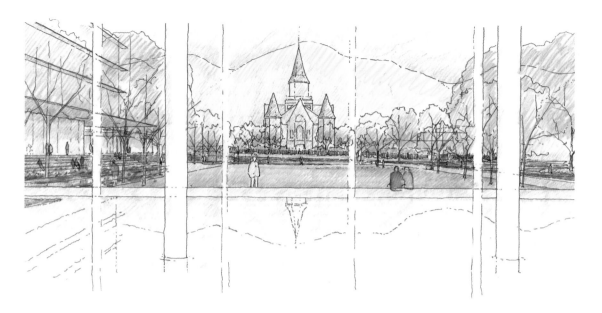

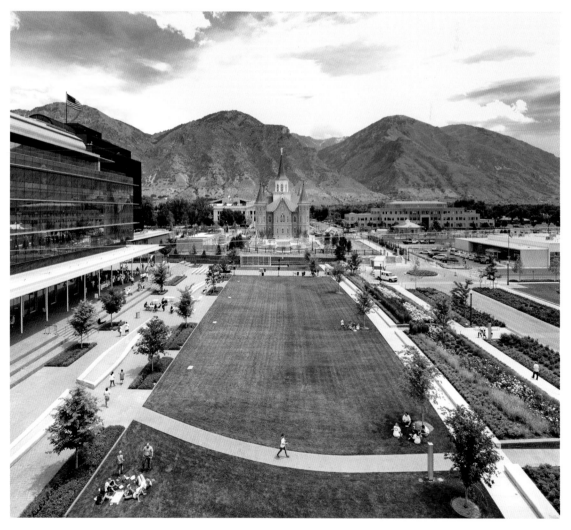

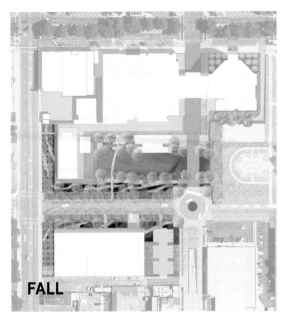

FALL

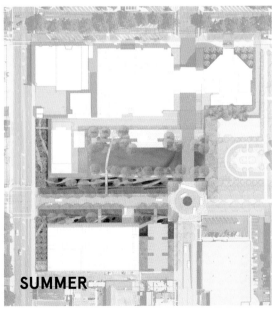

WINTER

As an urban design, the campus responds to its context by reaching out to engage the external streets while creating an inward sense of place. It serves the everyday Nu Skin community with gardens, seating walls, and pedestrian pathways, while also offering a celebratory place for their grand events. It honors the promoted culture of family and community, creating an enclosed place to assemble that respects its larger context.

With the primary forms and relationships established, Jennifer and her team turned to the design of the garden beds. Nu Skin leaders wanted a lush and colorful palette of plants that would engage employees and visitors throughout the year. Initially Jennifer explored the use of native plants, including sagebrush, that would build on the unique identity of Utah. However, these plants did not convey the level of excitement nor the refined look the Nu Skin leaders had envisioned.

Bernie and Jennifer developed a "sophisticated rainbow" palette choreographed to have a continuous and evolving blooming cycle as well as seasonal scents. Paying attention to the seasonal colors and textures, they created a design

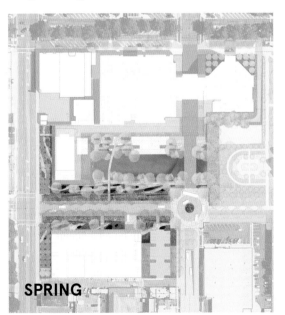

SPRING

SUMMER

LEFT *As the planted beds shape and define the primary spaces of the campus, it is critical that they work throughout the year. Seasonal planting designs emphasize the importance of colors and textures that will provide variety and delight.* RIGHT *A primary street connecting the campus to the city of Provo was designed to welcome pedestrians with a generous wall for seating—or balancing.* BELOW *The open space serves evening functions well, and these can be rendered as colorful as the gardens by daylight when lanterns and candles are added to the pool.* OVERLEAF *The main gathering space in use during a company event.*

reflecting the exuberance of the community while echoing the character of the broader natural environment. Lavender, roses, peonies, perovskia, and sage created a purple swath that echoed the colors of the mountains at sunset as well as that of many native plants. The team proposed grasses that shimmer and glow in the prevalent sunlight. The campus is now known for its elegant gardens, which contribute an intimate scale and experience to the immense surrounding landscape. The varied colors and scents change seasonally, adding a temporal character.

In the dry landscapes of Utah, water was used carefully throughout the campus. There is the graceful water canal set on the terrace of the main building; it bubbles as water spills over the ends. And there is the still pool on the western edge of the lawn, forming a forecourt for the glass pavilion. This calm body of water reflects the shimmer of the sky, the grasses and trees, the mountains beyond, and the Temple. As a whole, the landscape captures the deep values of Nu Skin—values that honor gathering together, celebrating community, and embracing the power of nature.

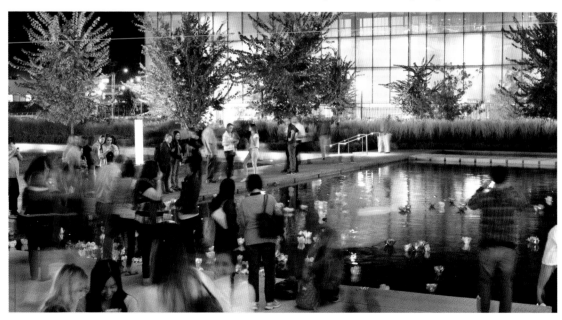

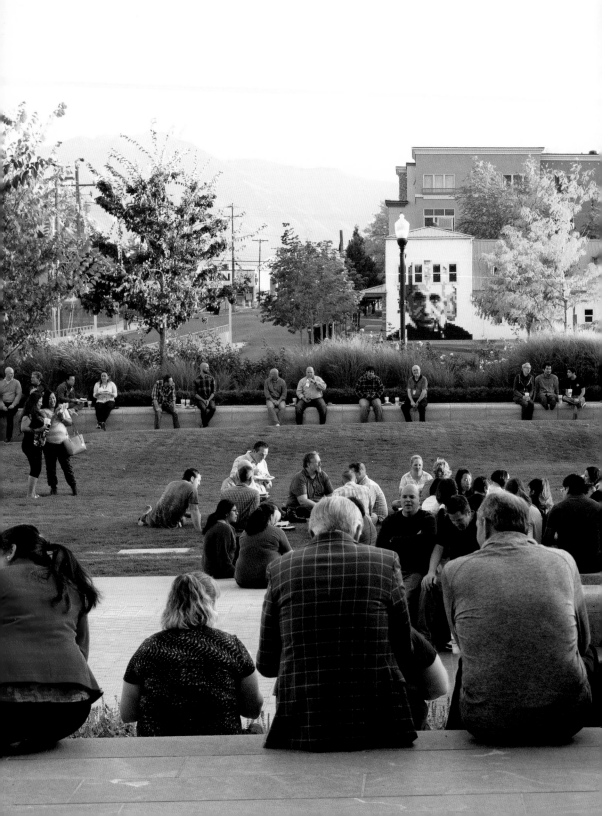

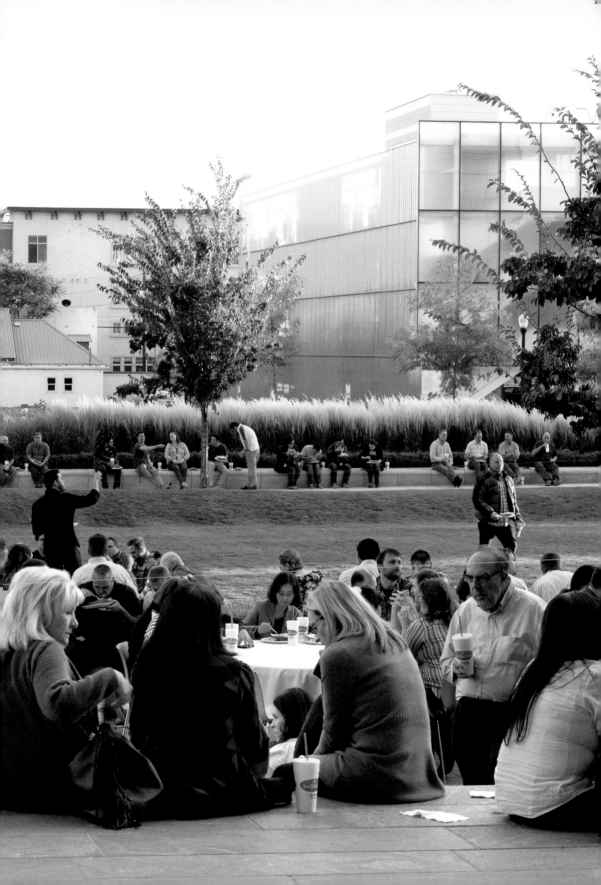

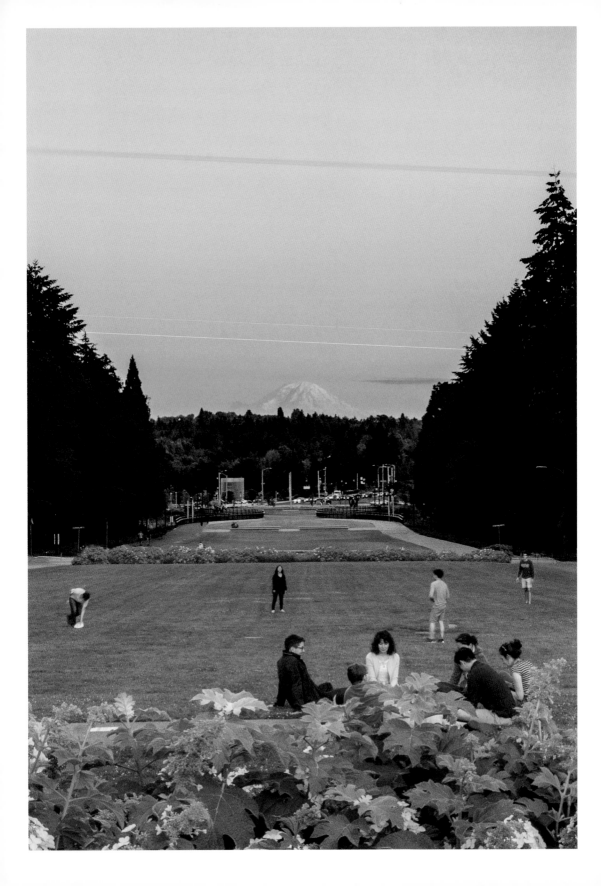

LOWER RAINIER VISTA
& PEDESTRIAN
LAND BRIDGE
2010–2015

Rainier Vista is the monumental axis of the University
of Washington's historic campus, designed by John C. Olmsted
of the Olmsted Brothers for the 1909 Alaska Yukon Pacific
Exposition. The axis was intended as a linear spine for the
campus that would focus the main quadrangle's view
on Mount Rainier, a majestic geological feature that defines
Seattle and its region.

GGN, in partnership with KPFF, was asked to extend and
clarify this vaunted feature. The new Lower Rainier Vista
design forms a land bridge to facilitate a contemporary and
multimodal integration of pedestrians, cyclists, buses,
and automobiles between the new light rail station at Husky
Stadium, Montlake Triangle, and the heart of the campus. The
Vista thus preserves one of the university's most beloved his-
torical features while also integrating modern infrastructure,
created in partnership with KPFF. It also includes new ADA
connections to welcome all visitors to the campus heart.

The challenge for GGN in tackling the University of Washington campus plan was to reconnect Rainier Vista, known as the fountain-to-mountain pathway, to a pedestrian and cycling land bridge that would serve as a major entrance into campus. The land bridge would connect a new light rail station built next to the Husky Stadium football arena with the main heart of the campus. In the final design, this monumental land bridge would connect the modern transit hub to the historic campus, serve as a grand entry to the campus, and solve a myriad of both engineering and visual challenges.

GGN needed to turn the challenging requirements into a welcoming threshold and route for pedestrians and bicyclists alike. At the same time, they needed to enhance the visual character of the historic Rainier Vista, including the view for those driving by at the southern end.

Emphasizing the view of the mountain in the original design had been a radical decision on the part of Olmsted; it would not always be visible due to cloud cover, and it was a view that might have detracted from the campus architecture itself. However, Olmsted decided the inspirational power was worth the risk and proceeded to design the view as a core element of the plan. He marked the vista with a major fountain at the top (today Drumheller Fountain) and trained the eye on the mountain. He framed the view by clearing a path through immense native trees, establishing a long, gently sloped lawn leading toward the water's shoreline below. This place has since become an iconic part of the UW experience.

GGN's design was both an engineering feat and a question of landscape preservation. It would have been easy to argue for simpler changes that would better meet ADA regulations as well as traffic patterns of pedestrians and cars, as long as one did not obscure the view of Mount Rainier. However, Shannon took the historical legacy of the campus seriously, working with it so that the original character could be strengthened while also addressing contemporary needs. This commitment required working with four transportation agencies—the Washington State Department of Transportation, Sound Transit, King County Metro Transit, and the Seattle Department of Transportation—as well as the University of Washington over five years.

Rather than significantly alter Rainier Vista to fit new circulation needs, the GGN team addressed the various impediments that had arisen in the past century and sought to strip away whatever had contributed to muddling the original purity of Olmsted's design vision. One major interruption was the underground parking garage inserted at the southern entrance. To accommodate the garage, a road crossed into the Vista and at the bottom, where the Vista met Pacific Place, a traffic triangle known as the Montlake Triangle stood, awkward and isolated. This process of

LEFT *Campus plan after the Alaska Yukon Exhibition was completed, with Rainier Vista forming the primary diagonal axis from the fountain to the view of the mountain beyond.* RIGHT *Aerial views of the campus; the existing landscape when GGN began the redesign (above) and the completed design (below).* OVERLEAF AND PAGES 242–243 *Aerial views of the Vista showing how the land bridge interacts with vehicular circulation and pedestrian/ cyclist paths below.* PAGE 244, ABOVE *A drawing of the view toward Mt. Rainier.* PAGE 244, BELOW *Facing Mt. Rainier after the project was completed.* PAGE 245, ABOVE *Relaxing on the lawn on an early summer evening.* PAGE 245, BELOW *The view towards Mt. Rainier before the project began.*

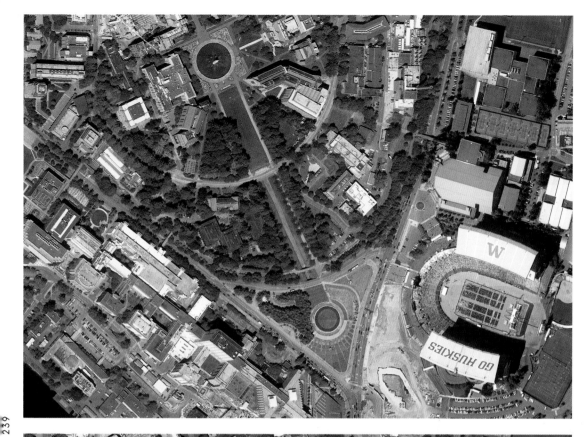

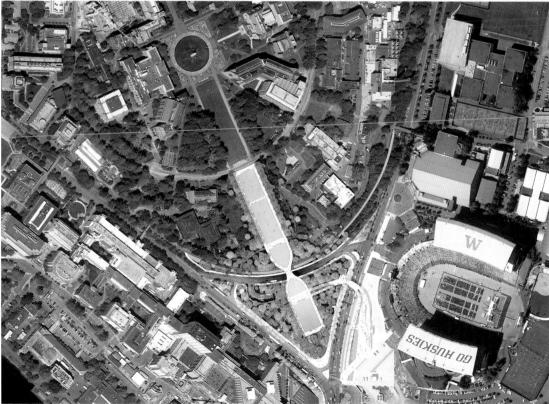

239

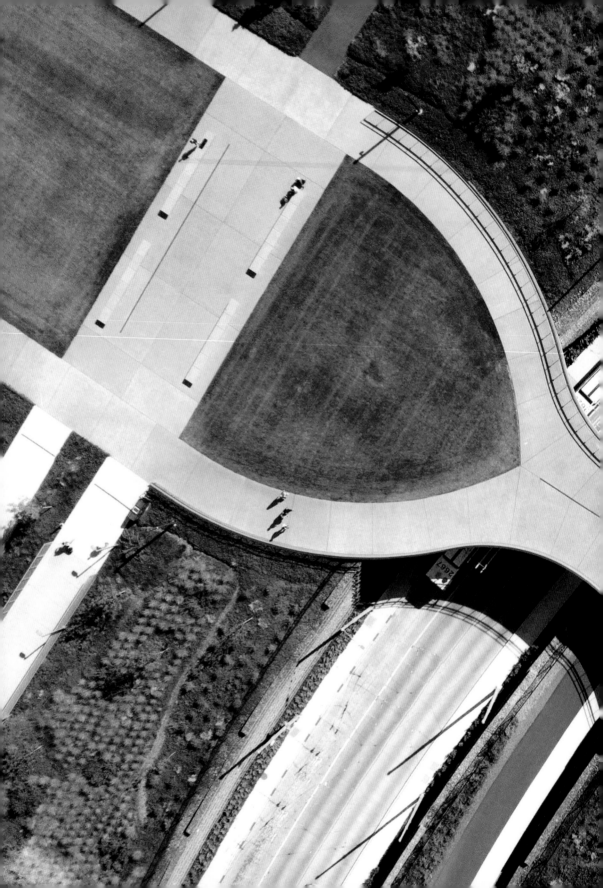

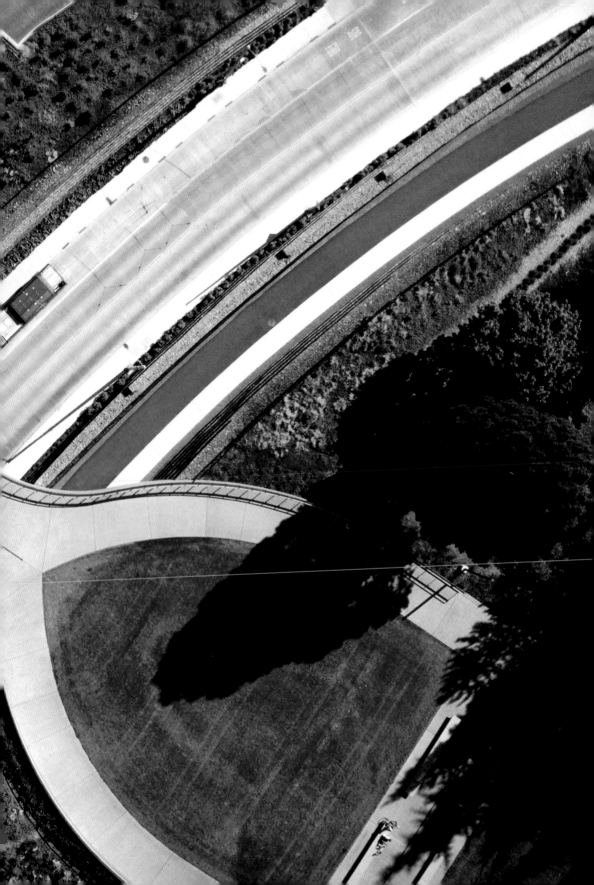

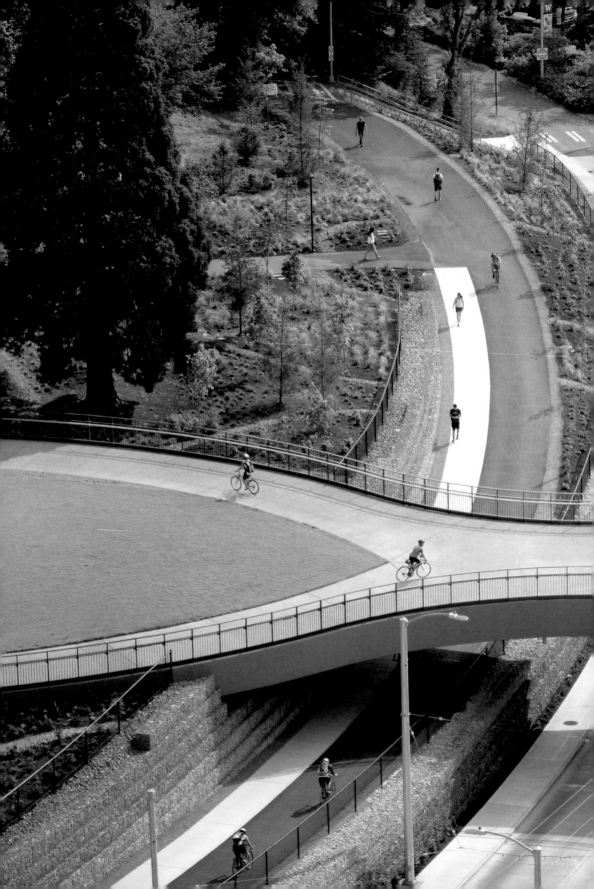

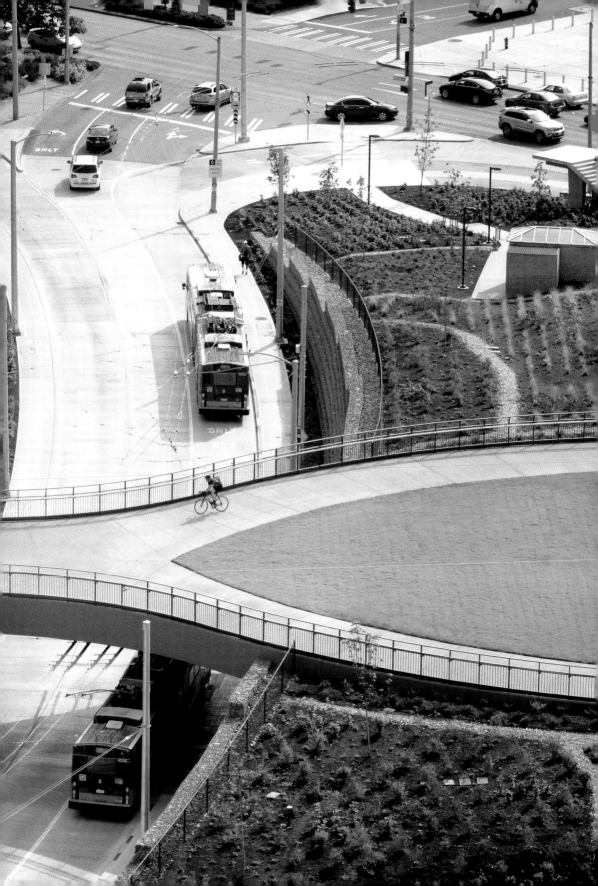

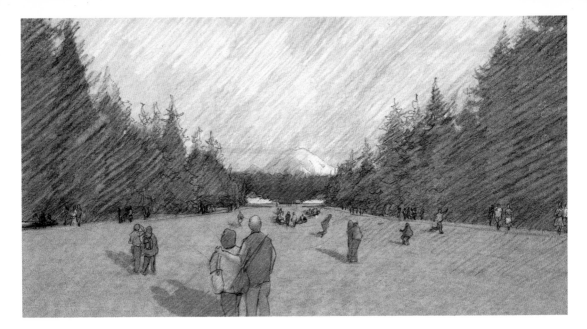

reviewing a problem, finding a solution, and then transforming the solution into an asset of the design was at the core of GGN's work.

A previous master plan by Michael Van Valkenburgh Associates had suggested a land bridge over Pacific Place to connect more efficiently and gracefully into UW's main campus. The site was particularly complex, as multiple pedestrian and cyclist routes would need to lace through and over the site and its adjacent roadways to better connect the campus with the new light rail station and an improved, regional, multi-use trail. GGN concurred that the land bridge would be helpful and useful. In addition to the land bridge that crossed the north side of the original triangle, there would be a second pedestrian and bicycle overpass, designed by LMN Architects in coordination with GGN, from the new light rail station, that would meet the land bridge above. Between the two bridges walkers and bicyclists could now enter the campus from the south without being impeded by car traffic, thus emphasizing the pedestrian-oriented character of the campus. Together, this required careful

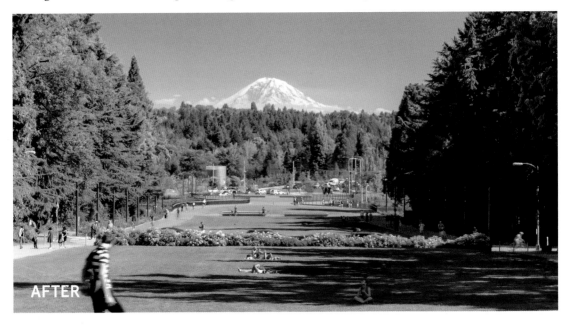

AFTER

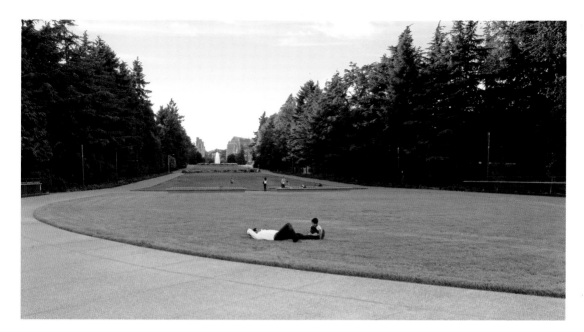

adherence to the core design goals to avoid it becoming primarily a multimodal infrastructure rather than an extension of the historic campus.

To design the land bridge, Shannon started with functional questions exploring the ways in which the Montlake Triangle could be reimagined as an asset to the campus. Could it be an extension of the campus landscape rather than a leftover parking garage landscape? Or by turning the question around, how could the campus landscape redefine the triangle landscape? In this way, the design team let a landscape language drive the form of the circulation elements and bridges, rather than the other way around.

This approach revealed how the Vista might be extended to reconnect Montlake Triangle: by lowering NE Pacific Place and the adjacent Burke-Gilman Trail by twenty feet, allowing buses to pass underneath without disrupting foot traffic across the same area. By carrying the linear thrust of the original landscape across the traffic triangle, the design essentially aligns the pieces so that the two became one long vista and route. The designers managed to retain the format and

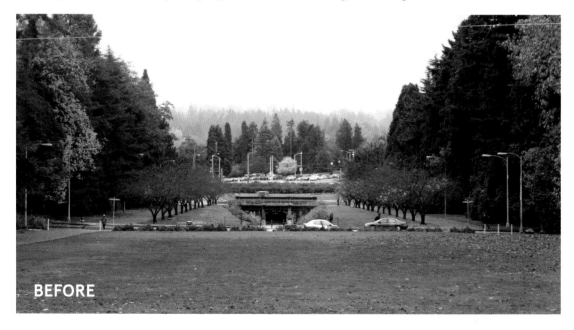

BEFORE

language of the historic Rainier Vista lawn without compromising its strength and simplicity.

Shannon and team turned their attention to the language of the core campus landscape—the Rainier Vista "mall" and its flanking, stately forests. By acknowledging the strength of this landscape language, they sought to preserve the experience while extending the Vista's reach. First was to retain the scale of Rainier Vista with the immense scale of the mountain view that juxtaposes the pedestrian scale of the lawn and paths. Another concern was assuring that the mall's bone structure of lawn and paths would "win" over the language of the new traffic engineering and circulation elements. The latter could either be fully integrated into the Vista, or they could quietly complement it from the side, but they could not distort or cut into the campus-scale landscape. This required partnering with the neighboring Sound Transit design team to engineer how to keep the pedestrian overpass from landing within the breadth of the Vista landscape.

Grading the land was essential to the success of the design. In section, the topography of Rainier Vista appears as an undulating ribbon of lawn—alternating between ramped portions that are subtly sculpted into inward-oriented amphitheater contours, and outward-focused prows that act as stable horizons below the hallowed view of Mount Rainier. The meticulously sloped lawn is framed on either side by low-growing native shrubs backed by magnificent trees. The landform undulations and frame of trees help to conceal traffic below retaining the focus on the campus landscape and distant views of the mountain. At the same time, the design accommodates cross-circulation, multiple intersections of people walking and cycling, and annual university events such as graduation.

There were also ecological functions that were important to incorporate into Rainier Vista. While swales and wetlands were not practical due to the intense use of lawns, the GGN team realized the functions by grading the land to slow down drainage and allow water to soak into the ground. With Drumheller Fountain at the top of the lawn and views of Lake Washington at the bottom, the sloped landscape suggests the natural path of the water from the top of the hill to the water below.

As the team focused on the design details, they also worked with the planting plan, as this was integral to the historic landscape. Plants along the upper portion of the Vista were limited to those that had been planted in the original campus design. The trees, many native, include Douglas fir (*Pseudotsuga menziesii*), western red cedar (*Thuja plicata*), and bigleaf maple (*Acer macrophyllum*). Shrubs that form an edge ecology include longleaf Oregon grape (*Berberis nervosa*), nootka rose (*Rosa nutkana*), evergreen huckleberry (*Vaccinium ovatum* 'Thunderbird'), coast strawberry (*Fragaria chiloensis*), and Oregon stonecrop (*Sedum oreganum*). The

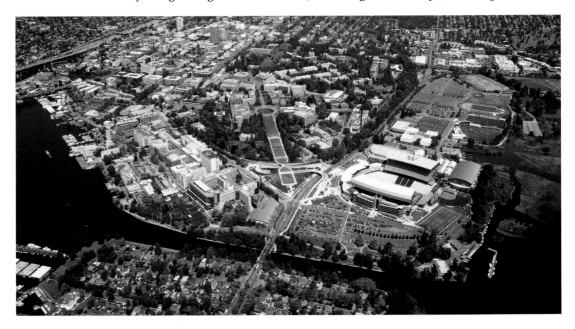

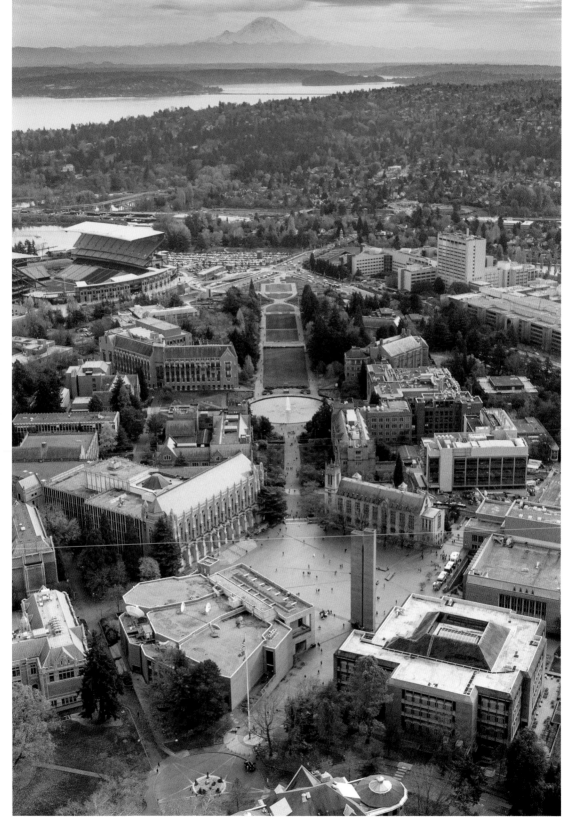

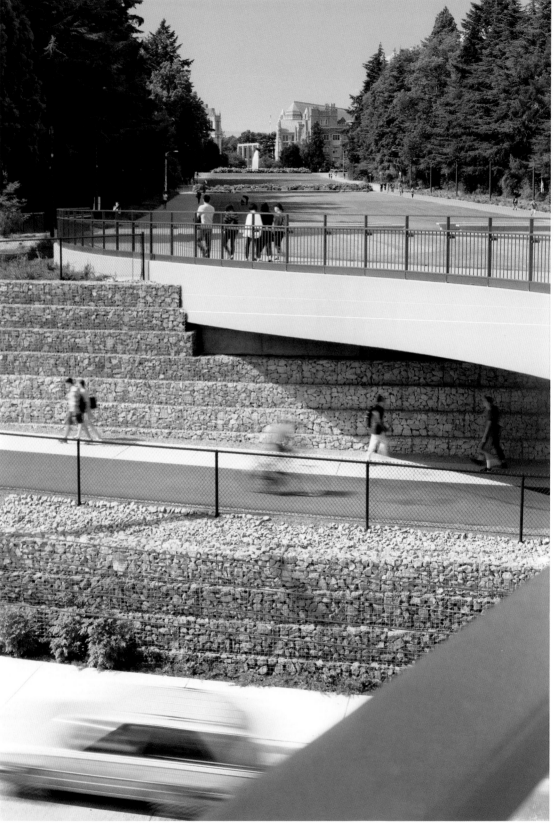

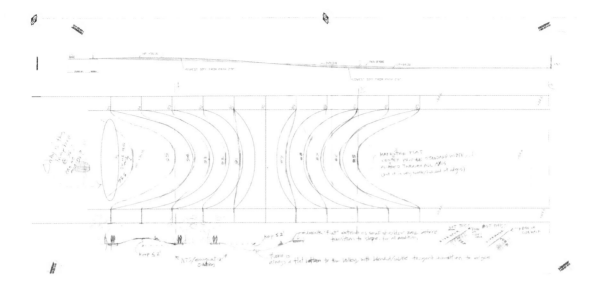

bottom half would be planted with bigleaf maple trees that would eventually create an immense canopy over masses of drought-tolerant grasses and native plants.

Even with the topography of the Vista established and the plantings set, there remained a problem: How would the bridge cross the roadway without creating unpleasant, dark, dank conditions for people below, specifically bicyclists and pedestrians? No one wanted to improve the quality of transit in the area only for some, with detriment to others. The designers began by

questioning the necessity for a grade-separated interchange between Pacific Place—an arterial street used by Metro buses, pedestrians, bicyclists, and private vehicles—and the new pedestrian and cyclist route connecting the new Sound Transit station to the main campus. Shannon and her team knew that the grading concerns were a design problem, not an engineering question of serving either pedestrians and bicyclists or vehicular traffic including buses. The design would need to address all the various ways people would visit and depart from the heart of campus.

PREVIOUS PAGES, LEFT *A view of the Vista showing its context in the surrounding campus and city.* PREVIOUS PAGES, RIGHT *Aerial view of the heart of the campus, revealing the strength of the Vista in drawing the eye to the scenery beyond.* LEFT *The layers of the land bridge appear as if built out of the geological structures below ground, creating gracious spaces below and above for pedestrians and bikers.* ABOVE *Determining the appropriate grading that would move water and people was critical to tackling the slope and views. Study by Shannon.* RIGHT *A detail of the gabion retaining walls used underneath the land bridge; nearby plantings and other airborne seeds will eventually spread and self-sow among the rocks, covering them.*

Continuity in Axis Width

Flexible Circulation

Collegiate Crossing

 + =

Working through multiple iterations, the GGN team found that if they minimized the bridge's width at the point where it crossed over the roadway below, they could also minimize the shadow it would cast over the road. In essence, they designed an abstraction of the University's famed collegiate Gothic architecture. This academic style is evident in the architecture anchoring the upper end of the Vista. For the land bridge, two Gothic arches were layered one on top of the other. The first is found in the convergence of paths on the upper surface of the land bridge as an extension of the Vista. The arch enabled the incorporation of the dynamic, asymmetrical movements needed to crisscross the formal, historically charged body of the symmetrical Vista lawn. The second arch is the bridge's form when visible from below and afar. This was the result of extensive studies of the endless matrices of geometry-grounded options to capture the authentic form of a Gothic arch, while smoothly elongating the bridge and its circulation into a crossing that would be graceful and elegant in any direction—including from beneath the bridge.

UW Arch

UW Quad

Collegiate Crossing

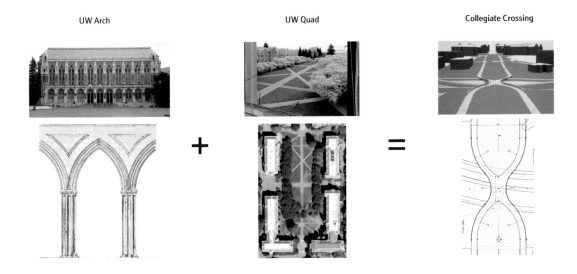

In shaping the bridge, it was clear that engineering demands would require it to be vertically thick. Shannon and the team treated this thickness as a character trait that could be imagined as underpinning the entire Vista. Conceptually the Vista was a "tuning fork" that had been pressed down into the campus forest and mountain. It only revealed its depth and fourth surface (the underside of the bridge) at the place where it spanned Pacific Place. The design of the bridge, particularly the undersurface, was then detailed to imply that the concrete was a consistent solid piece, as refined on its underside as it was on its top side. In this way, the idea was retained that this large slab of concrete had been inserted as a whole into the forest and mountainside. Additionally, the design team paid attention to the materials of the land bridge. They used aggregate and washing techniques to replicate the warmth and natural texture of the earlier concrete from the 1920s and fine-grained jointing patterns in the concrete to suggest Gothic arches and symmetrically frame the edges of the paths. For the railings, dark-colored metal, square tubing, and flat bar

LEFT, ABOVE *Diagrams of the designs combining campus quad-type crossing within the historic axial continuity of the Vista.* LEFT, BELOW *Collegiate Gothic arches show up in the pointed arches of the buildings and paths in Red Square on the other end of the Vista, and were then abstracted, along with the crossing paths of the Arts Quad, into the proposed new design for the land bridge.* ABOVE *Study by Shannon showing the concept of the Vista, both a historic formal landscape and a flexible campus crossing.* RIGHT *A sketch by Shannon exploring how the Vista would relate to the tree canopy on either side.* OVERLEAF *Rainier Vista as viewed from the bridge up to Drumheller Fountain and the main campus.* PAGES 254–55 *As students move across the land bridge, grasses provide year-long texture and color, and suggest the open nature of an academic campus.*

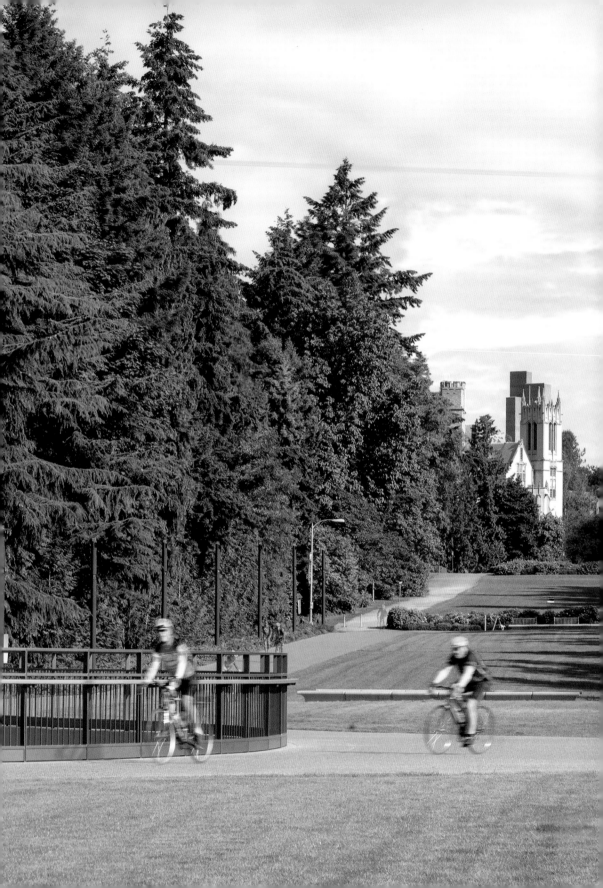

were used, contributing a human scale and feel
to the monumental spaces. While the land bridge
from below now appeared as one coherent piece,
Pacific Place needed to be further refined to create
a contrasting and positive experience. By finish-
ing the underside of the bridge as a "front" surface,
they would create an equality in value and gen-
erosity between those traveling below and those
with so-called privileged views above.

However, it remained challenging to imagine
how retaining walls on either side of the road
could be anything besides overwhelmingly heavy
and dark. The easiest solution would have been to
frame the depressed space with concrete retaining
walls. A concrete-boxed underpass would inevi-
tably feel like a dark tunnel—the opposite of what
was desired. Looking for precedents of beautiful
enclosed experiences, they found inspiration in
local ravines and the prewar concrete bridges that
spanned them. There was a rich, mossy quality in
these spaces that was warm and welcoming rather
than isolating. There was a utilitarian quality to
the simple concrete bridges.

Shannon drew on what she knew of the char-
acter of the ravines by designing walls of gabion
baskets—layered in bands influenced by different
geological strata—to retain the earth on either
side of the sunken roadway. With Rebecca Fuchs's
detailed research and Bernie's knowledge of how
to construct the appropriate gabion wall, this
placed a rough, warm, natural material alongside
people walking or bicycling under the bridge.
The intention was to plant the walls with sword
ferns and shrubs, as if they were older, wilder,
and offered more acute contrasts to the perfect,
clean bridge spanning overhead. As the project
progressed, the planting pockets were removed to
save costs. Nevertheless, over time, soil and plants
will organically find their way into the gabions
and populate them in a spontaneous way.

When Mount Rainier is out, Rainier Vista is
an awesome sight. Even when the peak is not
visible, it is an elegant campus axis. As the new
trees mature to match the canopies of the exist-
ing trees, the forested character of the campus
will once again enclose the Vista, now extending
to the Montlake entry court. This is a renewed
and rejuvenated enhancement of the foun-
tain-to-mountain experience the community
knows as Rainier Vista.

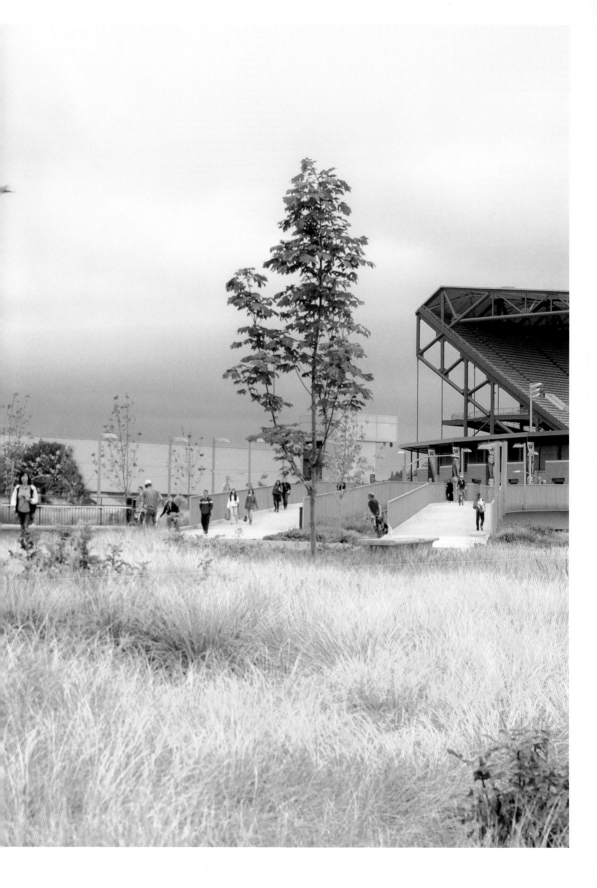

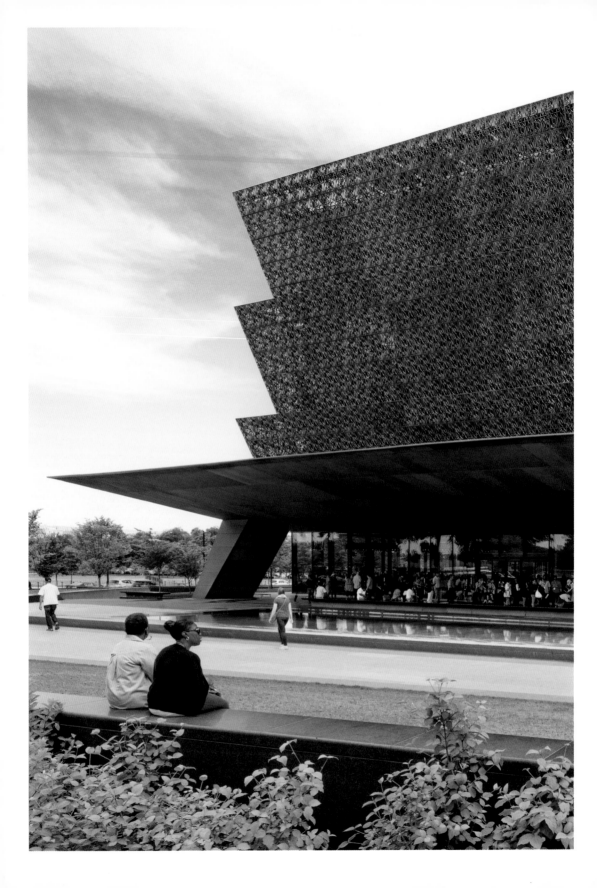

NATIONAL MUSEUM OF AFRICAN AMERICAN HISTORY AND CULTURE 2009–2016

The National Museum of African American History and Culture opened in 2016. The landscape design integrates a major new museum into the grand composition of the National Mall—more specifically connecting the Washington Monument, which stands to one side, and the American History Museum and other museums that line the most venerated public space in Washington, DC. In 2009, after an international competition, the Smithsonian Institution chose a submission by a team of design firms: the Freelon Group, Adjaye Associates, Davis Brody Bond, and SmithGroupJJR, with GGN in place as the landscape architects. The building is first and foremost recognized as a stunning work of architecture, set in an understated landscape that serves as a visitor's first introduction to the museum narrative, underscoring its vision and mission. The landscape design is an invitation to the museum and a quietly reflective path through the nation's history.

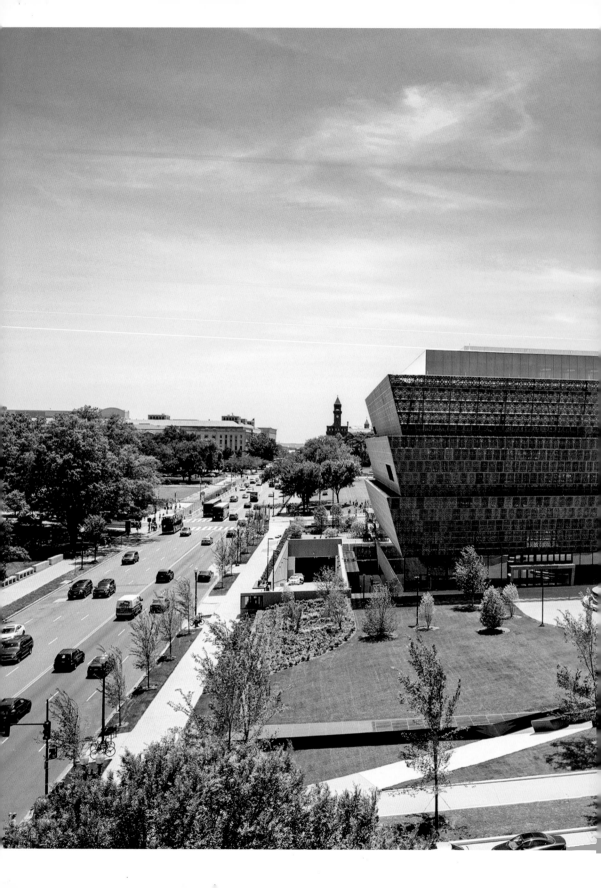

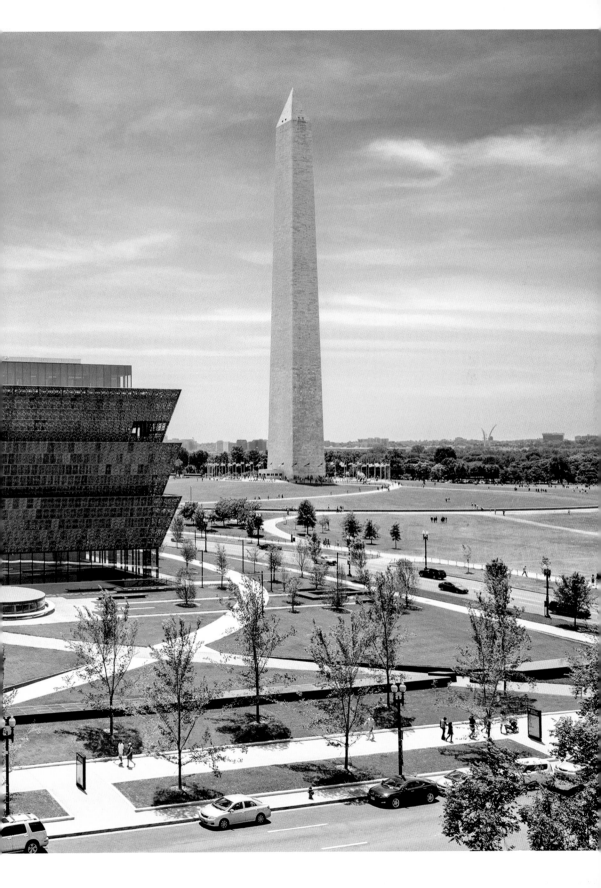

A remarkable work of deeply symbolic architecture, the National Museum of African American History and Culture (NMAAHC) is sited in an equally meaningful setting. This is not a mere coincidence of two strong works together, but a result of intense collaboration within the design team to realize the power of the museum's narrative and its place in American history. The core question was whether the design team could shape a site that would both be a part of the larger context of the national mall and a place that belongs uniquely to the museum. With the concept of a "pavilion in a park" the completed design explores and celebrates the dynamic role African Americans have played in the history and fabric of the nation and acknowledges the difficult path many have encountered on the road to citizenship—and continue to experience in the ongoing struggle for equality.

The unique team of designers revealed a keen understanding for the vision and needs of the museum, winning the competition and realizing the now-iconic project on what is possibly the last buildable site on the National Mall. GGN was tasked with integrating the building into its surroundings, connecting the site to its broader context, and providing the appropriate thresholds and circulation routes to and from the museum. To realize this success necessitated what Mabel Wilson described as "working together like a jazz quartet."[10]

The complexity of the project was compounded by the need to address multiple reviews, oversight, and security requests, given the project's site on the National Mall and its cultural importance. The GGN team, led by Kathryn and Rodrigo, worked closely with David Adjaye and Phil Freelon on the design. Hal Davis of SmithGroup shepherded the review process, including that with the Commission of Fine Arts (CFA), the entity responsible for overseeing the design and construction of all buildings and museums on the Mall. It was the CFA that challenged GGN to create a more powerful northern edge, inspiring them to move from their original idea of a water canal that would have served as a sustainability element to the abstraction possible in a polished black granite wall. Additionally, other public audiences were keeping an eye on the NMAAHC design. No other such museum existed in the nation, and it had been decades in the making. It was in a famously intimidating location. There was no room for a design miss, for skimping, or for neglecting important details.

The challenge for the GGN design team was identifying and realizing a dynamic balance between competing desires to integrate the museum into the National Mall and to create a landscape that was deeply reflective of the museum and its unique mission. Thinking and exploring through drawings and plaster models, they knew it would require a controlled hand

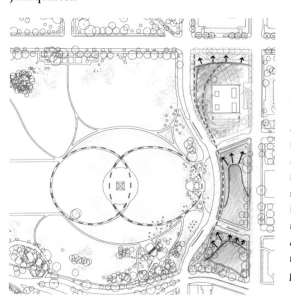

PREVIOUS PAGES *View of the landscape leading to the north entry of the museum; the curving paths between the two sites are visually connected, revealing the ways they echo those of the Washington Monument.* LEFT *A study of the Washington Monument in relationship to the new museum's landscape, to investigate how topography and geometry could link the two.* RIGHT, ABOVE *The museum sits at a key transition point between the rectilinear geometry of the National Mall to the east and the curvilinear composition that surrounds the Washington Monument to the west.* RIGHT *Sketch by Kathryn to study the relationship of the museum and its landscape to the Washington Monument.* OVERLEAF *The site plan, which exhibits the important role of trees and the perimeter in defining the museum's precinct as a self-contained area while simultaneously offering clear entry paths from four directions. The geometries of the architecture and landscape connect the precinct to the grounds of the Washington Monument.*

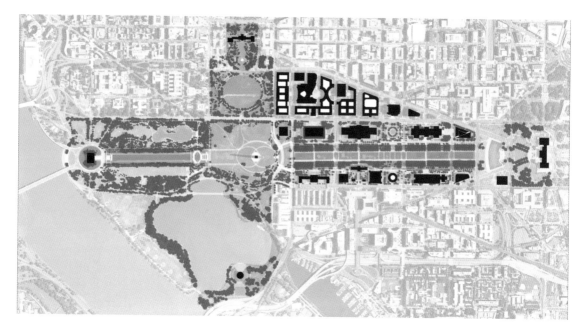

and a thoughtful integration of the human body with the landscape and site. As they developed the design, they realized they could grade the land to rise ever so slightly from its edges, creating a series of crossings and thresholds leading up to the museum entrance itself.

When the museum opened on September 24, 2016, President Obama noted that "this national museum helps to tell a richer and fuller story of who we are.... By knowing this other story, we better understand ourselves and each other. It binds us together. It reaffirms that all of us are American, that African American history is not somehow separate from our larger American story... It is central to the American story."[11]

From the outset, the project was considered by the design team as a unified building and landscape. The trees and water played important roles, serving as natural and symbolic elements that GGN would ground in the design's narrative. Landscape was also important because it embodies the history of the National Mall, where the Museum would be a significant landmark. The site was once a marshland donated by two

slave-holding states, Maryland and Virginia, for the establishment of the nation's new capitol. Surveyed by the free African American surveyor Benjamin Banneker, it was designed by Pierre L'Enfant. It was also a place that witnessed pivotal moments in the civil rights movement. These narratives along with the themes of resiliency, hope, and optimism, spirituality, and community, were important to reflect in both the architecture and the landscape of the new museum.

Siting the building was an essential early decision. The location is a linchpin between the Mall's formal axis and the picturesque north-south axis of the Jefferson Memorial and White House. It is also directly adjacent to the Washington Monument and is at the endpoint of the row of Smithsonian museums. This relationship to the site's context would be increasingly key as the design developed.

After much debate, the building was placed not at the center of the site but closer to the southeast corner, where it would be above potential flooding and aligned with the Mall's museum fronts. Additionally, the eventual design sited or located over sixty percent of the building underground. This allowed a more expansive landscape as well as two discrete scales and forms to be expressed as two distinct but equally significant entry routes from the south and the north to the museum. To the south would be the primary entry route and seating terrace; to the north, a more open landscape with its own entry journey.

The design of the museum's landscape was figured out iteratively. The competition was only the first approach of many. The team explored at least three distinct design concepts after winning the competition, as it sought to identify the right expression for the landscape and its architecture. It was both a part of the National Mall and its own space. The landscape needed to both gracefully absorb and clearly establish a sense of arrival and place that complemented the established building. An early decision was to create a contiguous landscape and entry reflecting founding director Lonnie Bunch III's emphasis on the idea that "We are one people." This meant that, unlike at other museums, the lobby should be on one floor and the landscape should be graded to meet both entryways. This decision alone

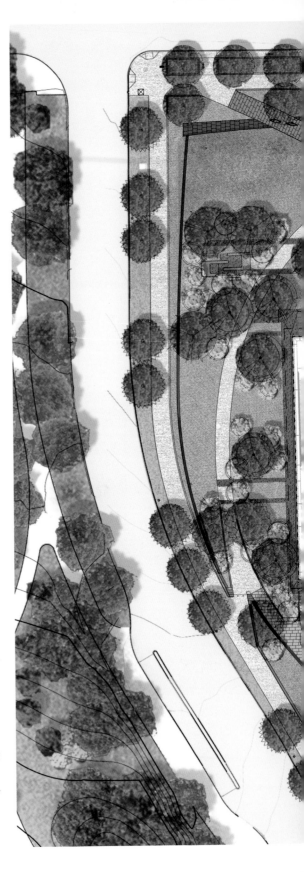

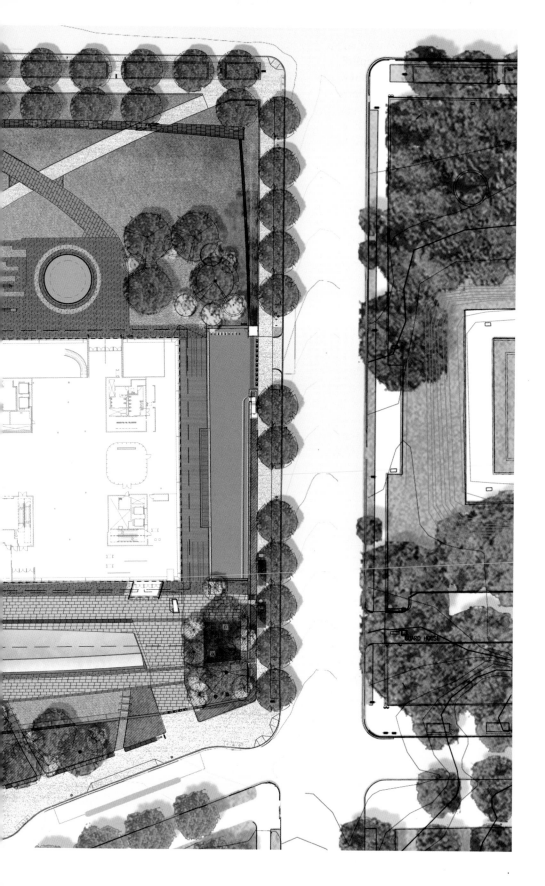

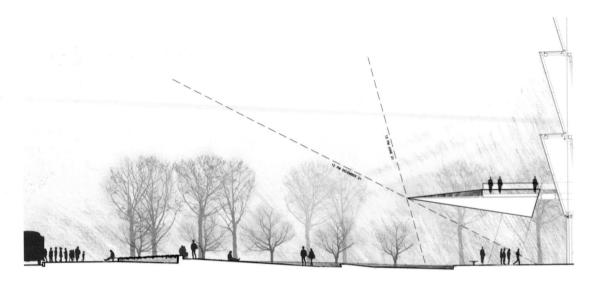

distinguishes the museum's intent from any of the others along the Mall; the power of design is amplified when landscape and architecture are designed in tandem and toward a common goal.

Creating entries to welcome visitors and contribute to the Museum's narrative was crucial, and GGN knew the pacing and experience of the entry journeys would be significant.

The simplicity of how the building meets the landscape to form a threshold was the result of multiple sketches and explorations by the team.

They designed the south entry in layers formed by a seating wall, followed by a mass of low shrubs with katsura and gingko trees as well as sassafras, suggesting forest textures and colors.

Water was emphasized in the landscape as a reminder that many African Americans who came to this country did so by traversing water—often during a forced voyage. At the edge of the Museum's 200-foot "porch," an iconic element of vernacular American architecture, a shallow reflecting pool offers a moment of transition. It is carefully articulated to suggest the intimate scale

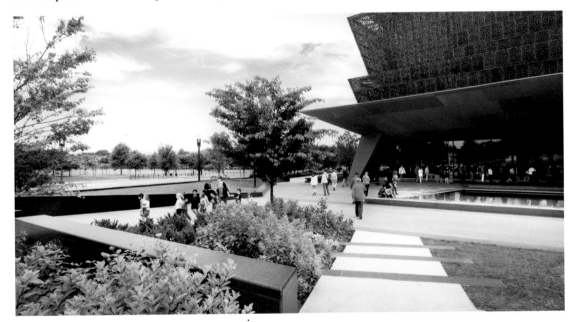

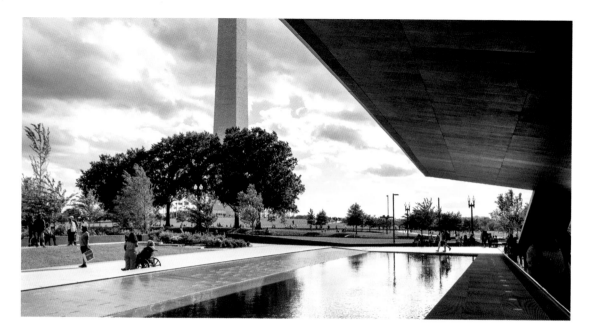

of the human body as well as to provide a moment of reflection on the history and culture that is the core of the Museum experience. The porch and pool hold the visitor for a momentary pause, and when the visitor looks up, the Washington Monument comes into view, suggesting diverse connections to the national story.

The pool, as a space of brief reflection, is layered with meaning that shapes the place physically and aesthetically. Water ripples at the top, where the pool angles down. Submerged in brass letters is a quote by James Baldwin: "I think that the past is all that makes the present coherent, and further, that the past will remain horrible for exactly as long as we refuse to assess it honestly."

Water flows down the gently angled wall and then empties into a central seam. The lower basin is a calm, shallow container that also receives flowing water. On the bottom surface of this second pool, the words of Frederick Douglass are inscribed: "Liberty exists in the very idea of man's creation. It was his even before he comprehended it. He was created in it, endowed with it, and it can never be taken away."

LEFT, ABOVE *Winter and summer sun angles determined the loacation of the fountain relative to the porch; it creates an environment that cools in the summer but allows sun to enter in the winter. Sketch by Rodrigo.* LEFT *The landscape of the museum porch is experienced as a series of layers that guide visitors intuitively toward the building's entry.* ABOVE *The careful grading of the landscape offers a sense of continuity between the museum and its larger context, while also obscuring the street.* RIGHT *The south entry landscape offers places for contemplation and gathering, allowing for intimate moments to be created even next to monumental experiences.* OVERLEAF AND PAGES 268–269 *Water ripples across the surface on one side of the water feature, while on the other the water is calm and smooth; the two streams meet in the middle as a metaphor for life, always comprised of moments of turbulence and moments of serenity.*

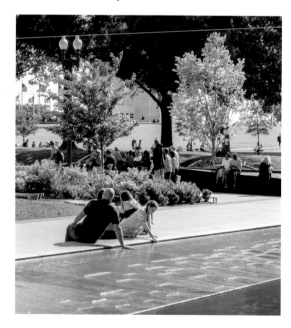

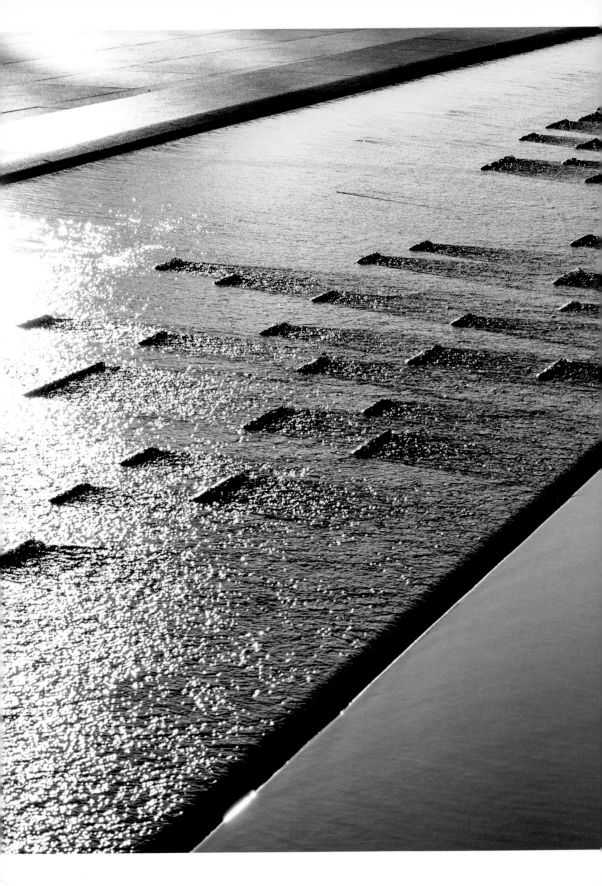

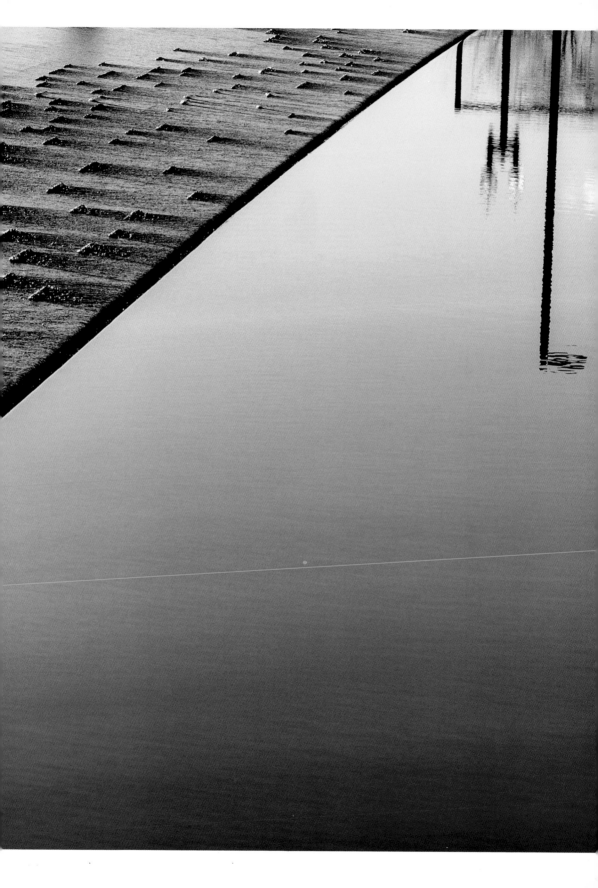

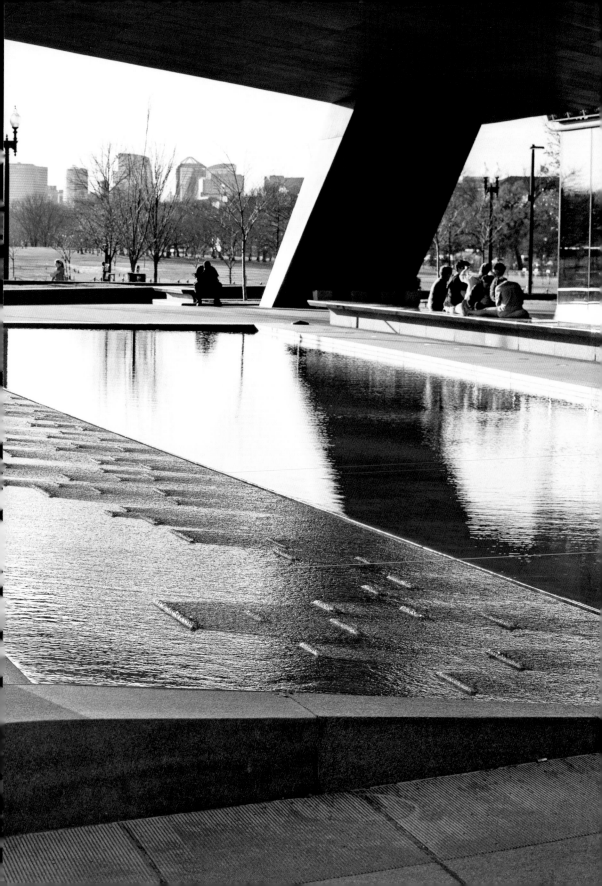

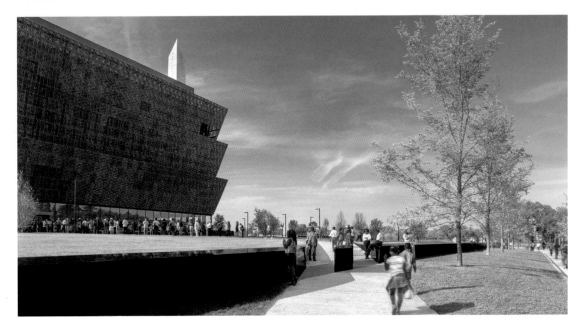

Human scale is deeply embedded in the sensual layering of the entryway as well as in the relationship of the pool and the porch. Moreover, the ephemeral qualities of the plants and the moving and reflective water symbolically link past, present, and future of both the Museum and the African American experience.

To the north, the landscape expands from Constitution Avenue to the Museum in layers, similar to the south entry. The threshold begins with a double row of American elm trees that extend the rhythm of trees lining Constitution Avenue. The second layer is marked by a gently curving wall of highly polished Mesabi Black granite, recalling the historic route of Tiber Creek. It is three feet tall and ranges from six to ten feet wide, 340 feet along the north, with openings near each of the two corners.

At the openings cut into the wall, there are substantial bollards. Besides satisfying security requirements, these frame a passageway that suggests the difficulties of travel for Africans and for African Americans during the Great Migration and into the twenty-first century. The wall

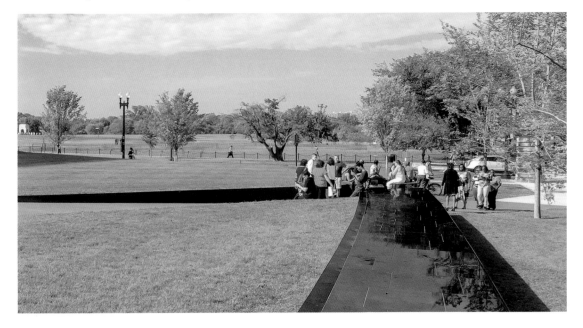

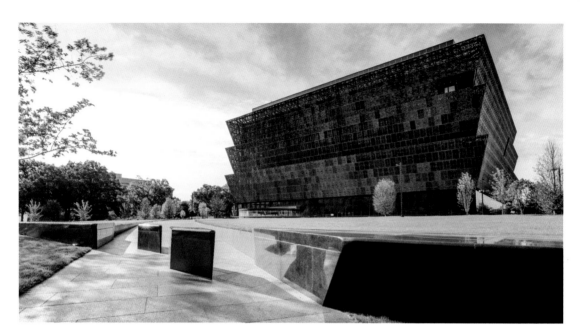

and bollards is not detailed as a barrier, but rather forms a threshold and moment of transition. As an echo of Tiber Creek, the polished stone reflects sky and clouds, resembling the movement and texture of water. From inside, the path ascends toward the middle with the Washington Monument increasingly visible until it is perfectly aligned, at midpoint. Ironically, as the designers now point out, this passage through the black marble was inspired only when they could not include the original plan for a water channel, yet has become one of the site's most popular spaces

in the landscape. While crossing water would have signaled a similar passage, the verticality of the wall may well offer a stronger articulation of the concept. Additionally, visitors use the wall to walk along, sit on, lean on, and marvel at the surroundings.

After crossing the symbolic thresholds of stone and water, the arcing paths, one of granite pavers and the other of concrete, echo the curves of paths designed by Laurie Olin in 2005 to provide security as well an appropriately reverential approach to the Washington Monument. Like

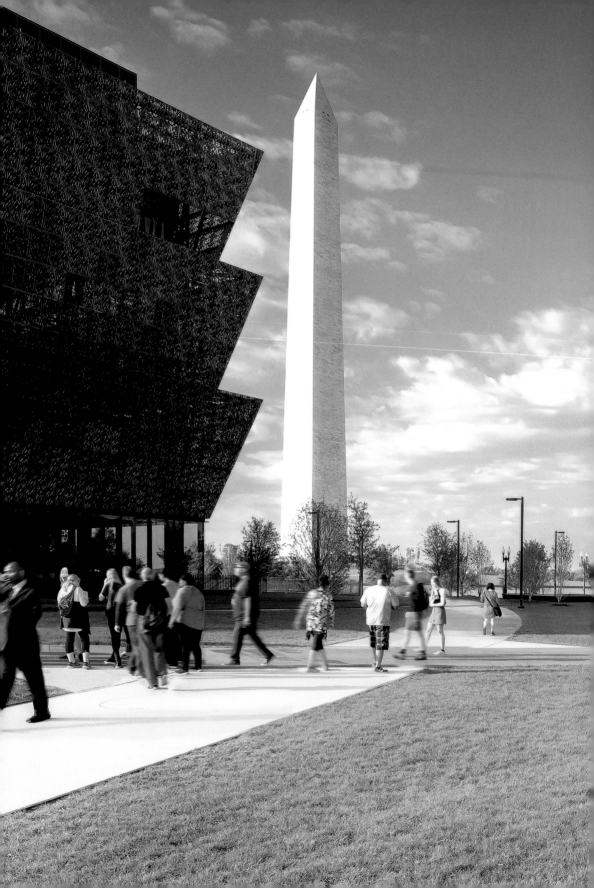

PAGE 270, TOP *From Constitution Avenue, the entryway lies*
across the elegant threshold of American elm trees and the polished
black granite wall. PAGE 270, BOTTOM *The wall recalls Tiber*
Creek as it flows through the undulating lawn. PAGE 271, TOP
The entry bollards read more as sculpture than as security feature,
though they are both. PAGE 271, BOTTOM *The perimeter*
wall, designed as a slice through the landscape, focused on details
and materials from the earliest sketches, by Rodrigo. PREVIOUS
PAGES *At the crossing of the entry paths, a view of the Washington*
Monument reveals how the angles of the capstone are echoed in the
museum's corona. LEFT *Over 349,000 crocuses bloom on the lawn*
in early spring. RIGHT *Sketches of bench options by Kathryn for*
encouraging community engagement through an interlocking com-
position. BELOW *The Reading Grove, where interlocking benches*
are based on an abstraction of interlocked hands. OVERLEAF *As*
a part of the National Mall, the landscape for the museum offers
diverse spaces for community gatherings as well as solitary contem-
plation or just giving museum-going feet a rest.

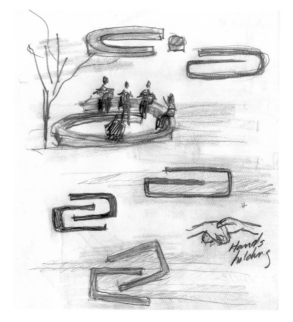

275

those of the Monument, the paths of NMAAHC
are not encumbered by trees, highlighting
views of the Mall and the Monument. Closer to
the Museum, Kathryn and Rodrigo planted groves
of trees, including those native to and part of the
cultural traditions of the Southeast, such as live
oaks, magnolias, and American beeches. These
reinforce the Museum's themes of resiliency, spir-
ituality, hope, and optimism grounded in place
and culture.

It is at the crossing point, where the two entry
arcs meet, that one of the remarkable views comes
into focus. As one moves along the path from the
east, the Museum's facade can be viewed in align-
ment with the Washington Monument, most pow-
erfully from the meeting point. This is the view
from which the angle of Adjaye's building corona
most dramatically repeats that of the Washington
Monument's capstone.

Within this dramatic landscape are also more
intimate spaces. One is offered by the Reading
Grove, dedicated to hope and optimism. A
community space that draws on the metaphor of
hands holding and an allegory of support between

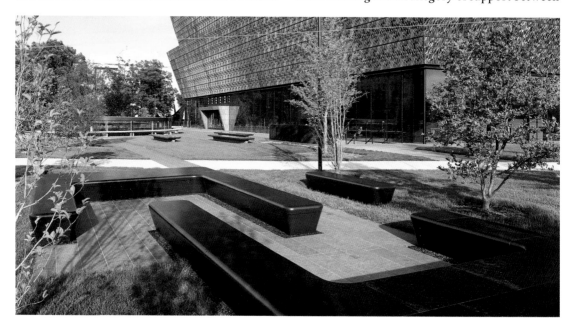

people, it features two interlocking U-shaped, powder-coated steel benches in a dark brown to match the building's mullions. On the ground, alternating bands of grass and stone suggest agricultural furrows of tobacco and cotton fields as well as acknowledging the many Africans who arrived with deep knowledge of farming. American elms and copper beeches surround American beech, cherry, magnolia, and live oak trees that comprise the grove, honoring the need for veiled and quiet spaces. There are many narratives to be shared, calling for moments of reflection and learning, and the benches create such space—whether for an intimate conversation or a discussion with a class of fifth graders.

GGN selected each of the plants to play a role in the larger narrative and experience of the place. Setting out 349,000 blue crocuses to bloom in February honors African American History Month; the blue color recalls the importance of blue beads for African American slaves as a symbol of hospitality. Dogwoods and magnolias provide a veil of white in spring and early summer, suggesting a spirituality of landscape. The flowering plants and contrasting textures evoke, as noted by Mabel Wilson, African American places of memory, conveying a complex relationship to the land.[12]

This important project in the nation's capital reveals the power of design as a collaborative project of investigation and exploration. As Jennifer Reut has written, it is a landscape that is experienced as the body moves through the site, "very much a dancer's landscape." The architecture and the landscape come together to create a moment of recognition, acknowledgment of a history at the foundation of who Americans are today.

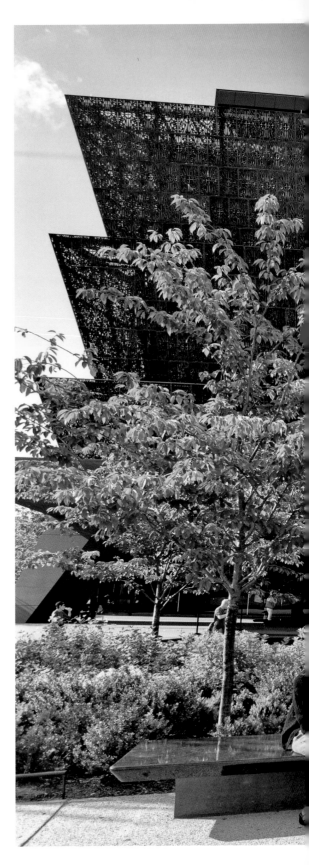

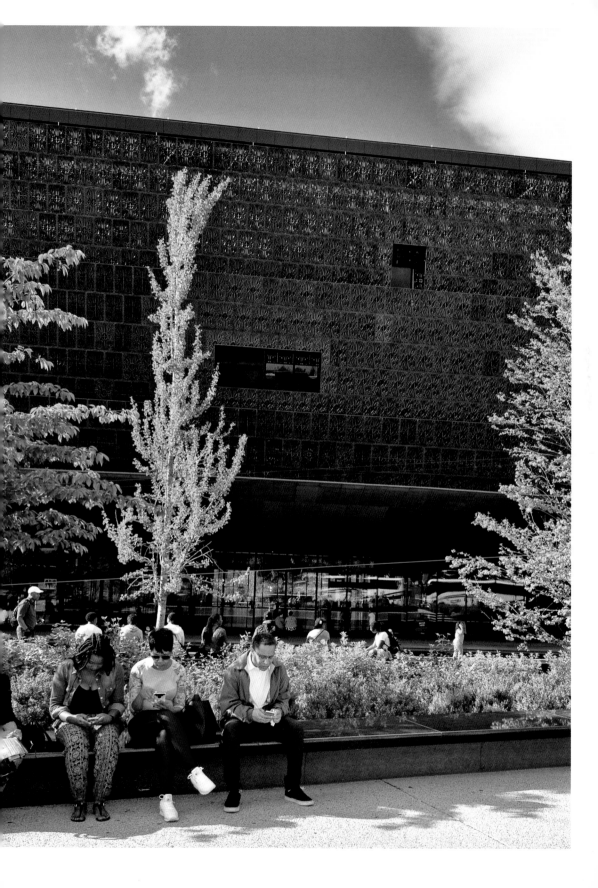

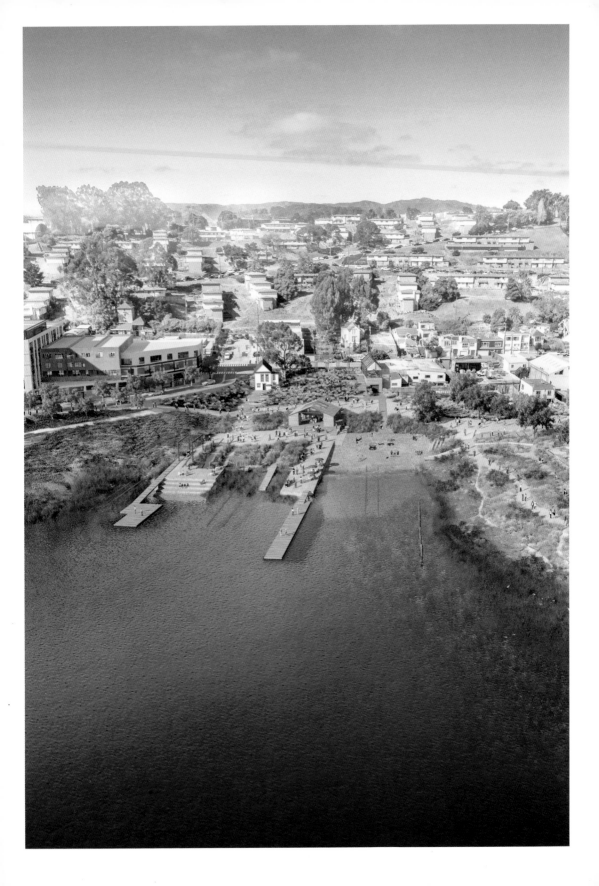

INDIA BASIN
SHORELINE PARK
2016–2018

Located in the Bayview-Hunters Point neighborhood of San Francisco, India Basin Shoreline Park connects the landscape, communities, and the waterfront. The proposed design unites the historic boatyard and Shipwright's Cottage and the underutilized India Basin Shoreline Park into one park, creating 1.5 miles of accessible shoreline along the San Francisco Bay and linking the Bay Trail and the Blue Greenway.

GGN was selected as the winning firm from the India Basin Waterfront Parks Design Ideas Competition to lead the concept design. The GGN team included MKA, civil engineers specializing in water resource strategies; Rana Creek, ecological restoration design firm; Greenlee and Associates, horticulturalists specializing in meadow design; Turnbull Griffin Haesloop Architects; and Alta Planning + Design, transportation planners.

In 2014, the City and County of San Francisco acquired the Shipwright's Cottage at 900 Innes Avenue, in between India Basin Shoreline Park and India Basin Shoreline Open Space. The park and open space are both underused, so the city—in collaboration with The Trust for Public Land and the San Francisco Parks Alliance, who was responsible for leading community engagement and funding from Build Inc.—conducted the Design Ideas Competition to reimagine a larger park that would actively connect the waterfront sites with the adjacent neighborhood. It would include an eight-acre park landscape offering local residents direct access to open space and waterfront, with expanded and improved recreational opportunities. Five landscape architecture teams submitted design proposals. After a juried review, GGN's proposal was declared the winning submission.

The expanded park, with its additional connecting links, take up just over 9.6 acres in the Bayview-Hunters Point neighborhood. It includes the India Basin Shoreline Park and the property at 900 Innes Avenue, located next to the intersection of Innes Avenue and Griffith Street. Currently, it is bordered by industrial, commercial, and residential uses to the west and south on Hunters Point Boulevard and Innes Avenue, the former Hunters Point Power Plant and Heron's Head Park to the north. India Basin, an extension of the bay, lies to the northeast.

Once a lively harbor, India Basin included extensive dry docks and shipyards from the early 1890s through both world wars, when the basin was used as a marina. However, by the 1970s, boating and shipbuilding industries had declined dramatically and the waterfront began to degrade. In 1999, to revive the neighborhood, Mayor Willie Brown named India Basin Shoreline Park a "Renaissance Park." Supervised by The Trust for Public Land, park improvements began in 2000 and the Bay Trail that ran through the India Basin Shoreline Park was completed, recreational fields were expanded, a playground and a basketball court were added, and benches and picnic tables were installed. Nevertheless, by 2014 it was clear the park remained isolated from the neighborhood and the shoreline was facing decreasing environmental and ecological health.

The historic Shipwright's Cottage was built around 1875. It was the first house built in the neighborhood and was the center of the emerging shipwright (wooden boat–building) industry in India Basin. This was where many historically significant scow-schooner fleets were carefully crafted during the early twentieth century, including Jack London's seventy-four-foot schooner, World War I submarine chasers, and World War II minesweepers. Boat-building and repair continued at the site until the late 1990s.

The vision for the design competition was to solicit concepts for extending the Blue Greenway/

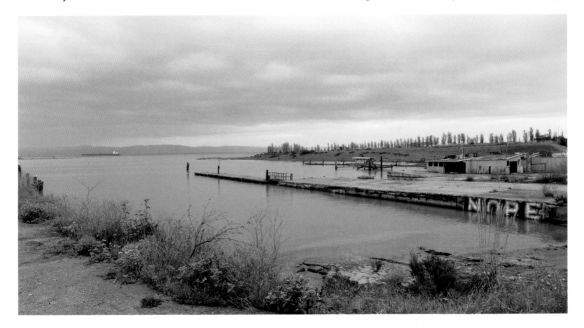

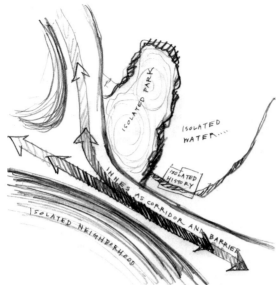

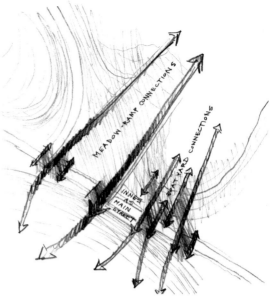

Bay Trail as a waterfront-access trail to connect the India Basin Open Space, Shipwright's Cottage, and the India Basin Shoreline Park, as well as a Class 1 bike lane that would run parallel to or in tandem with the walking route. Retention and restoration of the Shipwright's Cottage was a requirement that would be a part of the new park at 900 Innes Avenue, merging with the India Basin Shoreline Park, essentially creating one large park. Additionally, the new park concept would need to address the ecological and habitat health of the area, particularly in the mudflats

and marshlands, and the challenge of rising seas brought on by climate change.

In addition to the goals of the competition, GGN noted the challenge of gentrification that the local neighborhood faced, as the large public housing development was vulnerable to being replaced by expensive new real estate developments, especially if waterfront access was established. With these complex goals, GGN's approach, led by Shannon, was framed around a series of nested design gestures. The first idea was to replace hard edges with a gentle gradient of

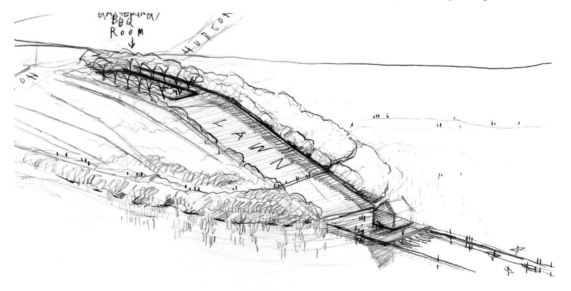

PREVIOUS PAGES, LEFT *The existing waterfront was an underused and neglected landscape, but it preserved relics of the wooden boat–building era as well as a rare portion of undredged, original shoreline, visible as the small "beach" in the lower right.* PREVIOUS PAGES, TOP RIGHT *Shannon's sketches explore circulation and the potential for new paths to connect the community with the environment while calming the traffic barrier.* PREVIOUS PAGES, BOTTOM RIGHT *The topography offers opportunities for a new version of the site's historic marine rails, which once connected industry to the water. Shannon's concept sketch shows a meadow echoing that form, bringing people to the formerly inaccessible shore.* LEFT *Stairways and pier-like paths connect the ridge to the waterfront. Sketch by Shannon.* BELOW *Rendered drawing by Keith exhibiting how the waterfront can create edge zones for ecological health and resilience.* RIGHT *Accessible and ped-scaled layers of spaces defined by reconfigured street crossings.* RIGHT, BELOW *Aerial photograph of Innes Avenue; it bars access for families and residents of public housing just up the hill.*

upland and marine landscapes that would wrap around the entire cove to create a "Big Soft Edge." The second move was the redesign of Innes Avenue, the main thoroughfare separating the neighborhood from the waterfront, to include controlled intersections, widened and complete sidewalks, street trees, and bike lanes. Building on the proposed ideas for Innes Avenue, Shannon introduced a sequence of walking routes and crossings that connect the water with the hills crossing over Innes Avenue to create a "Walkable Cross-Grain."

Finally, the proposal honored the only original shoreline remaining in San Francisco, at the historic boatyard, anchored by the Shipwright's Cottage. This would become a gathering space for the neighborhood that would retain the informal and varied interests of locals. India Basin Shoreline Park is emblematic of twenty-first-century design, as it addresses the challenges of urban waterfronts ecologically and culturally, engages communities in the vision of their own neighborhoods, and reveals how historical narratives enrich and serve contemporary populations.

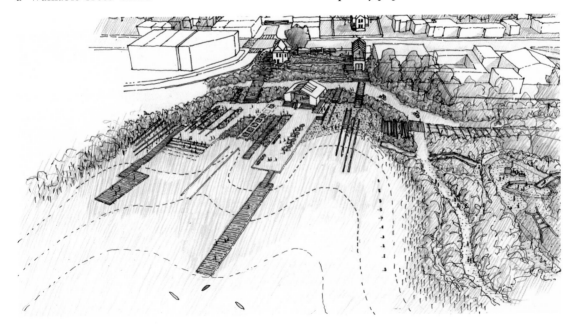

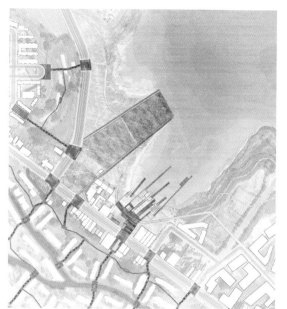

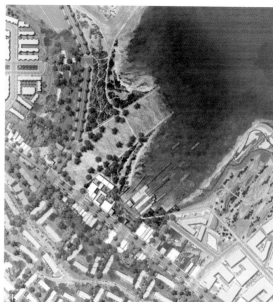

To unify India Basin into one unforgettable place, Shannon and the team pulled the walking path and bike trail as parallel ribbons to swoop along the shoreline. An additional shoreline walk echoes the broader trail while allowing closer access to the water and mudflats. Extending the walkways, docks provide access to deeper water as well as views back over the park and its larger neighborhood. These trails expand the 345 miles of the Bay Trail, in a plan that will eventually reach 500 miles. ADA accommodation takes into consideration not only movement along the trail but access to features, including the waterfront. Shannon layered these more pragmatic elements with rich ecological and cultural references, nods to the habitats of the waterfront, the boat-building industry's history, and the park itself.

The hillside neighborhood is equally important, and Shannon paid close attention to residents' ideas about how a good urban design might better connect the community to its local assets, particularly the park and waterfront. Tackling the foreboding interruption of Innes Avenue was a major priority.

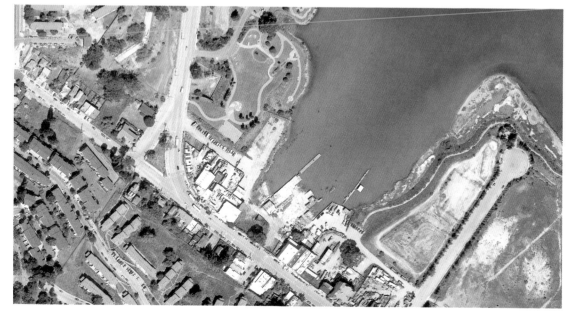

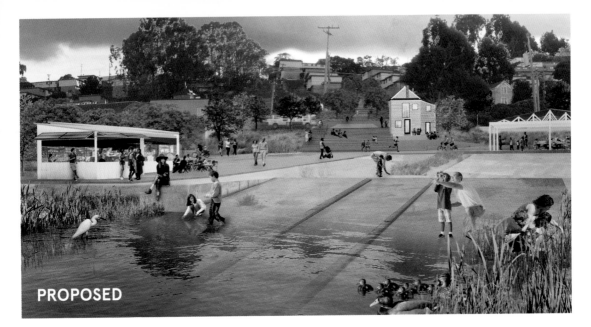

PROPOSED

Realizing that a major obstacle to the park's success would be the lack of easy access from the neighborhood, Shannon's concept began with the idea of a hill town rising up from the shoreline. This concept allowed her and the team to draw the design not only across and along the waterfront, but up and into the neighborhood. Designing for multiple and varied connections encouraged Shannon and the design team to meet a range of human and environmental needs. Design insertions of pedestrian-friendly street standards, hillside paths, stairs, and bike lanes

were all ideas intended to strengthen community identity and resilience.

To connect the larger neighborhood and its waterfront, the team recommended that Innes Avenue become a walkable shopping and community street. Currently a mix of 1950s public housing and a few scattered Victorian cottages, the neighborhood has a limited number of stores. GGN proposed reasserting traditional crossings at the scale of a walkable block, crossings that would connect with a network of pathways and stairways ascending the hillside. A street tree planting

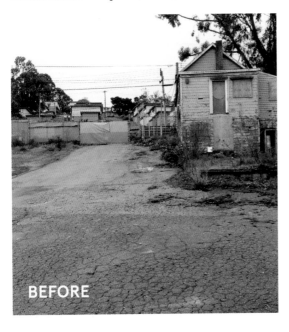

BEFORE

ABOVE *Proposed waterfront access, which would serves as a play space as well as a habitat for bay species. New stairs connect up the hill connect it to the neighborhood.* LEFT *A historically significant shipwright's cottage in the current view, looking toward the neighborhood from the site.* RIGHT, ABOVE *A drawing by Rebecca Fuchs of a proposed street crossing at the park's entry.* RIGHT *Existing streets offer little connection to the watefront; note the worn pathway leading to the housing complex above.* OVERLEAF, TOP LEFT *The new waterfront will connect to a regional path and to the neighborhood, bringing healthy recreation options to the long-isolated neighborhood.* OVERLEAF, BOTTOM LEFT *The health of the shore environment will be improved, and the shoreline more accessible to visitors and residents. Native plants will create bird habitat.* OVERLEAF, RIGHT *Proposed plan for the waterfront landscape.*

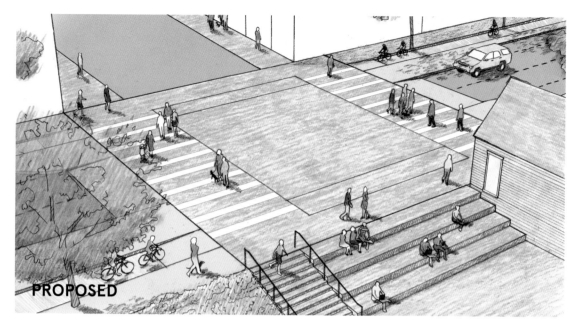

PROPOSED

plan and bike lanes were added, insertions that would counter the heavy traffic along the avenue and instead convey the character of a proper Main Street. This plan would provide the necessary bones for the district to attract daily services that the community sorely lacks. This, Shannon suggested, would generate a modest commercial district along the avenue, both giving rise to and benefiting from a safer place to cross.

On the steep side of the avenue, Shannon's plan designates paths that ascend the slope to connect hillside homes with the piers, boatyard, and shoreline below. The paths would include stairs where necessary, given the steep slope. They would also move across the landscape, weaving between residences, recalling their informal presence in the landscape for generations. Numerous historic springs dot the hillside, so Shannon suggested restoring a few along the new hill-climb routes to form verdant "springways" surrounded by native plantings that would also serve to naturally clean the seasonal, fresh surface water that runs down the hill to the bay. The Walkable Cross-Grain, together with the

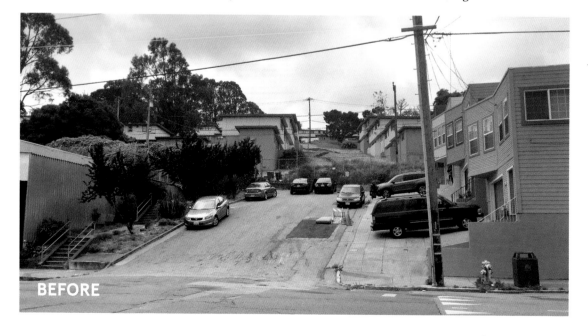

BEFORE

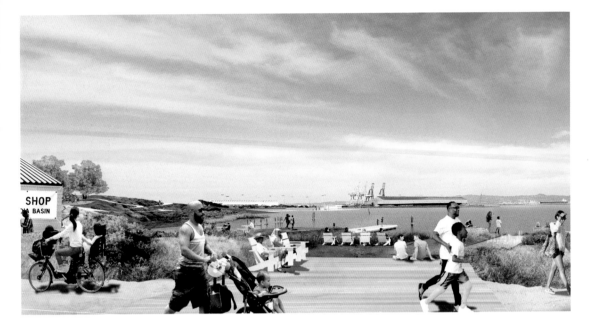

shoreline trails and piers, prioritizes people, ensuring high usage.

Building on community desires, Shannon proposed that the historic narrative of the boat-building activities serve as the central concept for the space at 900 Innes Avenue. Rather than a conventional civic plaza, the boatyard could become a town square. This would provide generous access to the waterfront, including kayak launches. The design is intended to retain the deeply textured, informal, and authentic character of the neighborhood and its industrial past. Per the requirements of the competition, the Shipwright's Cottage would be restored and a community space built framing the Innes Overlook, remaining active without putting an undue operative burden on the structure. The design is also an innovative approach to architectural preservation, demonstrating how the park might gracefully merge historic with modern.

Finally, and crucially, ecological health and resilience is an essential goal of the community project. India Basin will honor the green heart of its neighborhood, while also fostering healthier

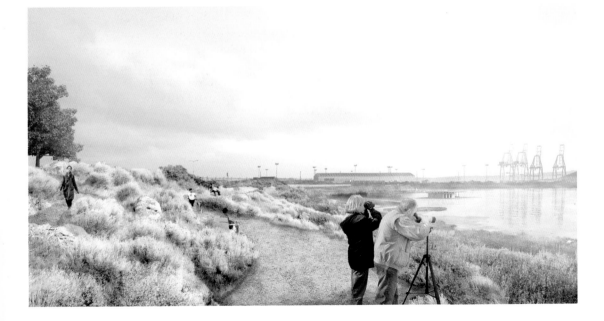

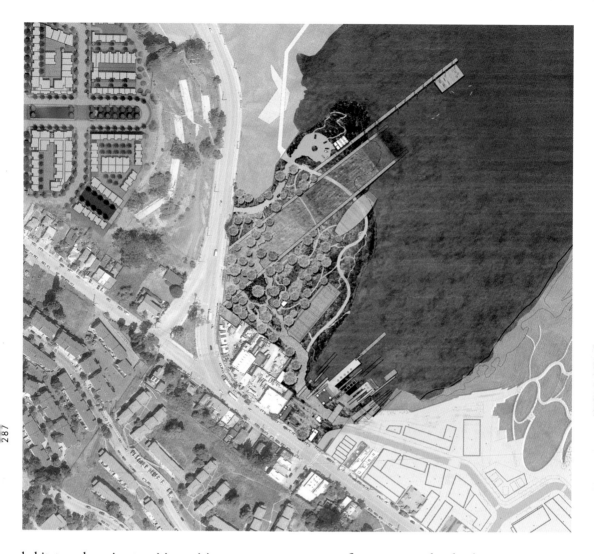

habitats and serving to mitigate rising seas as a green coastal storm surge barrier. The design for ecological health must address the dynamics of tidal mudflats and marshes, grassland, coastal sage, and at the top of the ridge, a coastal live oak landscape. A biological assessment noted the challenging presence of developed land, disturbed infill, mixed landscaping, sand/gravel, and riprap along the shoreline itself. Such elements are tackled through the design, including waste and storm water systems, an urban water treatment garden, and floating wetlands. Interest in expanded wetlands is high as they provide exceptionally bio-diverse habitats and there may be state funding for such projects.

As a community-oriented design project, India Basin Shoreline Park offers a remarkable example of what it means to design in a twenty-first-century urban landscape. GGN's ability to use design to unite, restore, renew, and reimagine the park and its community offers an extraordinary model for how landscape architects can provide a vision of a more resilient, healthy, and equitable future community and city.

ENDNOTES

1. Kathryn Gustafson, "Longing for Jacques Simon," *Topos 50*, March 2005, 44.

2. Gustafon Porter LTC and Gustafson Guthrie Nichol Ltd., "Towards Paradise" in *Out There: Architecture Beyond Building* (Venice, Italy: Marsilio, 2008): 56.

3. "Park Here," *New Republic*, October 6, 2010.

4. Regina Flanagan, "The Millennium Park Effect: A Tale of Two Cities" in *The Practice of Public Art* (Abingdon, UK: Routledge, 2008): 144.

5. Lurie Garden concept description, GGN files, 2004, 4.

6. Betsy Anderson, "Share the Wealth," *Landscape Architecture Magazine*, November 2014, 129.

7. Rogers Marvel Architects & Peter Walker and Partners were awarded the redesign of Constitution Gardens east of the Vietnam Veterans Memorial, while Olin Partnership & Weiss/Manfredi was awarded the design to bring new life to the Sylvan Theater, southeast of the Washington Monument. The winning design for Union Square, by GGN & Davis Brody Bond, was forwarded to the Architect of the Capitol.

8. Seattle Right of Way Improvements Manual: http://www.seattle.gov/transportation/rowmanual/manual/6_2.asp, accessed November 1, 2017.

9. Nancy Levinson, "Campus Planning Is Breaking New Ground," *Architectural Record* 192, no. 8: 8.

10. Mabel O. Wilson, *Begin with the Past: Building the National Museum of African American History and Culture* (Washington, DC: Smithsonian Books, 2016).

11. Spoken by Barack Obama, first African American president, at the National Museum of African American History and Culture, September 26, 2016.

12. Wilson, *Begin with the Past: Building the National Museum of African American History and Culture.*

Rodrigo Abela
Annelise Aldrich
Bernie Alonzo
Juliet Anderson
Emily Ang
Adrine Arakelian
Jasmine Aryana
Kate Austin
Jordan Bell
Michael Benson
Brian Bishop
Kevin Bogle
Kristelle Boulos
Stephanie Brucart
Jessica Calder
Melissa Cate Christ
Steven Chavez
Selina Chiu
Lesley Conroy

Azzurra Cox
Amy Cragg
Chihiro Shinohara Donovan
Cheryl dos Remedios
Amy Eastwood
Jeanne Ernst
Michael Espenan
John Feit
Nathan Foley
Jill Fortuna
Rebecca Fuchs
Takanori Fukuoka
Rikerrious Geter
Aria Goodman
Therese Graf
Seth Gray
Kathryn Gustafson
Jennifer Guthrie
Erik Hanson

Johnny Hartsfield
Shantell Hatfield
Tera Hatfield
Meg Herndon
Eric Higbee
Ian Horton
M. Humphreys
Selina Hunstiger
Misha Ickstadt
Fred Jala
Karen Janosky
Caitlin Jorgensen
Huei-Ming Juang
Shoji Kaneko
Patrick Keegan
Bryn Kepler
Adrienne Leach
Laurel Li
Katherine Liss

STAFF LIST

Ju Liu
Gareth Loveridge
Ashley Ludwig
Anita Madtes
Kelly Majewski
Peter Malandra
David Malda
Jitesh Malik
Liz Martini
Alex McCay
Austin McInerny
Ryan McPartland
Keith McPeters
Alan McWain
Katsunori Miyahara
Anne Morris

Kate Mortensen
David Nelson
Theresa Neylon
Shannon Nichol
Lynda Olson
Erica Owens
Emily Pizzuto
Jenna Rauscher
Katia Rios
Chris Saleeba
Cass Salzwedel
Laura Sanders
Teresa Schiavone
Lauren Schmidt
Emily Scott
Travis Scrivner

Yi-Chun Lin Stanley
Grant Stewart
Jillian Strobel
Makie Suzuki
Philip Syvertsen
AJ Taaca
Anne Thomson
Yuichiro Tsutsumi
Wolfgang Umana
Stacy Vayanos
Hannah Vondrak
Joan Walbert
Sarah Watling
Kara Weaver
Marcia West
Sara Zewde

This project began when I arrived in Seattle in 2007 to teach at the University of Washington. As I was learning to make my way through the city, Shannon and Jennifer introduced me to its extraordinary design community. I found myself seeking out GGN projects as I traveled, sending brief texts with simple observations: "Am in North End Parks. Love the water." Or: "In Lurie, where did the stone come from?" The simply beautiful landscapes revealed deeply embedded narratives that I, as a historian, appreciated.

As I have never practiced myself, I was interested in exploring the process that could lead to such designs. For my sabbatical year I dedicated a day a week in the office to observe while writing about another landscape architect, Richard Haag. Thus began, without any intention, my writing about GGN; it also helped me to more fully understand the design process and to interject its narratives in my teaching and research. This book only reveals the tip of what I learned.

When it came to writing this book, it was proposed and built as a collaborative project. I wrote the text and take full responsibility for any mistakes or misinterpretations. There are places I have included readings that don't fit acknowledged intentions, because, as I contend, we do not always know what we intend. The image selection was also a collaborative project, building on the ways in which I described the design practice and how we understood the problem-solving nature of the work. Together they build what we hope is an engaging and provocative narrative.

I want to acknowledge Shannon, Jennifer, and Kathryn for their generosity in welcoming a geeky historian to hang out in the office and ask a

ACKNOWLEDGMENTS

lot of questions. Rodrigo Abela, David Malda, and Keith McPeters spent hours with me either talking about projects, or, more often, sketching in order to make sure I understood how they thought about a project. Shannon, Jennifer, and Rodrigo visited projects with me to learn of the lived landscape alongside design intentions. Rebecca Fuchs, Bernie Alonzo, Grant Stewart, Tess Schiavone, Jordan Bell, and Kara Weaver as well as Cass Salzwedel and Lynda Olson answered a hundred and one questions about process and behind-the-scenes thinking. Each allowed me to peer over their shoulders and ask why and how they were developing a certain detail or idea or plan. I also want to thank those whom I interviewed, including clients, architects, and others with whom GGN has partnered. Furthermore,

I am immensely grateful for the careful stewardship of their landscapes.

Cheryl dos Remedios guided the final production with grace and composure. Stacee Lawrence, acquisitions editor for Timber Press, steered the messy process, keeping all of us focused on creating a book that would reflect the depth of the work. I hope we have done that.

Finally, I must thank my family. My adult children, Adrian and Natasha, and my partner Marc have become quite familiar with my landscape history projects, but I continue to be grateful for their ability to share my enthusiasm for beautiful places and my critique of those places that do not live up to what we so badly need in today's world: landscapes that are replete with beauty, integrity, and generosity. —Thaïsa Way

"In your park," the text read; it was one of the first texts that I received on my slippery new iPhone in 2007. What park? And who has my new phone number? An image followed. Someone was clearly in North End Parks in Boston and strangely thought to text one of the landscape architects from its past. Who knows such things? "This is Thaïsa," came the last line, after a casual observation about how the park was working for the people there. That was all.

Jennifer and I had just met Thaïsa Way a few days before, but she was already boldly acting on a discussion from our first meeting. We had exchanged an interest in observing and learning about each other's respective work, as practitioners and as historian. That would be great, we agreed. Maybe we will hear from her sometime when that rare convergence of topics comes up. This was before we realized that Thaisa doesn't wait for perfect opportunities.

As a ground-breaking historian of the overlooked stories of landscape, Thaïsa finds meaning and momentum in the fragments and mysterious prospects that would merely pose questions to the rest of us. This, along with her ability to work from raw materials and flat files, is largely to credit for this book, as well as a series of off-piste projects that we have all embarked on together. One of these projects is the Drawing in Design workshop and lecture series at the College of Built Environments, which GGN sponsors and she curates and leads.

At GGN, our diverse group shares a love for being immersed every day in puzzles and the infinite—wonderful problems of design. We thus have had the tendency for almost twenty years to dive into the next project's unsolved mysteries without thoroughly curating or summarizing our previous work. This, as you might imagine, makes any prospect resembling an invitation from a book publisher into an increasingly alien and unlikely task with every year that speeds by.

Therefore, when our wonderful editor, Stacee Lawrence, invited us to participate in a book by Timber Press, we hesitated as we had on several previous occasions. This time, however, Stacee's wry understanding of the workings and constraints of introverted and possibly perfection-obsessed design practices led us to take the leap. She and her colleagues Julie Talbot, Sarah Milhollin, and Kevin McConnell, as well as our talented graphic designers at Omnivore, were all forthright and profoundly patient with a group that insisted on working as we have always done in our practice—as a workgroup rather than as any single decision maker.

We are honored to be able to include new photos of several of our projects, by the renowned architectural photographer Catherine Tighe, throughout this book. Catherine's intensely curious, poweful, and often-disruptive insights about our work elevated this project as well as our understanding of our own built work.

Internally, Cheryl dos Remedios was the true leader of this project and is to thank for its completion on all fronts. Cheryl arranged and moderated dozens of important conversations when they needed to happen, ensured that long-buried and camouflaged materials were found, and, on the whole, inspired us to appreciate the value of sharing these stories. Jillian Strobel provided additional curatorial work and patiently kept the group on-task in answering questions and providing background materials.

The greatest thanks of all—for this publication and for the last nineteen years—is to our clients. From private owners and institutions to public agencies, our clients have generously provided us with the very opportunity to practice this work every day. The projects in this book are theirs.

—Shannon Nichol for GGN

THE LURIE GARDEN
Location: Chicago, IL
Size: 3.3 acres
Completion Date: 2004
Client: Millennium Park, Inc.
Piet Oudolf, perennial
 plantsman
Robert Israel, conceptual
 review
Terry Guen Design Associates,
 local landscape architect
 collaborator
KPFF, civil and structural
 engineer
GKC EME, MEP engineer
Schuler Shook, lighting
 designer
CMS Collaborative, water
 feature consultant
Jeffrey L. Bruce & Company,
 irrigation consultant
Mankato Kasota, stone
 fabricator
Northwind Perennial Farms,
 perennial grower
Davis Langdon Adamson, cost
 estimator
Walsh Construction, general
 contractor

FURNITURE
Maggie Bench
 Completion Date: 2005,2010
 Client: Millennium Park, Inc.
 Urban Accessories and
 Landscape Forms, fabricators
Charlie Table
 Completion Date: 2005,2010
 Client: Millennium Park, Inc.
 Landscape Forms, fabricator
Urban Edge
 Completion Date: 2012
 Client: Landscape Forms
 Landscape Forms, fabricator

**SEATTLE CITY HALL
PLAZA AND CIVIC
CENTER CAMPUS**
Location: Seattle, WA
Size: 5.8 acres
Completion Date: 2005
Client: City of Seattle
Bassetti Architects and Bohlin
 Cywinski Jackson, a joint
 venture, Seattle City Hall,
 architects
NBBJ, Seattle Justice Center,
 architect
Swift Company, local land-
 scape architect collaborator
SvR Design Co., civil engineer
Magnusson Klemencic
 Associates, structural
 engineer
Fisher Marantz Stone, lighting
 designer
CMS Collaborative, water
 feature consultant
Columbia Stone, Inc., stone
 installer
Hoffman Construction,
 general contractor

NORTH END PARKS
Location: Boston, MA
Size: 2.8 acres
Completion Date: 2007
Client: Massachusetts
 Turnpike Authority
Crosby | Schlessinger |
 Smallridge LLC, lanscape
 architect of record
DMC Engineering, Inc., civil
 and MEP engineer
Earth Tech, structural engineer
Collaborative Lighting, LLC
 and Ripman Lighting
 Consultants, lighting
 designers

PROJECT CREDITS

CMS Collaborative, water
 feature consultant
American History Workshop,
 historical consultant
Ioana Urma, architectural
 consultant on pergola
United Stone and Site, stone
 installer
Fletcher Granite Company,
 stone fabricator
McCourt Construction
 Company, general contractor

**ROBERT and ARLENE
KOGOD COURTYARD**
Location: Washington, DC
Size: .5 acre
Completion Date: 2007
Client: Smithsonian
 Institution
Foster + Partners, design
 architect
SmithGroupJJR, architect of
 record
George Sexton Associates,
 lighting designer
CMS Collaborative, water
 feature consultant
Lorton, stone installer
Coldspring, stone fabricator
Ambius, landscape contractor
Hensel Phelps, general
 contractor

**BILL & MELINDA GATES
FOUNDATION CAMPUS**
Location: Seattle, WA
Size: 12 acres
Completion Date:
 Phase I, 2011
 Phase II, anticipated 2022
Client: Bill and Melinda Gates
 Foundation
NBBJ, architect

KPFF, civil and structural
 engineer
ARUP, structural and MEP/
 AV engineer
CMS Collaborative, water
 feature consultant
Jeffrey L. Bruce & Company,
 soils and irrigation
 consultant
Coldspring, stone fabricator
Johnston Construction, stone
 installer
Seneca Group, development
 manager
Sellen Construction, general
 contractor

**WEST CAMPUS
RESIDENCES &
STREETSCAPE**
Location: Seattle, WA
Size: 4.9 acres

Completion Date: 2012
Client: UW Housing and Food
 Services
Mahlum, architect
SvR Design Co., civil engineer
Coughlin Porter Lundeen,
 structural engineer
PAE Consulting Engineers,
 Inc., MEP engineer
Luma Lighting Design, Inc.,
 lighting designer
Walsh Construction Co.
 (Poplar and Alder Halls),
 general contractor
W.G. Clark Construction Co.
 (Cedar Apartments and Elm
 Hall), general contractor

**MERCER COURT &
UW FARM**
Location: Seattle, WA
Size: 4.5 acres

Completion Date: 2013
Client: UW Housing and Food
 Services
Ankrom Moisan, architect in
 collaboration with Feilden
 Clegg Bradley Studios,
 architect
KPFF, civil engineer
Perbix Bykonen, structural
 engineer
Glumac, MEP engineer and
 lighting designer
W.G. Clark Construction,
 general contractor

CITYCENTERDC
Location: Washington, DC
Size: 10 acres
Completion Date: Master plan
 2006, Phase I 2013, Phase II
 anticipated 2019
Client: Hines|Archstone
Foster + Partners, master plan
 and design architect
Shalom Baranes Associates,
 architect of record
Lee and Associates, local land-
 scape architect collaborator,
 apartments at CityCenter
 and streetscape
Delon Hampton & Associates,
 Chartered , civil engineer
SK&A Group, structural engi-
 neer of record
Thornton Tomasetti, consult-
 ing structural engineer
Dewberry, MEP engineer
Claude R. Engle, lighting
 designer
CMS Collaborative, water
 feature consultant
Jeffrey L. Bruce & Company,
 soils consultant
Irrigation Consultant Services,
 irrigation
Rugo Stone and R. Bratti
 Associates, a joint venture,
 stone installers
Campolonghi, stone fabricator
Clark/Smoot, a joint venture,
 general contractort

THE PARK AT
CITYCENTER
Location: Washington, DC
Size: 0.6 acre
Completion Date: 2013
Client: Hines|Archstone
Delon Hampton & Associates,
 Chartered, civil engineer

SK&A Group, structural
 engineer
Claude R. Engle, lighting
 designer
CMS Collaborative, water
 feature consultant
Jeffrey L. Bruce & Company,
 irrigation consultant
Rugo Stone and R. Bratti
 Associates, a joint venture,
 stone installers
Campolonghi, stone fabricator
Clark/Smoot, a joint venture,
 general contractor

PIKE-PINE RENAISSANCE
STREETSCAPE DESIGN
VISION
Location: Seattle, WA
Size: 160 acres
Completion Date: 2013
Client: Downtown Seattle
 Association
Framework, urban design
 collaborator
Toole Design Group, multi-
 modal design consultant
Downtown Works, retail
 assessment consultant
ECONorthwest, economic
 assessment consultant

CHROMER BUILDING
PARKLET & STREATERY
Location: Seattle, WA
Size: .015 acre
Completion Date: 2014
Client: Urban Visions
Krekow Jennings, builder and
 collaborator
KPFF, structural engineer
City of Seattle, Downtown
 Seattle Association, and
 Seattle Parks Foundation,
 contributors and supporters

UNIVERSITY OF
WASHINGTON SCHOOL
OF MEDICINE
Location: Seattle, WA
Size: 4.5 acres
Completion Date: Phase 2,
 2008; Phase 3.1, 2013; Phase
 3.2, anticipated 2018
Client: Washington Biomedical
 Research Properties II and
 Vulcan, Inc.
Perkins + Will, architect
Coughlin Porter Lundeen, civil
 engineer

Magnusson Klemencic
 Associates, structural
 engineer
ARUP, engineer
AEI, MEP engineer
Horton Lees Brogden, lighting
 designer
Waterline Studios, water
 feature consultant
Sellen Construction, general
 contractor

NU SKIN INNOVATION
CENTER AND CAMPUS
Location: Provo, UT
Size: 8 acres
Completion Date: 2015
Client: Nu Skin Enterprises
Innovation Center Project
 Team
Bohlin Cywinski Jackson,
 Innovation Center, architect
NBBJ, Campus, architect
Magnusson Klemencic
 Associates, civil engineer
DCI Engineers, structural
 engineer
Van Boerum & Frank
 Associates, Inc., MEP
 engineer
Spectrum Engineers, electrical
 engineer
CMS Collaborative and
 Outside the Lines, water
 feature consultants
Jeffrey L. Bruce & Company,
 soils and irrigation
 consultant
KEPCO+ and IMS Masonry,
 stone installers
North Carolina Granite
 Corporation, stone fabricator
Oakland Construction, general
 contractor

LOWER RAINIER
VISTA & PEDESTRIAN
LAND BRIDGE
Location: Seattle, WA
Size: 6.3 acres
Completion Date: 2015
Client: University of
 Washington
KPFF, civil and struc-
 tural engineer, prime
 administrator
Shannon & Wilson, geotechni-
 cal engineer
AEI/Pivotal, electrical engi-
 neer and lighting designer

LTK Engineering Services,
 trolley systems engineer
Davis Langdon, cost estimator
Sellen/Merlino JV, general
 contractor

NATIONAL MUSEUM OF
AFRICAN AMERICAN
HISTORY AND CULTURE
Location: Washington, DC
Size: 5 acres
Completion Date: 2016
Client: Smithsonian
 Institution
Freelon Adjaye Bond/Smith
 Group, architectural team
Rummel, Klepper & Kahl, civil
 engineer
Robert Silman Associates,
 structural engineer
Guy Nordenson & Associates
 and Robert Silman, struc-
 tural engineers
WSP Flack & Kurtz, MEP
 engineer
CMS Collaborative, water
 feature consultant
Rugo Stone, stone installer
Coldspring and Structural
 Stone, stone fabricators
Ruppert Landscape, landscape
 contractor
Clark Smoot Russell, a joint
 venture, general contractor

INDIA BASIN
SHORELINE PARK
Location: San Francisco, CA
Size: 9.6 acres
Completion Date:
 Concept design, 2016
 Phase I, anticipated 2019
 Phase II, anticipated 2024
Clients: San Francisco
 Recreation and Park
 Department, The Trust for
 Public Land
Turnbull Griffin Haesloop,
 architect
Rana Creek Design, ecological
 designer
Magnusson Klemencic
 Associates, civil engineer
Greenlee and Associates,
 horticulture consultant
Fratessa Forbes Wong,
 structural engineer
Alta Planning + Design,
 transportation planning

PHOTOGRAPHY CREDITS

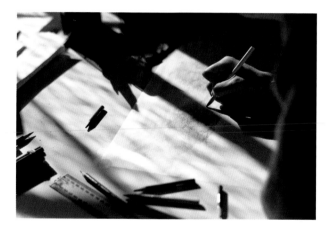

Published in the United States in 2018 by
Timber Press, Inc.

The Haseltine Building
133 S.W. Second Avenue, Suite 450
Portland, Oregon 97204
timberpress.com

Printed in China

Text and cover design by Omnivore

Library of Congress Cataloging-in-Publication Data

Names: Way, Thaïsa, 1960–
Title: GGN : Landscapes 1999–2018/written with
Thaïsa Way.
Other titles: Gustafson Guthrie Nichol
Description: Portland, Oregon: Timber Press, 2018.
Identifiers: LCCN 2018011960
ISBN 9781604698237 (hardcover)
Subjects: LCSH: Landscaping industry—
United States.
Classification: LCC SB472.53 .W39 2018 | DDC
635.068—dc23
LC record available at https://lccn.loc.gov/2018011960

A catalog record for this book is also available
from the British Library.